Contemporary
Arab Women's Art
Dialogues of the Present

Curatorial Practice Archive
California College of the Arts
1111 Eighth Street
San Francisco, CA 94107

Curator: Siumee H. Keelan Editor: Fran Lloyd

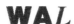

First published in 1999 by the
WOMEN'S ART LIBRARY
FULHAM PALACE, BISHOPS AVENUE
LONDON SW6 6EA

Published on the occasion of the touring exhibition:
Dialogue of the Present, the Work of 18 Arab Women Artists
Venues: Hot Bath Gallery, Bath
 Plymouth Arts Centre, Plymouth
 Brunei Gallery, SOAS, London
 Pitshanger Manor and Gallery, London
 University of Brighton Gallery, Brighton

ISBN 1 902770 00 5

British Library Cataloguing in Publication Data
A catalogue record for this book is available from the British Library

Designed and typeset by Siumee Keelan, Keelan Roberts

Printed in the UK by Principal Colour, UK

Cover illustration: Zineb Sedira
Don't Do To Her What You Did To Me No.2, 1996
The Gallery of Modern Art, Glasgow

PUBLICATION SPONSORED BY:
HH SHEIKH DR SULTAN AL-QASIMI

In memory of
my mother
Susannah Lloyd

CONTENTS

PART I

Chapter One

Chapter Two

Chapter Three

Chapter Four

PART II

Chapter Five

Chapter Six

ACKNOWLEDGEMENTS

EDITOR Fran Lloyd

In many ways this book has been a collaborative effort formed through the work of previous writers who, from differing perspectives, have established the basis for a new way of looking and thinking about identity, women's art practice and the spaces of contemporary Arab women's art. It has also been created through the work of the curator, the artists and the other writers who have willingly taken part in the production. I would like to thank them all for their contributions, and the Women's Art Library staff for supporting the overall project.

In particular I would like to thank the curator, Siumee Keelan for her good humour and continuous support, without which this project would not have been realised, and Melanie Roberts for her generosity of time and her meticulousness.

I would also like to thank Kingston University for providing me with some research leave, my colleagues for their support, Susan St. Clair for invaluable library help, Chris Lomzik for technical expertise, and both Nancy Brenner and Cheryl Springer for their administrative help in difficult moments.

Finally, I would like to thank my husband Patrick Warren and my children, Luke, Camille, Duncan, Nathan and Saskia, for the endless patience and support they have shown over the last few months.

CURATOR Siumee Helen Keelan

Dialogue of the Present, the Work of 18 Arab Women Artists is intended to enhance the awareness of contemporary Arab women's art and this has been made possible by the support received from the Women's Art Library and our sponsors. The success of *Dialogue of the Present* was the result of teamwork and I would like to thank everyone who has worked on this project and the artists for the loan of their work. However, a special mark of appreciation should go to:

The Women's Art Library staff: Margaret Woodhead, Managing Director and Althea Greenan, Librarian and Valentine Parguey, who was a voluntary helper at WAL.

The artists: Thuraya al-Baqsami, Maysaloun Faraj, Batool al-Fekaiki, Saadeh George and Azza al-Qasimi who have given specific help.

Dialogue of the Present, related events and this publication were most generously supported by HH Sheikh Dr Sultan al-Qasimi, the Supreme Ruler of Sharjah, UAE, Visiting Arts, the Arts Council of England, the London Arts Board, the Foreign and Commonwealth Office, Kingston University, and the National Bank of Abu Dhabi.

Donation was also received from the Arab Bankers Association.

I would also like to acknowledge the support of Saffron Books who will be publishing the papers of the accompanying symposium, *Displacement and Difference* (ISBN 1 872843 22 0).

In addition, I would also like to thank our hosts the Hot Bath Gallery, Plymouth Arts Centre, Brunei Gallery, Pitshanger Manor and Gallery, and University of Brighton Gallery.

Last but not least, I would like to thank all the artists who have submitted their work for consideration and would like to extend my regrets that space dictated a limited number of participants.

CONTRIBUTORS

FRAN LLOYD is Head of the School of Art and Design History at Kingston University and the MA Course Director for Art & Design. She was educated at Manchester University where she is completing a Ph.D on *New British Sculpture of the 1980s*. She is a lecturer and writer. Her publications include *Deconstructing Madonna*, (ed., Batsford,1993) and *From the Interior: Female Perspectives on Figuration* (KUP, 1997). She is currently contributing to a forthcoming publication on *Feminist Visual Culture: An Introduction* for Edinburgh University Press, 1999 and editing the symposium papers for *Displacement and Difference* for Saffron Books, 1999.

SIUMEE HELEN KEELAN is a freelance curator and lecturer. She was educated at Kingston University where she obtained a BA and MA. Her primary interest is in the promotion of the understanding of different cultures and women's issues. Past projects include *Fantasy, 1994*, the work of fifteen British women artists which toured the United Arab Emirates. Keelan's most recent projects include *From The Interior*, a joint exhibition of the work of artists from China and Britain. *From The Interi*or toured nationally in the UK (1997-98) and will be touring to China in 1999. *Dialogue of the Present, the Work of 18 Arab Women Artists* is touring the UK (1999 to 2000). She is currently organising a major touring exhibition of contemporary Japanese art.

TINA SHERWELL is the Director of the Archive of Palestinian Art, Al-Wasiti, and currently lives in Jerusalem where she is completing a Ph.D on the *Representations of Palestine.* She was trained as an artist at Goldsmith's College, London and is a founding member of the Jesser Artists' Group in Jerusalem. She has published widely on Palestinian art and culture and has curated several exhibitions of contemporary Palestinian Art in Israel and abroad.

SALWA MIKDADI NASHASHIBI is the president and founder of the International Council for Women in the Arts, a non-profit educational organization, established in 1989 to recognize the outstanding contributions of Arab women in the visual arts. She has travelled and worked in various parts of the Arab world including a recent two year residency in Jordan. Nashashibi is a writer, lecturer and curator. In 1994 she organised the major American touring exhibition, *Forces of Change: Women Artists of the Arab World*. She lives in Lafayette, California, USA.

MELANIE ROBERTS is a freelance researcher, writer and lecturer on modern and contemporary art. Educated at Kingston University and the Courtauld Institute, her principal research area is in the relationship between British artists and art related institutions of various kinds including that of 'history'. The various ways that artists are inscribed and are able to inscribe themselves in critical and historical discourses has led to a particular interest in oral history. In relation to this, Melanie Roberts regularly interviews artists for the National Sound Archive's *National Life Story Collection - Artists' Lives*.

PREFACE

Fran Lloyd

Contemporary Arab Women's Art, Dialogues of the Present aims to provide a knowledge and understanding of the richness and diversity of Arab women's contemporary art practice by focusing on the work of artists who currently live in the vastly different spaces of the Middle East, North Africa and Great Britain. As the title suggests, this book refuses to contain Arab women's art to an ahistorical, timeless past. It is concerned with the spaces of modernity where art produced by women within Arab countries, and the Arab diaspora is present/ed as part of contemporary art practice.

Published to coincide with the exhibition, *Dialogue of the Present, The Work of 18 Arab Women Artists* which is the first major touring exhibition of contemporary Arab women's art to be shown in Britain, this book is both an act of documentation and a critical space. Such spaces and records are important as sites of visibility and meaning from which women artists have, at least historically, frequently been marginalised or excluded on the basis of gender, race or geographies. In addition, the making of art is an active process which takes place within the complex and contradictory cultural, political and economic spaces of society. It is an interactive process where meaning is continually in production; for the artist through the act of making, for the writers, and for different audiences through the act of encountering the object in a gallery, through a reproduction or the written or spoken words which frame it.

The multiple dialogues are both those that have engendered the art (through the diversities of location as place, history, and memory, continually re-made in the present), and those which the art engenders

through its presence across the many local and international sites.

Most western non-Arab audiences know little about contemporary Arab art and we know even less about Arab women's art practice; its histories, its geographies and the complexities of being female, an Arab, and an artist in the contemporary spaces of the Middle East or North Africa or the diaspora. *Contemporary Arab Women's Art* seeks to change this by focusing on the work of women who produce art from both traditional and contemporary materials in a variety of different forms which include painting, drawing, printmaking, photography, video, ceramics, installation and sculpture. The following essays provide a much needed context for their art practices where the specificities of the multiple effects of colonialism, the differing conditions of art education and the traumas of war and displacement all have a bearing on how the artists are located and how they locate themselves within postcolonial spaces. Written from different geographies, generations and different perspectives, they provide a sense of the complex continuities and discontinuities which are part of Arab women's art and the various conditions in which they practice as well as the issues which surround their work.

The initial two essays provide an introductory framework to the complexities of cross-cultural dialogues, the issues of identities, histories and geographies which are involved as well as the subtle forms of imperialism that work to marginalise non-eurocentric art in the west. Moving to the particular, the subsequent two essays concentrate on different aspects of contemporary Arab women's art practice: the imaging and re-imaging of the female body, and the supporting art structures which underpin professional practice in the Arab world. The latter essay is accompanied by an extensive appendix which provides a wealth of information on the art institutions, galleries and art spaces in the Middle East, North Africa and the Arabian Peninsula.

The second part of the book, *Diverse Bodies of Experience*, focuses on the work of the eighteen Arab women artists who are part of the accompanying exhibition, *Dialogue of the Present*. Spanning five gen-

erations and coming from ten different countries, the artists' work is informed by their diverse geographies, histories and experiences. This section brings together two important but different bodies of writing: a statement by each artist followed by a spectator's response to the artist's work. On one level the two texts represent a dialogue between the audience and the work and, in some cases, the artist. At another level, they invite the reader to participate in the production of further meaning through dialogues with, and between, image and text. Over-all, they provide a powerful sense of the diverse experiences and meanings which the works embody for the artists as producers, and the audiences as active participants: a process of continuous rene-gotiation and questioning.

In production during the recent political events which threaten to frag-ment, the urgency of maintaining dialogues in the present could not be more evident or more poignantly underscored.

For the purposes of clarity this publication uses the common European version of a name rather than the Arabic translation.

Part I Chapter One

i/you
self/other
male/female
west/east
white/black
subject/object
mind/body
progress/stasis
coloniser/colonised
international/national
national/local
inclusion/exclusion
pure/impure
time/timeless
location/dislocation
centre/margin
placement/displacement
presence/absence
inside/outside
veiled/unveiled
fixity/fluidity
sameness/difference
permanence/change

"Every identity is placed, positioned, in a culture, a language, a history ... But it is not tied to fixed, permanent, unalterable conditions. It is not wholly defined by exclusions".
Stuart Hall, *Cultural Identity and Diaspora,* 1990

"Some years ago my Arab identity was a fact of politics and culture and of life ... Now ... If I am asked I should say my identity is Middle Eastern, not Arab at all. That way I can be postmodern, updated, moving with the time".
Nawal El Saadawi, *Why Keep Asking Me About My Identity,* 1997

Calligraphy by Saadeh George

CROSS-CULTURAL DIALOGUES:
Identities, Contexts and Meanings
Fran Lloyd

Writing as a western woman and a historian of art, I am increasingly conscious of the binary oppositions which dominate western thinking and work to privilege one thing above another: male over female, west over east, mind over body, and so forth. The resultant hierarchy means that one body of things or one group of people is diminished or made other by comparison to the dominant, primary term. Divided and unequally valued, they do not share the same space.

Questions about positioning are central to the issue of a cross-cultural dialogue. Can such a dialogue ever occur or are we always bound by our positioning within a binary system which privileges one set of cultural values over another? How ever much we may think otherwise, do we always subtly frame and classify art produced in the diaspora or in non-western countries as other and create a separate sphere of difference for it? Or, in the postmodern and postcolonial world which supposedly characterises the late twentieth century, do we subsume this difference into a floating sign of sameness which ignores the ways that we as historical subjects are differently located by gender, race and class within its power structures?

These questions have been the subject of much recent international and local debate and they have become particularly pressing at a time when geographical boundaries have been radically altered not only by war but by the spread of new technologies and increased mobility.[1] Countries that were once distant are now near, and the signs of a homogenised culture are visible across the globe. As the crossing

of borders has become more commonplace through travel for work or leisure, through migration, and through displacement, we can no longer conceptualise the world in the same way. Spaces that were once local have become national and the geo-political boundaries that once marked the limits of a country have become more fluid as the diaspora grows.[2] Similarly, old divisions that framed the east and the west no longer hold up as increasingly the east is in the west and the west is in the east, just as the private and the public have proved to be interconnected through state control.

These changes suggest that former modes of identification are now under pressure and that new modes of being are in production. Variously termed postmodern, postcolonial, post whatever, at the centre of these is the question of identity which has been the foundation on which the western binary oppositions have been built. Until recently western thought has seen identity as something permanent, as an 'I' which is formed early in childhood and remains more or less permanent and unified throughout life. Linked to concepts of progress, and therefore linear time, the boundaries of this fixed 'I' are predicated against what is outside the self, the 'you' or 'them' which is other. Although well established before the eighteenth-century western Enlightenment project, this fixed concept of identity is often seen as fully embodied in its central narrative of an unequivocal belief in progress which informed the growth of empire, imperialism and the assured supremacy of western values relating to culture, science and medicine (with their clearly defined subject and object) and the accompanying 'othering' of women and non-western cultures. Linked to the mastery of sight and control over the visible world, the embedded systems of classification operate across a multitude of sites which include the cultural.

The effects are numerous and far reaching. They can be seen, for example, in the way in which the Arab world has been perceived by the majority of western writers since the eighteenth century as part of the oriental east, separate from the west and therefore part of a different order. Unlike the progressive west, the oriental east was consid-

ered backward; a static uncivilised entity, caught in an ahistorical past from which it needed to be released in order to enter the modernised world of the west. Edward Said, in his polemical book on Orientalism, states that for the west the Orient was "one of its deepest and most reoccurring images of the Other",[3] and using Michel Foucault's concepts of power and discourse, Said goes as far as to argue that without examining Orientalism as a discourse one cannot understand the "systematic discipline by which European culture was able to manage - and even produce - the Orient politically, sociologically, militarily, ideologically, scientifically and imaginatively ... because of Orientalism the Orient was not (and is not) a free subject of thought or action".[4]

Since the late 1960s the inadequacies of a fixed concept of identity, the binary oppositions and the associated 'grand narratives' of western culture, have been challenged on various fronts including those excluded or marginalised by gender, race, sexuality and class. Such a system privileges fixity over fluidity and allows no room for resistance to, or negotiation of, the dominant discourses, nor does it acknowledge the multiplicity at all levels of society including the personal. Influenced by feminist theory, psychoanalysis, structuralist and poststructuralist thought, identity is now generally acknowledged as less fixed and more fluid in ways which allow the individual some agency.

In particular, these ideas have been useful to the study of cultural identity, the study of how we see ourselves and others within the social world. Stuart Hall, writing within a postcolonial world and acutely aware of the effects of 'othering' through his own history as a colonial subject and his experience of the African diaspora, discusses two divergent ways of thinking about cultural identity. The first is "in terms of one, shared culture, a sort of collective 'one true self', hiding inside the many other, more superficial or artificially imposed 'selves' which people with a shared history and ancestry hold in common".[5] The second view "recognises that, as well as the many points of similarity, there are also critical points of deep and significant difference which con-

stitute ... 'what we have become' ... (it) is a matter of 'becoming' as well as of 'being'. It belongs to the future as much as to the past".[6] The difference here is one of agency, or as Hall succinctly writes: "identities are the names we give to the different ways we are positioned by, and position ourselves within, the narratives of the past".[7]

Referencing the 1960s writings of Frantz Fanon [8], Hall recognises that the view of one shared culture enabled the rediscovering of 'hidden histories' which "played a critical role in all post-colonial struggles which profoundly reshaped our world".[9] It was of particular importance in circumstances where one was not just being constructed as the other but made to 'experience ourselves as 'Other'".[10] However, Hall maintains an insistence that this rediscovery does not take place in the past but in the space of the present where the forces of politics, history and representation operate. For Hall the diaspora is not defined by an 'essence or purity' but by diversity, the "conception of 'identity' which lives with and through, not despite, difference; by *hybridity*. Diaspora identities are those which are constantly producing and reproducing themselves anew, through transformation and difference".[11]

This reformulation of cultural identity in the west (long held in other philosophical traditions) subtly introduces a dynamic and an agency into identity which has the potential to unfix, or to exceed the binary opposition.[12] It is particularly useful in a discussion of Arab identity, where Arab identity is not (and never has been) able to be located in one 'sacred homeland' or one nation. There is no one originary point tied to a nation because there is no nation. The Arab world is made up of multiple and disparate cultures and religions, territories and identities, which are now located on three different continents and in over twenty different sovereign states in the Middle East and North Africa. It also includes those in occupation in Palestine and the Arab diaspora in other Arab countries, as well as those in various parts of the globe.

Given the complexity of these histories which inform the present, it is worth briefly outlining a few co-ordinating points. As the map of the pre-Islamic Middle East and North Africa shows (Plate1) the

geographies once associated with the Arab world were extensive. Within these geographies, if one looks for the sources of Arab identity, one is immediately aware of the vast time scale involved and the succession of migrations and occupations. One is looking at the 6th Millennium BC for some of the earliest Neolithic cultures in the high plateaux of the Middle East and Africa, and the 5th Millennium BC for the low lying plains of Mesopotamia where the Sumerian empire spread to the Indus Valley (in present day Pakistan) by way of the island of Bahrain in the Persian Gulf. Their successors, the Babylonians existed in parallel time to pre-dynastic Egypt while, slightly later, Assyria in the 3rd Millennium BC, spread from this area into the Mediterranean and modern Iraq, Syria, Jordan, Palestine, and North Egypt to become the dominant power in the Middle East by 612BC. Africa, meanwhile, was a vital trade link both to the Mediterranean via the caravan trains which travelled across the Sahara, and to Arabia and Iran, to India and beyond.

In effect, this represents six millennia of pre-Islamic cultures. By comparison, the Islamic culture which is now associated with these geographies is young. The Prophet Muhammad, born into the nomadic Bedouin culture of the Arabian Peninsula in 570 or 571AD, preached a monotheistic teaching based on visionary experiences in which the Qur'an was dictated by the Archangel Gabriel. Seen as a fulfilment of the Jewish and Christian religions, Islam quickly spread and by 647BC had conquered Iraq, Palestine, Syria, Egypt. Iran followed, then present day Pakistan and North Africa, and, by 710 AD, Spain and parts of France, and finally parts of Central Asia. Across these differing sites the legal and religious language was Arabic and the Kufic script became dominant (particularly given that translation of the Qur'an was forbidden).

The 661AD dispute between orthodox Muslims (Su'nites) and the more mystical and philosophical Shi'ites from Persian Iran, finally led to a schism in the Islamic world. The Su'nite caliphates (areas ruled by the deputies of Muhammad) included not only the Middle East and parts of Asia but the North African caliphate created by Muhammad's

Plate 1 The Pre-Islamic Middle East and North Africa

Plate 2 The Islamic Middle East and North Africa
Includes current place names

daughter and the independent caliphate in Spain from the 710s AD, centred in Cordoba. Originally a Roman city, Cordoba was to become the most prosperous Islamic city, second only to Baghdad. In 762AD the capital of the Arab world was moved from Damascus to the old Sumerian centre of Madinet as Salem- the city of peace - or present day Baghdad.

The peak of Islamic culture in terms of territory and wealth is usually seen to be the thirteenth century with, for example, semi-independent Islamic states covering three quarters of present day Spain and Portugal. (Plate 2) After this Islamic power declined. Arab Muslims were expelled from Spain in 1492 and the Turkish Ottoman Empire spread steadily from the early 1500s. By the end of the sixteenth century all Middle Eastern and North African Arab countries, except for Morocco, had become part of the Ottoman Empire. As the Ottoman Empire receded in the nineteenth century European colonialism spread.

It is from these histories, however brief, that one can understand the importance that certain places and peoples have held for the continual re-making of Arab identity in the present, especially given the subsequent histories of colonialism. It also reminds us that "a pure and seamless ... identity breaks down when you begin to trace the ceaseless migration of people's throughout history".[13]

Egypt was the first country in the Middle East and North Africa to establish independence from the Ottoman Empire, only to be invaded by the English in 1882. The rest of the Arab east (sometimes referred to as the Mashriq) remained under direct Ottoman control until after the First World War. In the 1920s the territory was broken up in the states of Lebanon, Syria, Palestine and Transjordan under French and British mandates.[14] In the late nineteenth century the Maghrib, or the Arab west, came under colonial rule. In 1830 Algeria and then Tunisia were occupied by the French, while Morocco and Libya were occupied early in the twentieth century by the French and Italians respectively. Sudan meanwhile fell under Anglo-Egyptian control and although the Arabian Peninsula was never colonised, much of the west area by the

Indian Ocean came under British control, while Aden in the South Yemen became a strategic outpost.

Colonial control varied within the different geographies and had a profound effect on the way differing Arab subjects were (and are) positioned in terms of gender, class, language and the other myriad forms of cultural and political identity. In general, British colonial policy left indigenous cultures and religions relatively intact, while French and Italian colonial policies sought cultural and religious assimilation and settled large communities in the colonial land. As Badran and Cooke note:

> "In the Mashriq, (including Egypt and Arab lands in western Asia excluding the Arab Peninsula), there was a move towards secularisation directed by new Arab élites and state authorities. They wrested control out of the national educational systems from the Islamic authorities and restricted the scope of Islamic legal jurisdiction to mainly those to do with laws governing the family".[15]

By the beginning of the twentieth century the French language had supplanted Turkish among the upper classes. Elsewhere, Turkish remained the language of this class until the 1920s when it was replaced by English and French throughout the Mashriq. Arabic, however, remained the official language and after independence, and the introduction of free education at university level, it became the major written and spoken language. Thus, despite following European educational models, the teaching was in Arabic which remained the language of the majority, albeit with different dialects.

The situation was very different in the Maghrib. French and Italian replaced Arabic or Turkish as the language of government and education and gradually became the language across the classes. Language, a common mark of identity, or a 'measure of dwelling' as Homi Bhabha calls it,[16] is particularly important to Arab identity given the differing Arab geographies. At various times, and only in some geographies, colonialism, and to a lesser degree class, played a role

in disrupting this continuity. After fifty years of colonial rule many Moroccans, for example, could speak but not write in Arabic.[17] Fanon, who came from the French colony of Martinique and then lived in Algeria and Tunisia, wrote of this experience where "to speak the language of the coloniser is to carry the imposed weight of an entire civilisation and to bury one's own traditions and history".[18] Similarly, as in the Mashriq, colonial law often superseded Islamic law .

By the 1960s most Arab countries had became independent except for Palestine. In 1948 it was taken over by the new state of Israel which resulted in numerous wars and the dispersal of Palestinians across various sites internationally.

As Badran and Cooke note:

> "The Arabian Peninsula is an exception in many ways. Never under colonial rule nor absorbed into the European-dominated market system until the discovery of oil in the 1930s, Islamic authorities retained fuller control over everyday life. The Arabic language and Islamic/Arab education remained in force".[19]

Within these colonial and postcolonial geographies women were positioned differently by gender, race, class and religion. The majority of Arab women were unequally placed, politically, socially and culturally.[20] This difference was often highly visible through the divisions of public and private spheres and, in some cases, the further division of the spaces within the home (although, as Yuval-Davies notes, the private is often structured by the state).[21] In addition, like many Muslim and non-Muslim women in other parts of the east and Asia, the veil in its various forms, marked difference.

As Salwa Nashashibi's essay makes clear, gender was (and still is in some countries) one of the key determining factors in education in the Middle East and North Africa alongside class. Although foreign missionary schools in Lebanon and Egypt before the mid-nineteenth century educated boys and girls, the state schools of the latter part of the century were predominantly for boys: upper class girls relied upon

a private tutor system. In 1925, Egypt was one of the first Arab countries to formalise secondary state education, including art education, and here male and female had equal access. However, similar institutions were not opened until the 1950s in Saudi Arabia and, in the case of university education, not until the 1960s, as against 1929 in Egypt.[22]

Most visibly, these educational opportunities "disturbed patriarchal patterns of control over women"[23]: patterns which had been established through the harem system, which segregated the sexes and secluded women within the home, and through the face veil which "maintained distancing of the sexes if or when women left home".[24] The practice within the geographies of the harem system and of veiling varied across countries and classes in the nineteenth century. Although it was not solely an Arab practice, most urban upper and middle class Arab women lived within this system and veiled: the urban lower class tended to veil but rural workers tended not to.[25]

The veil must be the most outwardly visible and most publicly contested sign and site of gendered difference in Arab cultures across the world. The continuous and discontinuous histories and geographies of the veil are complex and the subject of much debate across a range of different sites and from different perspectives, including those Badran calls the invisible face of Arab feminism.[26] Huda Sha'rawi (1879-1947), the leader of the first Egyptian women's nationalist demonstration in 1919 and the founder of the Egyptian Feminist Union in 1923, for example, was one of the "last generation of women to reach maturity while the harem system prevailed".[27] Her memoirs show the existence of debates on Islam and unveiling in the Cairo harem salon of the 1890s, founded by Eugènie Le Brun Rushdi, a French woman who married an upper class Egyptian and converted to Islam.[28] Adopting a westernised form of feminism, Sha'rawi, who publicly removed her veil in 1923 at the train station in Cairo, spoke out against veiling while Malik Hifni Nasif (1886-1918) also from Egypt, a strong advocate of rights for women within marriage, viewed unveiling as a western imperative. The harem system, and the face veil among upper class

and middle class women in Egypt, had ended by the late 1920s, the rest of Mashriq from the 1930s, and in Sudan and the Maghrib from the 1950s and 1960s following liberation. In the Arabian Peninsula, except in Saudi Arabia, changes occurred in the 1970s and 1980s. Recently, however, with the rise of Islamic fundamentalism, the veil has returned, and in the late 1990s it is more usual for middle and upper class women to veil in most Islamic countries, including Egypt, Kuwait and Sudan. Often this is partial but more recently, full veiling is gaining ground.

Veiling in its many different physical forms signifies a vast array of complex meanings which vary according to their histories and geographies. In the west the veil is generally regarded as a sign of Islamic repression. However, in the Arab world it is a more complex cultural sign which in some geographies operates as a sign of resistance to oppression, a sign of class and, as Nasif suggests, a rejection of western values and lifestyle.[29] While in Egypt and Lebanon, for example, unveiling was generally associated with independence and the growth of Arab feminism in the 1920s, in Algeria, by contrast, the veil became a symbol of resistance to colonialism.

Writing in 1987, Marie-Aimée Hélie-Lucas, a sociologist and anthropologist born in Algiers in 1939, provides an illuminating account of the complex positioning of Algerian women during the Algerian War in the 1950s. After discussing the mismatch between the reality and the perceived view of Algerian women's role as freedom fighters (formed through Frantz Fanon's books and Gillo Pontecorvo's popular film, *The Battle of Algiers*, 1965) Hélie-Lucas discusses the veil: "Although there is no doubt that veiling women is a measure for control and oppression, it became for a time a symbol of national resistance to the French. During the war, French officials had insisted that Algerian women should be freed from the oppression of the veil. French army trucks had transported village women to urban areas. There they were forced to unveil publicly thereby proving their renunciation of outworn traditions. Both Algerian men and women resented this symbolic rape".[30]

Although it had a practical purpose, as Hélie-Lucas explains, its association with tradition and nationality had an equally oppressive side:

> "Fanon praised the revolutionary virtue of the veil - it allowed urban women fighters to escape the control of the French army. They could hide their guns under their veils and travel incognito ... How, therefore could we take up the issue of the veil as oppressive to women without betraying both the *nation* and the *revolution*?" [31]

In this account the veil becomes the contradictory sign of oppression and resistance, tradition, backwardness, violation and virtue, a means of escape, a symbol of nation and revolution.

Thus, located within the differing geographies of colonialism, the veil changes its meaning both across areas and within an area. In the Maghrib for example, where colonial imposition was particularly severe, the veil became a symbol of national identity. In Egypt it did not hold this weight of nationalism and, as Badran and Cooke note:

> "Egyptian women could fight for nationalist as well as feminist goals without incurring the criticism that their feminist demands were dividing the nation against itself".[32]

> "One of the earliest slogans of nationalism in Algeria was promoted by the *ulama* (religious leaders), 'Arabic is our language. Islam is our religion. Algeria is our country'. Women were supposed to raise sons in the faith and preserve traditional moral standards and to teach the language of their forefathers ... Women should be bound to tradition, while men had some access to modernity. Yet it is now commonplace that tradition serves the purposes of those in power. Tradition is seen as ahistorical and immutable, modernity draws from the wealthy West - whatever that means".[33]

The linking of women with nation, tradition or religion (a familiar operation of gendered binary oppositions) assigns women a specific place or role which works to constrain and to exclude them, denying them modernity. In times of national struggle, where the identity of the nation is under threat or is just being re-created, to challenge the role

is to question, as Hélie-Lucas argues, 'the past (as tradition) and the future (as revolution)'. Traditionally, "Like her sisters along the Mediterranean basin, the Arab woman has been expected to marry early, create a family and perpetuate the tradition of promoting the careers of her sons over those of her daughters". [34] However, the needs of the nation change as the nation changes, and frequently the focus on woman as the bearer of these national identities means further constraints and controls.

As I indicated earlier, there is a tension between Islamic law and constitutional law which means that, as Kandiyoti notes "The legal equality granted under the constitution of modern states is circumscribed by family legislation and personal law in the areas of marriage, divorce, child custody, maintenance and inheritance rights". [35] In more fundamentalist countries these social laws are often used to regulate the female body, not only through marriage but for the needs of reproduction and maintenance of the values of the state. Deniz Kandiyoti forcibly argues that "Wherever women continue to serve as boundary markers between different national, ethnic, and religious collectivities, their emergence as fully fledged citizens will be jeopardised, and whatever rights they may have achieved during one stage of nation-building may be sacrificed on the altar of identity politics during another". [36]

The importance of these implications for female identity extend across the boundaries of nations in the Arab world and the diaspora as Hélie-Lucas describes well:

> "During wars of liberation women are not to protest about women's rights. Nor are they allowed to before or after. It is never the right moment. Defending women's rights 'now' - this now being any historical moment - is always a betrayal of the people, the nation, the revolution, religion, national identity, cultural roots ... Leftist Algerian men are the first to accuse us of betrayal, of adhering to 'imported ideologies' of Westernism. They use the same terminology that our government uses against the left at large. We are caught between two legitimacies: belonging to our people or identifying with other oppressed women". [37]

The work of Arab women artists is informed by the complexities of these histories and geographies which have shaped their access to education, their relationship to past artistic traditions (both in the east and the west), and their negotiation of the present within both a local and an international context. Located differently by age, class and religion, their art is also created against and through other 'narratives of identity' which are part of this history: the stereotypes of the Arab woman, both past and present, women as colonial and postcolonial subjects, and the political and social realities of their present which include war, displacement and exile.

Turning now to the discussion of contemporary Arab women's art practice within these spaces, or to use Griselda Pollock's phrase "generations and geographies",[38] I want to focus on the diversity of their experience without collapsing it into sameness by erasing differences. Acting as a shorthand, generations and geographies references the specificities of their location "in time and space, in history and social location".[39] By making us aware of the need for the particular it also provides an understanding of the specificities of women's art practice in the contemporary world. Identities are located within generations and geographies and are particularly important when addressing the work of Arab women artists given their differing histories and geographies as colonial and postcolonial subjects in Arab countries and in the diaspora. These are the formations which actively shape and locate the work in the present and the conditions within which, through which, and against which, women negotiate and re-create or re-vision themselves.

By focusing primarily on the work of the eighteen artists who are part of the accompanying exhibition, *Dialogue of the Present* (documented in the second part of this book) I want to give some sense of these specificities while avoiding monolithic categories which work to essentialise, to stereotype, to constrain and to reduce complexities, contradictions and multiplicities to a seamless whole.

The artists do not represent all Arab women artists, all geographies and all histories (an impossible curatorial task). Neither do they represent the history of contemporary Arab women's art practice or, equally problematic, a postmodern view which sees the work existing together outside of the historical and the particular.[40] The meeting point for the artists is their awareness of being Arab which inflects their art practice in different ways: necessarily carrying different meanings, each negotiating and inscribing identity differently.

The mapping of the artists' geographies and histories is particularly complex given that the territorial boundaries of nations have been subject to change through colonisation and postcolonial wars and occupations. These boundaries and divisions do not indicate local political or cultural links, just as the shifting topographical terms such as the Near East, currently renamed the Middle East, do not necessarily represent a sense of identity of place. As Nawal El Saadawi cogently writes,

> "Some years ago my 'Arab identity' was a fact of politics and culture and of life ... Today ... If I am asked I should say my identity is Middle Eastern, not Arab at all. That way I can be postmodern, updated, moving with the times".[41]

The issue is further complicated because the majority of the artists discussed here have moved from their country of birth for numerous economic, political or professional reasons. Such displacement, whether imposed or voluntary, makes for a multilayered mapping where the artist and the work is multi-sited and complex relations exist between the place of origin and the present country or countries of the diaspora.

In terms of geographies, the eighteen artists come from ten countries which include: in the Middle East, five from Iraq, Leila Kawash (who now lives in Britain and America), Firyal al-Adhamy (who now lives in Bahrain), Batool al-Fekaiki, Maysaloun Faraj and Jananne Al-Ani, born of Irish and Iraqi parents (now all living in Britain); Thuraya al-Baqsami from Kuwait; Rima Farah from Syria, (now in Britain); two Lebanese,

Saadeh George and Mai Ghoussoub who are both now in Britain, and Laila al-Shawa, a Palestinian. Six are from North African countries: Kamala Ibrahim Ishaq from the Sudan, who now lives in Muscat, Oman (in the Arabian Peninsula); two from Morocco, Malika Agueznay and Wafaa El Houdaybi who both trained and continue to live there; Sabiha Khemir, a Tunisian who is now in Britain, and two Algerians, Zineb Sedira (brought up in the diaspora of France) and Houria Niati, both of whom now live in Britain. Najat Maki and Azza al-Qasimi come from the United Arab Emirates (Dubai and Sharjah respectively), where they continue to live. (Maki divides her time between the UAE and Cairo).

In terms of histories the artists span five generations from Kamala Ibrahim Ishaq born in 1939; Laila al-Shawa, Leila Kawash, Malika Agueznay, Houria Niati, Batool al-Fekaiki and Firyal al-Adhamy born in the 1940s; Thuraya al-Baqsami, Saadeh George, Mai Ghoussoub, Maysaloun Faraj, Rima Farah, Najat Maki, Sabiha Khemir born in the 1950s; Zineb Sedira, Jananne Al-Ani, Wafaa El Houdaybi born in the 1960s and Azza al-Qasimi born in 1974. Of these eighteen, only five (who span four generations) continue to live in their country of birth: Malika Agueznay, Thuraya al-Baqsami, Najat Maki, Wafaa El Houdaybi and Azza al-Qasimi. However, both Maki and al-Baqsami have lived for a substantial period of time in other countries and all of them have travelled widely.

The majority come from predominantly Muslim countries, while several are from Lebanon, Syria and Palestine which have significant non-Muslim communities. Most are Muslim, but some are not. Similarly, the majority (as one would expect given the conditions of training) come from professional backgrounds, although this changes through the generations.

Regarding education their geographies and generations follow the overall patterns outlined by Salwa Nashashibi's essay where the artists born in the 1930s, 1940s and early 1950s were initially trained within the colonial directed systems of either the French in Cairo, as in the case of al-Baqsami, al-Shawa and Maki, or in Morocco with Malika

Agueznay; or, under the British system in the established centres of Iraq, as in the case of al-Fekaiki and al-Adhamy, or Khartoum in Ishaq's case. Lebanon included both systems. Again, as with all generalisations, there are notable exceptions. Kawash, for example, trained in America because her family worked there, while Faraj, born in California, trained in Baghdad as an architect. Equally, many of the artists have attended occasional courses in different parts of the world.

Those born into the postcolonial geographies of the latter part of the 1950s and the 1960s have tended to cross cultures by training in Britain. Some trained locally first and then, often through voluntary or forced exile, continued their education in Britain. Significantly, many of the earlier generations moved to Britain for similar reasons during this period, including Ishaq who studied at the Royal College of Art in 1969 and Niati.[42] By contrast Sedira, born in the Algerian diaspora in France, trained there before moving to London.

While the choice of materials has a basis in training with the earlier generations tending toward painting, drawing and printmaking, with the middle generations of the 1950s including sculpture and installation, and the later generation including photography and video, the artists cannot be fixed on this basis; installation, photography, painting, printmaking and sculptural objects are present throughout the generations. In addition, several artists use a combination of these forms which also encompass illustration and ceramics.

What emerges from this brief overview is the sense of a continual crossing of geo-political and cultural boundaries through education, the effects of colonialisation and the postcolonial conditions of war, displacement, nationalism and the rise of Islamic fundamentalism. Moving between cultures involves a continuous negotiation of the past and present across Arab countries and the diaspora. Looking across and through the generations, although differently located, there are axial points where the artists meet. These are at the precise point where the personal, the social and the political of the past and present interact through history, place, and memory. In Stuart Hall's terms they are

Plate 3 Houria Niati , *Ziriab...Another Story* (detail), 1999
Installation at the Hot Bath Gallery, ink on paper

"not the rediscovery but the *production* of identity. Not an identity grounded in the archaeology, but in the *re-telling* of the past"[43]: the act of inscribing their identities as women, as Arabs and as artists.

Not surprisingly, one connecting intersection is the concern with the negation of their identity as women and Arabs. This takes multiple forms. For Niati, growing up during the Algerian War of Independence, this took place across the various cultural sites of colonialism. Continuing the concerns of the earlier installation, *No to Torture* (Plate 45), which foreground the erasure of Arab women's identities through Orientalism, Niati's recent installation (Plate 3) centres on language. Through the story of the *Ziriab* Niati points to the other locations of Arab culture denied in colonial and postcolonial Algeria until recently: the forgotten grandeur of Cordoba in Spain, the exile of an Islamic musician and a collective tradition rooted in the North African Berber

people. Simultaneously, by performing the songs in Arabic whilst putting on Algerian clothing and jewellery, Niati brings the suppressed female body, the language and the music not only into the present, but into the gallery space which has also excluded or disembodied the other through gender and race.[44]

Ishaq's work, informed by the political realities of the Sudan, also uses the suppressed female body as the site of a re-telling of African identities that were repressed during colonisation. Using oral history and the diverse sources of Pharaonic, African, Coptic and Islamic traditions embedded in Sudanese culture, Ishaq concentrates on the invisibilities brought about by a later predominately masculinist culture. Aware of continuities and discontinuities, Ishaq's work is determinedly woman-centred although concerned with fragmentation. Speaking of the confinements and yet securities of the domestic sphere, it also signals the economic and political instabilities of present-day Sudan where military power, aligned with a move to Islamic fundamentalism, works to further undermine social and artistic freedom. Like many Sudanese artists, Ishaq now lives abroad.[45]

Although different in form, al-Shawa's work also focuses on the suppression of both Arab identity and its particular effect on the lives of women and children within occupied Palestine. Like many of the Arab women discussed here, her life has been fundamentally changed through the politics of territories. Born in Gaza in 1940, she witnessed the Israeli occupation in 1948 and the subsequent wars including the Intifada, the 1987 Palestinian uprising.[46] Based on photographs of the walls of Gaza where 'the raw dialogue' between Palestinian and Israeli occupiers was visibly recorded, al-Shawa's powerful images such as *Letter to a Mother* (Plate 4), suggest the silencing of the histories of both women's voices (and bodies) and the personal which make the homogenising of any people more difficult, particularly in times of war. It echoes Mona Hatoum's observation (made in a different context) that "Whenever I watched news reports about the Lebanon, I was struck by how the Arabs were always shown en masse with mostly hysterical females crying over dead bodies. We rarely heard about

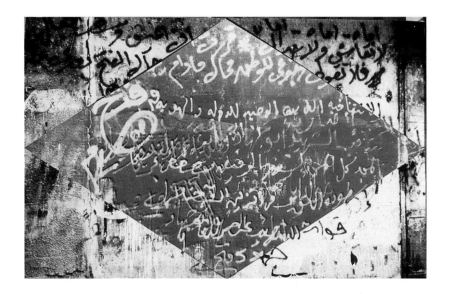

Plate 4 Laila al-Shawa, *Letter to a Mother*, 1992
Silkscreen on canvas, 95 x 150cm

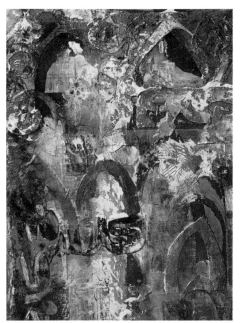

Plate 5 Leila Kawash, *Diaspora* (detail), 1992
Mixed media collage on canvas, 90 x 75cm

the personal feelings of those who lost their relatives".[47] Doubly refer-
encing graffiti and calligraphy, the writing in al-Shawa's images
foregrounds the harsh realities of Arab experience in contemporary
Palestine while connecting with past histories and the loss associated
with occupation and the diaspora.

In 1992 Leila Kawash, an Iraqi living in Britain and the USA, produced
Diaspora (Plate 5) in response to the Gulf War. As she explains:

> "During the war with Iraq ... when Americans hit on this shelter
> [with] a lot of children, and they all ran out and one of them
> called out 'Allah el Akbar' (God is Great). And I was painting this
> painting and when I went back to it, these words, it was like he
> gathered all the strength - it was like he was combating the
> whole war with these two words. ... I spray painted these words
> and it obliterated all the gold that I was putting on before".[48]

As in al-Shawa's work, the diaspora is an inscription point for at least
two cultures and, in this case, one is symbolically scarred by events in
the home land. The diaspora, as a place of separation and displace-
ment is uppermost here. In recent work, the diaspora has become the
site for an archaeology of the self, a remembering of an early Arab
Sumerian goddess and the negotiation of a female identity associ-
ated with fluidity within the geometric forms of the traditionally male
art of Islam.[49] It offers an inscription into the present, against and
through changing circumstances, or to recall Stuart Hall's definition,
"Diaspora identities are those which are constantly producing and
reproducing themselves anew, through transformations and differ-
ence".[50]

Linked to the diaspora, the theme of exile is prevalent. As Edward Said
eloquently writes: "Exile is strangely compelling to think about but ter-
rible to experience. It is the unhealable rift forced between a human
being and a native place, between the self and its true home: its
essential sadness can never be surmounted".[51] Although one might
query the 'true home' philosophically, the experience of this division
and rupture is real for many of the artists now living in other Arab coun-
tries or in the west. For the Iraqi artists, al-Adhamy and al-Fekaiki (and

many of those previously mentioned) the need to maintain their contact with their histories and therefore their cultural identities is strong. Al-Adhamy's disturbingly disembodied images such as *Looking Forward* (Plate 18) and *From Palestine*, both drawn from the actual artefacts of past Arab cultures, are a means of inscribing in the present a different model of Arab identity, more diverse and embracing than the dominant Islamic model now established in Iraq. As images of both nearness and farness they embody the experience of exile.

Al-Fekaiki's work, by contrast, focuses on her memories of Baghdad, once the capital of the Islamic east and Ishtar, one of the most important goddesses in Assyro-Babylonian mythology. A warrior, particularly worshipped at Ninevah, she was also the goddess of love and voluptuousness. Interestingly, the Arabs who conquered the area made her into Athtar, a god. Combining the contradictions of war and love, al-Fekaiki uses her as a symbol of the present where desire is the basis of both destruction and the longing of return to a mythical place from which one is exiled.[52] In both cases memory is active, always in the present, constructing and negotiating identities.

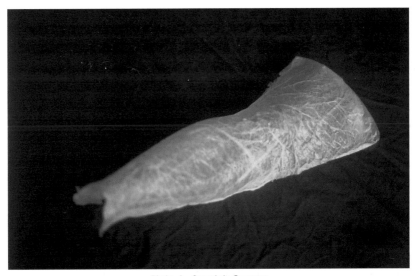

Plate 6 Saadeh George
Today I Shed My Skin: Dismembered and Remembered, 1998
Detail of installation, mixed media, life size

Closely connected, but painfully different, is the theme of exile within one's own home land: the state of division from within rather than without that Fanon discussed. For George, a Lebanese born of Jewish and French parents, identity was once fluid and multiple in a country of many religions and cultures. The war in Beirut changed this in 1975. Beirut became internally divided by borders and restricted areas: no place for those who crossed the boundaries of identities. Taken from her body, the casts literally embody the traces of place and memory and the experience of working as a doctor in Lebanon. They also explore the acute experience of exile which Said articulates:

> "Most people are principally aware of one culture, one setting, one home; exiles are aware of at least two, and this plurality of vision gives rise to an awareness of simultaneous dimensions ... where expression or activity in the new environment inevitably occurs against the memory of these things in another environment. Thus both the new and the old environments are vivid, actual, occurring together contrapuntally".[53]

This is an experience shared by the majority of these artists.

At first sight, the sculpture of Ghoussoub, also from the Lebanon, could not be more different than George's. In *Diva*, for example, (Plate 33) she constructs an over life-size female figure in metal with beads and material attached: a homage to the female Egyptian singer Um Kulthum, a trace of history made physical. For Ghoussoub, Kulthum acts as a reminder of the memory of a recent past where Beirut, her home city, was once the cosmopolitan cultural centre of the Middle East, a place of art, dancing and music. However, this is no romantic image of the past but a defiant act of embodiment and resistance to the stereotypes and constraints associated with Arab women, where the body, its senses and desires, is either made into the oriental other or is suppressed in the name of the father. Here to re-locate is to re-member.

In Al-Ani's work the crossing of borders and the connected state of being in-between is a constant theme. An Iraqi, with a Muslim father and an Irish Catholic mother, she continually crossed the accepted

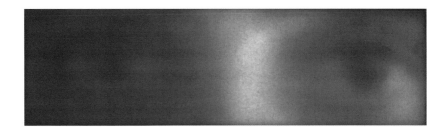

Plate 7 Zineb Sedira, *Silent Sight,* 1997
Video still, computer generated, back projected onto tracing paper

divisions of both nation and religion; neither one or the other, either in Iraq or in Britain. Al-Ani's recent video work includes *One Thousand and One Nights* [54], where her mother and sisters recall their recurring dreams. Chillingly, through potent images, they each independently image the instability of Iraq from the unease of the late 1960s through to the invasions, local uprisings and killings of the late 1980s which made them leave. Significantly, the women's voices are only heard when the spectator chooses to engage with the work by putting on the headphones: otherwise the video screen is moving but silent.

By contrast, Sedira, born of Algerian immigrant parents, was brought up in the diaspora of France in the aftermath of the Algerian war, in what she calls the in-betweenness of the 'beurette' [55] negotiating two cultures. The recognition of exclusion/inclusion, marked most visibly by the veil, has been a significant theme in earlier work such as *Silent Sight.* (Plate 7) The gaze is all present and yet the title suggests a silencing where the body, as a site of negation, veils the very identity it marks. Her recent video work concentrates on the crossing point of the embodying veil and the veiling of the mind. Here the emphasis is

on the fluidity and multiplicity of identity which has been informed in part by crossing from the in-between of France to the different in-between of Britain.

Where the artist crosses from and moves to is important. These locations, each with their own geographies and histories, are the spaces within which identity is both created for them and within which they continually negotiate and produce identity anew through their own histories and geographies. Thus different things have to be negotiated in different places, and this negotiation will be different according to the geographies and generations of both the artist and place. Al-Baqsami, for example, is located in Kuwait and continually moving across international sites, her imaging of the Arab woman is informed by these quite different cultural and political spaces and, as her artist's statement makes clear, she is fully aware of the tensions between them at both a local and international level. (Plate 23) Directly affected by the Iraq invasion through her husband's imprisonment, and the rise of Islamic fundamentalism, al-Baqsami's images focus on the conflicting positions Arab women occupy and the resulting confusions which echo Hélie-Lucas' earlier accounts of being 'caught between two legitimacies': between nation and gender, Islamic and constitutional law and, between the east and the west. For, as Laura Nader notes, "Women are no longer treated as Arab women but as 'potential westerners' in many parts of the Middle East".[56] '

Al-Qasimi explores the same issue of local and international tensions, or what is often called the 'politics of location', by focusing on the different attitudes to love, marriage, the body and female sexuality. Located in Sharjah but regularly travelling abroad, she uses the language of modern western art to comment upon the crossing of cultures in a variety of different ways. For al-Qasimi the works of Picasso, and the accompanying emphasis on the autobiography of the producer, are not a disembodied style or the egotistical statements of an artist but a metaphoric language for personal agency which represents a different view of the world. This is equally as evident in the prints which focus on the signs of her culture imaged from a different

perspective. (Plate 78) As such they speak of longing and desire, for reconciliation and negotiation of difference.

Similarly, but differently, several of the artists have chosen to engage with the language and materials associated with traditional Arab and Islamic Art as part of their renegotiation of identity. Farah and Agueznay, who live in Britain and Morocco respectively, employ calligraphy, the most highly esteemed and continuous form of Islamic art.[57] Originally associated with the Qur'an, calligraphy is simultaneously a literary and a visual language embedded within the everyday environment of Arab countries. As Rosa Issa notes it was a "symbol of identity against the coloniser" and changed from "a highly circumscribed art form ... into a new form of modern artistic expression" by the 1970s.[58] Within this context, the work of Farah and Agueznay operates as both a continuity and a disruption. Farah takes the language apart and reassembles it to carry new meanings for herself, while Agueznay uses its language to re-inscribe the feminine body into its history. Both are conscious of their work as an inscription where through the act of making they carry the marks of the female body through nearness, texture and touching. Given the dominance of the 'language of the father', to use Lacan's term, their work becomes a form of 'writing the body' into that language which is close in concept to French feminism.[59] In other prints Agueznay merges the qualities of touch and textural layering with images of the female gaze. (Plate 8)

El Houdaybi's work, by contrast, uses the materials and signs associated with the histories and geographies of Morocco: the strong Islamic tradition of Meknès with its old Qur'an schools, Berber decoration and the continuing tradition of women tattooing with henna. (Plate 66) Using leather as a support or a framing device, El Houdaybi builds the work in a ritualistic way that includes preparing and cleaning the leather, cutting, shaping, sewing, layering and then painting. The process, like the imagery and materials, recalls everyday, repetitive actions and the signs of labour are retained in the finished work. The works simultaneously reference a history of Moroccan women, and the body of the artist performing her identity as both woman and artist

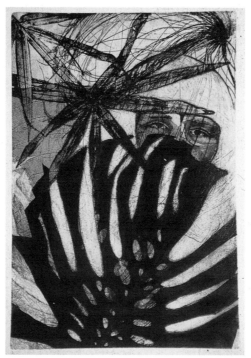

Plate 8 Malika Agueznay, *Regard,* 1990
Zinc etching, 49 x 34cm

in a contemporary Morocco that is fully aware of the gestures of western modernist painting and the divisions of art and craft.

Maki's large paintings also combine the languages and materials of western and eastern art. Taking her imagery from Egypt, where she trained and now lives for part of the year, she creates meticulously layered surfaces that reference the traditions of weaving and the modernist marks of western painting. The large figures emerge and disappear into these layers where memories of African stories and myths are combined with the materials of childhood: henna, saffron, and natural dyes. Thus through the process of making Maki recreates a sense of her location both through memory and materiality, and through the crossing of art and craft divisions.

This awareness of combining the traditions of art and craft is particu-

larly strong in Faraj's ceramics and Khemir's illustrations when working in the context of Britain. Both re-engage and renegotiate traditional forms of past Arab and Islamic art and use them to comment upon the present. In Faraj's statement the connection between making and re-affirming an identity against the horrors of war is particularly strong. In common with many of the artists discussed here, they are both conscious of wishing to intervene and leave their traces in a history of contemporary Arab art. As Muslim women in the diaspora they are also aware of their work as a way of reaffirming their identities within a secular culture which has different views of beauty, the symbolic and the divine form.[60]

In looking back through and over the work it is clear that there are numerous points of connection that could be drawn out to form other patterns: the metaphors of absence and presence; veiling and un-veiling; nearness and farness; the continuous dialogue with different forms of western art; the matrilinear connections that include the an-cient females of mythology, the threads of story telling and the mother/daughter relationships through the imaginary and the real.[61]

The prevalent theme however is the continuous crossing of territorial boundaries (both through geographical displacement and through the contrapuntual spaces of memory) and the continuous re-inscrib-ing of identity. The coincidence of these two modes of moving is not accidental as many writers have noted.[62] Both travel and identity (in the sense that I have used it) imply an active subject, unfixity and a continuous present. For Said, for example, even the displacement of exile can be productive: "The exile knows that in a secular and con-tingent world, homes are always provisional. Borders and barriers, which enclose us within the safety of familiar territory, can also become pris-ons, and are often defended beyond reason or necessity. Exiles cross borders, break barriers of thought and experience".[63]

In particular several writers have discussed the conditions that geo-graphical displacement may provide for writers and artists. Homi Bhabha refers to it as the 'third space' while Salman Rusdie, for

example, writes: "Our identity is at once plural and partial. Sometimes we feel that we straddle two cultures; at other times, that we fall between two stools. But however ambiguous and shifting this ground may be, it is not an infertile territory for a writer to occupy. If literature is in part the business of finding new angles at which to enter reality, then once again our distance, our geographical perspective, may provide such angles".[64]

More recently, writers such as Caren Kaplin, Julia Kristeva and Janet Wolff have perceived this 'deterritorialization' as a particularly productive site for women artists and writers;[65] not just because it can generate new perceptions, but as Wolff argues, it can also "facilitate personal transformation, which may take the form of 'rewriting the self', discarding the lifelong habits and practices of a constraining social education and discovering new forms of self-expression".[66] Given that women generally "do not have the same access to the road", being away from home can be liberating.[67]

Certainly the work of these artists suggests a connection between the crossing of boundaries and the continual re-negotiation of cultural identities through both loss of place and through new encounters. The interesting question is how this rewriting actually takes place in the act of making and how this might be embodied in the final object. Given that identity is not just an idea of who we are but an embodiment through the gendered body, (through geographies and through generations) the act of making carries the traces of the artist's embodiment. Rosemary Betterton describes embodiment as a shift from "how the female body should be represented - to the question of subjectivity - what it means to inhabit that body: from the problem of *looking* (distance) to the problem of *embodiment* (touch)".[68] This juxtaposition of looking at and being in emphasises the necessity to think about the specificities of the gendered body without privileging a disembodied sight which, as Tina Sherwell's later essay shows, has tended in the west to be linked with control over an object or territory.[69]

Embodiment acknowledges the interconnections between the

physical and the mental which constitute the totality of being at any one point of time, and therefore negates the linear narratives of the self and the mind/body split which underpin the binary opposition discussed at the beginning of this essay. Equally the act of embodying implies that the making of art is not necessarily a representation of the already known which is transcribed onto the surface but that it can be an act of discovery or "coming-into-language from a space of uncertainty".[70] Thus, while recognising social and historical positioning (for there is no body outside of this) such an approach offers the possibility of creating new identities and imaging change which can produce new conditions for the future.[71] In addition, as Pollock notes: "This emphasis on materiality, touch and embodiment offer ways of discussing what is specific to the procedures, and the effects of making objects, images, for people to look at ... use and be affected by".[72]

Within these terms, the presence of the embodied artist can be seen at the level of mark-making where traces of the gendered body reside, through the use of materials, the subject matter and, finally, the effect of these on the body of the viewer.[73] It is through these interconnected 'bodies' of the work that different audiences produce meanings within the various contexts of the gallery or the written word. This returns us to the initial question of how can cross-cultural dialogues occur particularly within the frame of the west where the binary oppositions are still dominant and the history of art of the twentieth century has remained a 'a white monopoly' excluding others on the basis of difference.[74]

Here I would argue that cultural identity is once again central. All that has been said of the artist as an active embodied subject applies equally to the spectator; they are also positioned by generations and geographies, located by gender, and continually negotiating and producing identities and meanings in the present. It is by the recognition of this positioning, through the located and gendered body, that the spectator can encounter the specificities of difference and negotiate new meanings against and through the stereotypes which

contain difference within the boundaries of predetermined meanings. Or, to quote Nawal El Saadawi's previous question more extensively: "Why keep asking me about my 'identity'? It makes me turn your question round ... Why does no one ask what is your 'identity'? Is it that ... it does not require any questioning, does not need to be examined?"[75]

This suggests both a critical distance which questions naturalised frameworks while acknowledging difference and, at the same time, a nearness or engagement with the specificities of the works or texts. Crucially this recognition that both sameness and difference can exist in the same space exceeds the binaries that constrain and fix positions.[76] By engaging with works of art or texts, moments of crossing the boundaries of subject/object, here/there, self/other are experienced.[77] Such embodied moments change the way we see something. They produce new meanings and enrich and expand, rather than diminish and constrain. They are moments of dialogue where two bodies occupy the same space and re-negotiations of difference and sameness occur. Neither one remains the same, both change.

Dialogues of the Present is about change. It is also about the co-existence of sameness and difference in one space. Most importantly, it is about the possibilities of making a difference in the way we image ourselves and others through the specificities of new cultural encounters. Dialogues of the present are informed by the past but the present is the only place of making a future where otherness, through gender or cultural stereotypes and any form of essentialing on grounds of difference, has no place. Contrary to stereotypes of both the past and the present, Arab women artists are active subjects in the contemporary world.[78] Their work is multisited and clearly demonstrates that there is no one form that is identifiable as contemporary Arab art. It is both produced and sold within the old binaries of the east and the west, and across the newly constituted sites of the postmodern world where as Siumee Keelan's essay shows, different conditions and expectations operate.

The multiple dialogues are a series of negotiations which occur simul-

taneously and inform each other in complex and sometimes contra-dictory ways at a personal, local and international level, across time and space. These include the dialogue of each of the artists with their own histories and geographies, the continuous dialogue between the east and west, and that within the complex territories of the Arab world and in the diasporic communities spread throughout the globe. They also include the dialogue where meanings are produced and nego-tiated on the basis of difference and sameness by the artist and the audience in the encounter with the art work and the texts which sur-round it.

Finally, it is a dialogue within the spaces of Arab women's art and an intervention into the local, national and international art spaces within which these artists work. Located between an Arab tradition where poetry and music are more highly regarded than art, and a western curatorial practice that is resistant to change, these re-negotiations work against "disembodiment, immobilisation and silence".[79]

A restitution of body. Bodies of new women ... A loud voice that gives body. Body and new forms restoring a darker, deeper texture to other ... voices.[80]

Assia Djebar

FOOTNOTES

1. An influential essay that helped to frame these issues was Fredric Jameson 'Postmodernism, or the Cultural Logic of Late Capitalism', *New Left Review,* No. 146,1984, pp53-92; For a more extreme view of postmodern conditions and effects see Baudrillard's ideas on the Simulacra and Simulation in Jean Baudrillard, *Selected Writings*, Mark Poster (ed)., Cambridge, Polity Press, 1988

2. I am using the term diaspora in the general sense of displacement from the country of birth through the effects of colonialism in the past or present. For a more detailed discussion of this and the troubling term 'postcolonialism' see the introduction in Patrick Williams and Laura Chrisman (eds)., *Colonial Discourse and Post-Colonial Theory*, Hemel Hampstead: Harvester Wheatsheaf, 1994,ppl-20

3. Edward Said, *Orientalism: Western Conceptions of the Orient*, London, Routledge & Kegan Paul Ltd., 1978, p1

4. Said, p3; Said's approach to culture has caused much debate. See John Mackenzie who devotes two chapters to a critique of Said and Linda Nochlin (the American feminist art historian) who used similar approaches in relation to Orientalist painting: *Orientalism: History Theory and the Arts*, MUP, 1995. Recent writing focusing on gender and Orientalism includes: Çeylan Tawadros, 'Foreign Bodies: Art History and the Discourse of l9th Century Orientalist Art', *Third Text*, No3/4, Spring/Summer, 1988 and S. Graham Brown, *Images of Women; The Portrayal of Women in Photography of the Middle East*, London, Quartet Books, 1988

5. Stuart Hall, 'Cultural Identity and Diaspora', 1990. First published in *Identity Community Culture, Difference* by Jonathan Rutherford (ed)., London: Lawrence and Wishart, 1990, pp222-37. Reproduced in Patrick Williams and Laura Chrisman (eds)., *Colonial Discourse and Post-Colonial Theory*, pp393-403: p393

6. Hall, p394

7. Hall, p394

8. Born in the French occupied Mauritius, Fanon (1925-1961) studied medicine in Paris and subsequently used Jacques Lacan's psychoanalytical theories to provide a strident critique of the psychological effects of colonialism. Fanon, *Black Skin, White Masks,* London, Pluto Press,1986 (1st published 1952)

9. Hall, p393

10. Hall, p394

11. Hall, p402

12. Here Hall is using Derrida's concept of '*differance*' (sic), that meaning is always deferred. See Christopher Norris, *Deconstruction: Theory and Practice*, London, Methuen, 1982 for elucidation of these ideas.

13. Gilane Tawadros, 'The Case of the Missing Body' in Jean Fisher (ed)., *Global Visions Towards a New Internationalism in the Visual Arts*, London, Kala Press and INIVA, 1994, p108

14. Much of this history is indebted to Margot Badran and Miriam Cooke (eds)., *Opening the Gates: A Century of Arab Feminist Writing*, Indiana, Indiana University Press,1990

15. Badran and Cooke, pxxv

16. Homi Bhabha, cited in Olu Oguibe, *Crossing, Time. Space. Movement*, Florida, Contemporary Art Museum, 1998, p61

17. In this context Hélie-Lucas raises the question of "the legitimacy of Arabic in a country where the dominant ethnics are Berber and speak Berber languages" in 'Women Nationalism and Religion in the Algerian Liberation Struggle' in Badran and Cooke (eds)., *Opening the Gates*, ppl05-114; p114

18. Frantz Fanon, *Black Skin, White Masks*, p19

19. Badran and Cooke, pxxvi

20. Although generalisations are always dangerous, the vivid accounts of Arab women

writers contained in Badran and Cooke together with the writing of Nawal El Saadawi supports this. See footnote no.40

21. Yuval-Davies, Nira cited in Deniz Kandiyoti, 'Identity and its Discontents: Women and the Nation' from *Millennium: Journal of International Studies*, Vol.20, Issue 3,1991, pp429-43. Reproduced in Patrick Williams and Laura Chrisman, (eds)., p383

22. Badran and Cooke, pxxvi

23. Badran and Cooke, pxxvi

24. Badran and Cooke, pxxvi

25. Badran and Cooke, pxxvii

26. Badran and Cooke provide an overview of Arab feminism where they distinguish between the 'invisible', the less public, and the 'visible', the public movements. The initial invisible phase, from the 1860s to the early 1920s, was centred in Egypt via the "books produced by middle and upper class women which were circulated in the harems and in women's journals." The second visible phase, from the 1920s to the 1960s, includes the organised public movements in Egypt, Lebanon, Syria and Iraq in the 1930s and 1940s, and Sudan in the 1950s. They identify the third phase, from the 1970s, as a "resurgence of feminist expression in some countries such as Egypt, Lebanon, Syria and Iraq" while "other Arab countries experienced their first wave of feminism", fuelled in part as they note by the *United Nations Decade of Women* (1975-1985). Badran and Cooke, pxxi. For a broad survey of feminism see also Margot Badran 'Feminism as a Force in the Arab World' in *Contemporary Thought and the Women*, Cairo, Arab Women's Solidarity Press, 1989; Badran 'Feminists, Islam and the State in 19th and 20th Century Egypt in Deniz Kandiyoti (ed)., *Woman, Islam and the State*, Macmillan, London and University of California, 1990

27. Badran and Cooke, p40

28. Huda Sha'rawi, Harem Years: *The Memoirs of an Egyptian Feminist*, London ,Virago, 1986

29. Arab feminists have continued to address the issue of the veil and Islam. The Moroccan writer, Fatima Mernissi, for example, argues against veiling on the grounds that the spirit of Islam was to procure equality for women not to impose restrictions. See Mernissi, *Beyond the Veil*, Cambridge, 1975 and *The Veil and the Male Elite: A Feminist Interpretation of Women's Rights in Islam*, trans. Mary Lakeland, New York, Addison-Wesley, 1991. Leila Ahmed also sets Islam's prescriptions concerning women in an historical context. Tracing the varying status of women from pre-Islamic times in the Middle East through the successive periods of Islam to the present, she emphasises the role of women in constructing the verbal texts of Islam. Ahmed argues against a western-style feminism which uncritically inscribes itself into the old imperialist narratives which imply that Muslim women can only seek equality by rejecting their own culture for western ideals Leila Ahmed, *Women and Gender in Islam*, New Haven, Yale University Press, 1992

30. Hélie-Lucas, 'Women, Nationalism and Religion in the Algerian Liberation Struggle' in Badran and Cooke (eds)., 1990, p108

31. Hélie-Lucas in Badran and Cooke (eds)., p108

32. Badran and Cooke, pxxvi

33. Hélie-Lucas in Badran and Cooke (eds)., p108

34. Shehira Doss Davezac, 'Women of the Arab World: Turning the Tide' in Salwa Nashashibi, *Forces of Change: Artists of the Arab World,* Lafayette, California: Inter National Council for Women in the Arts, 1994, p39

35. Deniz Kandiyoti, 'Identity and its Discontents: Woman and the Nation' in Patrick Williams and Laura Chrisman (eds)., p383. See also Hélie-Lucas on birth control and state taxes in Badran and Cooke, pplll-112

36. Kandiyoti, 'Identity and its Discontents' in Williams and Chrisman, p382

37. Hélie-Lucas in Badran and Cooke, p113

38. Griselda Pollock, *Generations and Geographies in the Visual Arts: Feminist Readings*, Routledge, London, 1996

39. Pollock, p19

40. Rasheed Aareen provides a useful discussion on the western curatorial practices which work to exclude the historical in his essay 'New Internationalism' in Jean Fisher, (ed)., *Global Visions*, pp3-11. See also Annie E. Coombes, 'Inventing the 'Postcolonial': Hybridity and Constituency in Contemporary Curating', in *The Art of Art History: A Critical Anthology* edited by Donald Preziosi, Oxford and New York, Oxford University Press, 1998, pp486-497

41. Nawal El Saadawi, Egyptian writer, activist and founder of the Arab Women's Solidarity Association. 'Why Keep Asking Me about My Identity?' in *The Nawal El Saadawi Reader*, London, Zed Books, p117

42. For further information on Ishaq see *Seven Stories from Africa,* Whitechapel Art Gallery, London, 1995. By contrast, Niati left Algeria to travel and always intended to return.

43. Stuart Hall, 'Cultural Identities', 1990, p393

44. Describing the motivation for the work Niati says "In Algeria women were fighting and dying. They were tortured. Western nations of the Oriental world imagined a fancy world of women." Cited in Salwa Nashashibi, *Forces of Change*, p30. For further information on Niati's deconstructions of Orientalism see Salah M. Hassan 'The Installations of Houria Niati', *NKA Journal of Contemporary African Art*, Fall/Winter 1995.

45. Wijdan Ali comments on the dire conditions in Sudan where the cultural policies favour a primarily orthodox Islamic trend close to that of the Islamic Fundamentalist Party and the National Islamic Front. Art materials are scarce and art positions are determined by political affiliation: "Sudan is probably one of the few Islamic and Arab countries where government patronage of the arts is almost entirely absent and artists are left to fend for themselves." Wijdan Ali, *Modern Islamic Art, Development and Continuity*, University Press of Florida, 1997, p118

46. Wijdan Ali provides a detailed account of the problems of Palestinian artists after the 1967 war. Those in Israel were not recognised as Palestinian by the Israeli institutions or by the West Bank and Gaza artists. See Ali, *Modern Islamic Art*, Chapter 11, 'Palestine', ppl05-113. Ali regards al-Shawa as the "first Arab artist to mix photography with painting and graphic art and the first to utilize realism as well as symbolism in depicting a sociopolitical subject." (p110). Al-Shawa herself writes of the outrage that these events "have been sanctioned by the 'civilised world', and that the west is "a power that is trying to destroy you without ever trying to understand what you are about." Cited in Salwa Nashashibi, *Forces of Change*, 1994, p30

47. Mona Hatoum, a Palestinian born in exile in the Lebanon, in discussion of her own work, *Measures of Distance*, Michael Archer, *Mona Hatoum*, London, Phaidon Press, 1997, pp139-140

48. Nashashibi, *Forces of Change*, p30

49. Rosemary Betterton discusses the importance of this self-archaeology in relation to the work of contemporary Arab and Jewish women artists in *An Intimate Distance: Women, Artists, and the Body,* London and New York, Routledge, 1996, ppl6l-193

50. Stuart Hall, 'Cultural Identity', p402

51. Edward Said, 'Reflections on Exile', 1984 cited in Michael Archer, p110

52. In 'Cultural Identities' (p402) Stuart Hall makes the link between the endless desire to return to 'lost origins', to be one again with the mother, and Lacan's psychoanalytical theories of the imaginary (the undivided) and the symbolic (the entering of the language of the father).

53. Edward Said, 'Reflections on Exile', 1984 cited in Archer, p113
54. The title refers to the *Arabian Nights* where Princess Sheherezade tells stories for 1001 nights in order to save her head. The original 17th century translation by the French scholar, Antoine Gallard was called *The Thousand and One Nights* and this expression is often also used as a description of Baghdad.
55. 'Buerette', a play on butter and Arab, is used in colloquial speech to describe females born of North African immigrant parents. See page 215
56. Cited by Shehira Doss Davezac in Nashashibi, *Forces of Change*, 1994, p41
57. Calligraphy masters sold their works rather like we would sell paintings today. Women were supposedly barred from practising calligraphy although, as Irwin notes, in some areas their names are recorded. Robert Irwin, *Islamic Art*, London, Laurence King Publishing, 1997, p141
58. Rosa Issa in *Signs, Traces, Calligraphy, Five Contemporary Artists from North Africa*, Barbican Centre, Concourse Gallery, London, UK, 1995 (unpaginated)
59. 'L'écriture féminine' or 'feminine inscription' emerged as a concept within French feminism as an attempt to reconsider Lacan's psychoanalytic theories of the female as absent 'other' or the passive recipient of the male gaze. Although the ideas of Julia Kristeva, Luce Irigaray and Hélène Cixous are radically different from each other in many respects, they all focus on 'the feminine' in culture through language which can disrupt in the case of Kristeva, or know the world differently through the multiplicity of the feminine body as in Irigaray and Cixous. Janet Wolff provides a useful discussion of these approaches in the chapter on 'Women's Knowledge and Women's Art' in *Feminine Sentences: Essays on Women & Culture*, Cambridge, Polity Press, 1990
60. Ihab Hassan, 'Queries for Postcolonial Studies', *Third Text*, Vol.43, Summer 1998. In this provocative essay Hassan argues against the materialist approach dominant in postcolonial studies including the refusal to consider the 'spirit' "in countries like Morocco, where intellectuals must continually juggle three conformities: Nationalism, Marxism, Islamism (sic) in their new and diverse guise." p65
61. For these artists, this operates differently for the generations: the earlier generations draw from mythology and a sense of place, whereas the later generation like Al-Ani and Sedira draw more directly on the autobiographical and establish a more immediate lineage.
62. The relationship between Modernity, emigration and the city has been the subject of much writing since the mid 19th Century and often linked with the male stranger or exile. The following recent texts address these concepts in terms of gender: Betterton chapter 7 on 'Identities, Memories and Desires' in *An Intimate Distance*; Janet Wolff, *Resident Alien: Feminist Cultural Studies*, Polity Press, 1995
63. Edward Said, 'Reflections on Exile', 1984 cited in Michael Archer, p111
64. Salman Rusdie, *Imaginary Homelands: Essays and Criticism 1981-1991*, Granta Books, 1991, p15 cited in Janet Wolff, *Resident Alien*, p7
65. Wolff cites Caren Kaplin, 'Deterritorializations: The Rewriting of Home and Exile' in *Western Feminist Discourse, Cultural Critique*, No6, Spring 1987; see also Julia Kristeva, *Strangers unto Ourselves*, New York, Columbia University Press, 1991
66. Janet Wolff, *Resident Alien*, p9
67. Wolff provides an incisive critique of travel metaphors in 'On the Road Again: Metaphors of Travel in Cultural Criticism', *Resident Alien*, pp115-134; p128
68. Betterton, p7
69. Timothy Mitchell provides an interesting link of the "world-as-exhibition" and Orientalism in 'Orientalism and the Exhibitionary Order' in Donald Preziosi (ed)., *The Art of Art History: A Critical Anthology*, pp455-472

70. Catherine de Zegher, (ed)., *Inside The Visible, an Elliptical Traverse of 20th Century Art*, MIT Press, 1996, p27

71. In this context the idea of feminine traces or 'feminine inscriptions' allows both a way of looking back to previously marginalised art in order to uncover these feminine traces and a way of understanding the process of making as an inscription. *Inside the Visible*, a major touring exhibition of women's art, was based on this premise. See Catherine de Zegher, (ed)., *Inside The Visible, an Elliptical Traverse of 20th Century Art*, MIT Press, 1996

72. Pollock 'Trouble in the Archive', *Women's Art Magazine*, no 54, Sept/Oct. 1993, p11

73. This formulation is indebted to Hilary Robinson who explores these four levels in terms of four bodies of experience. See 'Border crossings: womanliness, body, representation' in Pollock (ed)., *Generations and Geographies*, 1996, pp138-146

74. Rasheed Araeen in Jean Fisher (ed)., *New Internationalism*, p6

75. Nawal El Saadawi, p118. Araeen similarly argues that the west must look to itself to see how its national cultures are conceived and concludes that "western notions of the mainstream as representative of indigenous values, continually reconstructed by indigenous artists, has not changed." Rasheed Araeen in Jean Fisher (ed)., *New Internationalism*, p6

76. Stuart Hall also recognised the importance of sameness and difference in his discussion of identity. 'Cultural Identities', p397

77. The increasing recognition of these more fluid modes of identification within postcolonial and postmodern spaces have prompted a re-thinking of the western models of classification through which the binary system operates, particularly in relation to gender and the accompanying privileging of the male over the female. For example, Bracha Lichtenberg Ettinger, employing psychoanalytical theory has developed the concept of the feminine 'matrix' as a way of decentralising the m, (see 'The With-In-Visible Screen' in Catherine de Zegher, *Inside the Visible*, pp89-113; Norman Bryson 'The Gaze in the Expanded Field' in Hal Foster (ed)., *Vision and Visuality, Dia Art Foundation Discussions in Contemporary Culture*, No2, Seattle, Bay Press, 1988) and Homi Bhabha, following on from Stuart Hall, has centred on hybridity and the space of 'translation' in *The Location of Culture*, London and New York, Routledge, 1994. All recognise the need for a more dynamic model where sameness and difference can co-exist while also taking into account the who, the when, and the why.

78. Postcolonial studies have tended to represent non-western subjects, particularly women, as homogeneous, passive, disempowered people. For an incisive analysis of this positioning see Chandra Talpade Mohanty 'Under Western Eyes: Feminist Scholarship and Colonial Discourses' in Williams and Chrisman (eds)., pp196-220

79. Joan Bosca, 'Frida Kahlo: Marginalisation and the Critical Female Subject', *Third Text*, No12, 1990, p40

80. Assia Djebar, born in Algeria, is a novelist and film director. Introduction to Nawal El Saadawi, *Women at Zero Point*, 1986. Translated by Miriam Cooke, Badran and Cooke, p387. See Assia Djebar, 'Forbidden Gaze, Severed Sound' in *Women of Algiers in Their Apartment*, Charlottesville and London University of Virginia Press, 1992

Chapter Two

ENSURING VISIBILITY:
Art, History and Patronage
Siumee Keelan

Many have asked, or may have wished to ask, why a Chinese person should take a close interest in the work of Arab artists. If I myself were an Arab, and took an interest in western art, this question might not arise. It would be considered normal. I wish to challenge the value judgement that assumes if a person takes an interest in art from outside their natural/cultural background then the art chosen must, of course, be western art.

In Britain, the awareness of Arab art is limited to being seen from an anthropological or purely aesthetic perspective. Collections of historical art can be readily seen at large museums including the British Museum and the Victoria and Albert Museum. The visibility of contemporary Arab art is even more limited and this lack of awareness even extends to the Arab diaspora community. The common perception of Arab art is of a nonrepresentational work and many people are unaware of the diverse artistic expression generated by Arab artists, and in particular the work of Arab women. There are many reasons for this low profile. The main one is lack of exposure in terms of public exhibitions, publications and sponsorship. As a global nomad (a term used by the artist, Jacqueline Morreau), I have spent the last two decades commuting between the UK and the Middle East. Prior to my contact with the Middle East, my taste in art was Eurocentric and failed to appreciate the richness and variety of Arab culture.

Dialogue of the Present is phase II of a Women's Art Library initiative to encourage a dialogue between cultures. Phase I was *Fantasy* (curated by Brenda Martin and me) in which the work of fifteen British women

artists including Jacqueline Morreau, Alexis Hunter and Monica Sjoo toured the United Arab Emirates in 1994.[1] It was the first British women's group exhibition to show in the UAE which coincided with a rapidly growing interest in contemporary art in the region. We were over-whelmed by the enthusiastic reception the exhibition received and a number of contacts were made, laying the ground work for phase II, *Dialogue of the Present, the Work of 18 Arab Women Artists.*

Dialogue of the Present is intended to be an exciting and innovative showcase of the work of these Arab women artists working in the Mid-dle East, Africa and Europe (originating from ten countries and three continents). The exhibition does not, however, pretend to offer a sur-vey of Arab art. That would be an impossible task as the Arabs repre-sent the largest and the most diverse ethnic group in the world occu-pying vast regions in the Middle East and Africa. Instead, the exhibi-tion offers an opportunity to enhance the awareness and understand-ing of an aspect of Arab culture. *Dialogue of the Present* aims to invite and encourage the audience to evaluate the western stere-otypical conception of Arab art as that of geometric and iconographic work. The exhibition showcases a range of materials and techniques, from the use of traditional material of natural leather and vegetable dyes to photography, video and installation.

As many of the artists divide their time between more than one coun-try and often reside in a country not their own, they have to negotiate different cultures. The recurrent issues surrounding identity and dislo-cation are apparent in many of the works of these artists. The Leba-nese artist, Saadeh George's *Today I Shed My Skin* (Plate 32) is a po-tent reminder of the fragility of identity, and the effects of displace-ment.

The artists reflect and reiterate their origins in Arab cultures through a process of questioning as well as celebration, revealing a multiplicity of experimental perspectives. This not only involves reconciling per-sonal interests and views, but is also affected by whether their training was experienced in western art colleges where teaching challenges

1. *Fantasy, an exhibition of the work of 15 Contemporary British Women Artists,* Introduction by Fran Lloyd, Women's Art Library, London, UK, 1994

the perpetuation of tradition. A blending of French, African and Arab culture is powerfully visualised by the cross-platform work of Houria Niati in the installation, *Ziriab Another Story*. (Plate 46) Given the strength of the effect of tradition on cultural values in Arab societies, the effect on artistic expression is considerable. Looking at this work in the context of an international show, *Dialogue of the Present* highlights different cultural interpretations of the possibilities of art.

Exhibitions concentrating on the work of women and all artists of non-western origins are quite common now but this was not always the case. It was less than twenty years ago that we saw the emergence of all-women group exhibitions as a direct result of the women's art movement. This period also saw the rise of activist racial equality groups. These trends positively energised artists to make and show their work whilst encouraging them to question their previous marginalisation, and to seek equal public representation and reappraisal. The eighties also saw an increase in cultural studies, offering and encouraging a reassessment of accepted values in the arts. We have to ask, however, do these trends mean that the work of women and non-western artists is no longer sidelined? While it is true that the work of women artists has gained greater visibility, it is only in short term projects such as exhibitions. Long term visibility, for example in monographs and published works, is still a remote prospect. In the area of contemporary non-western art, the struggle for global recognition is still in its infancy as the adjustments in thinking required are greater. Non-western art requires a contextual knowledge and a greater willingness from a western audience to accept a new perspective.

Globalisation is a term that is much bandied about in the nineties, but the template of this 'new art' continues to be biased towards Eurocentricity. While it is natural that western art enjoys a higher status in the west, its global influence needs to be examined. The confidence that western art has achieved is the culmination of a number of factors. One of the effects of colonialism was to diminish the culture of those colonised and progressively replace it with that of the coloniser. The

main protagonists were the French and the British who imposed their religion, language and culture on the colonies, and at times forcibly denied the colonised a proper role for their indigenous culture and language. Often, a justification for the insensitive actions during the colonial period was that the cultural changes imposed were 'for their own good'. The subtext of this 'justification' was, of course, that the existing religions and social values of the non-western societies in question were, by definition, inferior purely because they were non-western.

Although we are no longer in the age of colonialism, western imperialism is not completely buried but exists in a different form, albeit less overtly. This subtle form of imperialism is perhaps more insidious in that it tends, without any deliberate objective, to replace the cultural identity of the non-western culture concerned. While the depth and vibrancy of western culture cannot be denied, it is vital that the richness and diversity of non-western cultures, their histories and their values, are not submerged by a globalisation of purely western cultural values. We must ensure that there is an equal exchange. One must also not forget the contribution of non-western art to the development and emergence of modern western art. The plundered 'artefacts' brought back during the heyday of the colonial period were a major source of inspiration for the pioneers of modern art. Unfortunately, these artefacts were (and are) read as an affirmation of the 'primitiveness' of non-European cultures - both ancient and contemporary.

The education industry plays a vital role in legitimising and confirming what canons deserve attention. Western education is biased towards its own achievements to the detriment of others, if only because of limited space on the curriculum and the lack of experience of the teaching staff. Euro-centricism thus becomes self-reinforcing despite the presence of pupils from other countries. On a more international level, the cultural values of western nations are advanced through state supported agencies such as the British Council, Alliance Française and the Goethe Institute whose aims are to promote and establish the artistic, linguistic and cultural values of the sponsoring state. Apart

from Japan, most non-western countries lack the equivalent state-supported art 'export agencies'. Even when there is some attempt to support or foster cultural initiatives, economic constraints limit both the scale and the effectiveness of such efforts. Consequently, the global awareness of European cultural heritage has escalated and in the area of visual arts, Eurocentric methodology is much admired and copied.

Until this century art in these countries was largely self taught and or learned informally. It was a part of daily life and until recently did not operate in a separate sphere. Formal art education in most non-western countries is a western import and a relatively new phenomenon. These 'new' centres for the formal learning of art are modelled on western institutions and are in danger of becoming Eurocentric in their approach to teaching and standardisation. Indigenous art tradition has not been given the credit it deserves and undue importance has been placed on western art. Western art has been associated with modernity and progress and has found an audience committed to its supposed superiority. There is nothing wrong with learning from another culture and indeed it is counterproductive to have tunnel vision and work in isolation. However, the danger of a wholesale adoption of western culture should be recognised in order to prevent the risk of a complete erosion of local cultures and a subsequent foreign replacement. Such a trend can only be detrimental to cultural identity.

How did western art achieve this apparent supremacy? The criteria that define 'art' are complicated and very much linked to the mechanics of the western art world. In the west, art is both commercialised and compartmentalised. It is distributed physically and intellectually through a network of dealers, collectors and museums, as well as through critics and academics who specialise in particular artists and schools of art. In the west, art has become a form of currency, an investment. It is akin to stocks and shares. The value of art fluctuates according to market trends in terms of supply and demand. In fact, the value of art has very little to do with quality or quantity. It has to do

with fashion, promotion, sponsorship and patronage, who does the buying, the collecting and the selling. In such an environment, non-western art is a 'niche product' and thus pushed to the margin.

Non-western art does not have the same level of support that western art has enjoyed since the Renaissance. Museums and art galleries in the west provide not only a showcase for western art and culture but also act subtly to promote the supremacy of western culture. They are the temples of culture and bestow a seal of approval and classification on works selected both for their permanent collection and temporary exhibitions.

Western art has traditionally had the backing of wealthy private individuals. These patrons helped to support both individual artists and entire industries devoted to the promotion of art (including paintings, architecture, sculpture and the performing arts). There was also considerable state and quasi-state support for art during the last four centuries in Europe. These included royal patronage of both artists and musicians in the courts of England, France, Spain and Italy together with the support of the Catholic Church for Southern European artists and the Municipal support for artists in Northern European Protestant States. During the modern period, individual sponsorship of art has continued. In monetary terms, the greatest amount of support has perhaps been in the United States. American patrons continue to support and promote not only American but also British and European artists. Max Ernst and other Surrealists enjoyed the patronage of Peggy Guggenheim, and Gwen John's work was much encouraged by the patronage of the American, John Quinn. The confidence of the contemporary art scene in Europe and America is encouraged by the significant support of wealthy individuals. The visibility of the American Conceptual artists, Walter de Maria and James Turrell is much enhanced by the involvement of the de Menil family, the owner of the world's largest private collection of twentieth century art. In England, Charles Saatchi is best known as a dealer and collector of innovative contemporary art. In addition, a network of trusts and foundations (including the Dia Art Foundation, founded by the de Menil family)

has grown to provide financial support for the promotion of art in its many forms. This network of support is particularly valuable in that, by its very nature, it is independent and therefore avoids the uncertainties of either individual philanthropy or state sponsorship.

It is true to say that similar networks of support for art exist in non-western countries. They are, however, still in their infancy and both public and private sectors outside of the west regard art sponsorship as a low priority. The limited support given to artists in non-western countries has to do with historical precedence as well as economic limitations. In most non-western countries, the museum and art gallery as temple of culture is a relatively new concept. This is because in these countries, art was and is regarded as functional and not as a 'collectors item'. In the area of private patronage a similar situation exists and in the absence of adequate financial support, it is difficult for the artistic sector to develop and gain global recognition in western terms.

Confidence in one's achievement is bound up in an intricate network of motivation. The promotion given to western culture has increased the confidence of its artists as well as subtly deflating the ego of others, becoming the arbiter of taste. To retain one's own sense of identity, it is imperative to assert one's visibility and to prevent a submersion of one's cultural identity. To be seen is to be 'heard'! Taking the tactics of the west as an example, non-western countries need to promote a higher profile for their cultures both at a domestic level and at an international level. State support should not be the only source of support. Business institutions and private individuals should take a greater role in mediating the representation of their cultures through supporting initiatives that attempt to reinstate the centrality of their cultures. Initiatives such as *Dialogue of the Present* are much needed to alter perceptions and to validate the contribution of Arab artists in order to challenge the influence of Eurocentricity in the arts.

Chapter Three

BODIES IN REPRESENTATION:
Contemporary Arab Women Artists

Tina Sherwell

I have long been interested in the representation of Arab women in Orientalist painting of the nineteenth century and the stereotypes of Arab women that circulate today in our contemporary culture. Being a woman who is Palestinian and English, and whose initial training is as an artist, these issues of representation seem to bear direct relationship to my identity. *Dialogue of the Present* has provided me with the opportunity to extend my research interests previously centred on the representation of Palestinian women, to consider the way in which Arab women artists represent their bodies in their art work. This essay therefore marks an expansion of my area of enquiry and it is very much an exploration that sets out to raise questions rather than necessarily answer them. As I soon discovered, the field of Arab women's art is vast and one cannot attempt to do justice to the subject in the space of this essay. However what I intend to do is highlight some of the issues that I would argue arise when Arab women step into the frame of representation and take on the challenge of representing their own bodies and the bodies of other Arab women. I will draw my examples from the expansive arena of contemporary Arab women artists.

From the outset one finds that there is an absence of literature on the art of Arab women. Perhaps this problem can be accounted for by understanding that contemporary Arab artists have not enjoyed the spotlight that other post-colonial artists have been privilege to, and here I think of the exhibitions that have been held of contemporary art from the Indian sub continent and Africa. One of the problems that confronts the discourse of Arab art is that texts and exhibitions

have tended in the most part to focus on the achievements of the past which in some ways have served to dwarf contemporary practice. It is still not unusual for example to find people who are deeply astonished to discover that there is a contemporary art scene in Arab countries.

Arab women artists then are confronted with a double burden. As feminist art historians have highlighted, art is synonymous with male creativity; a male artist needs no gendered prefix. Not surprisingly Arab women artists still need to receive exposure. Probably one of the most significant exhibitions in recent years, to address this issue was *Forces of Change*, curated by Salwa Nashashibi which featured the work of over fifty Arab women artists from around the world. *Dialogue of the Present* can also be seen as another mile stone in the attempt to bring to light Arab women's art.

Up until this point I have been using the term Arab woman with frequency without raising the question or defining of what one means by Arab woman? As soon as we begin to deconstruct this label we run into problems. What comes to our immediate attention is that the term provides an umbrella for a wide diversity of experiences. Neither what it means to be an Arab, nor what it means to be a woman are fixed categories. What it means to be an Arab today is different from what it was to be an Arab fifty or a hundred years ago. Being Arab encompasses a multitude of experiences that comes from Arabs who are living in different economic, social and political circumstances across the globe. All these histories go to make up what it means to be an Arab today. Similarly the frame of the term 'Arab woman' is neither a static nor a fixed concept. Arab women are found in a multitude of different circumstances and their identities tempered by religious beliefs, class backgrounds, the social contexts in which they find themselves, and personal experiences. As Stuart Hall has noted, identities do not have a fixed essence but rather are always being made and remade, as they are constantly transformed by and challenged by the events of everyday life; both those in one's immediate life, and those made in the power houses of the world that have direct conse-

quences on the lives of subject peoples. Nor must we forget that all Arabs and Arab women are not positioned equally in relation to one another but that power relations are an important part of identities. Individuals are placed in positions whereby they oppress and exploit people and yet they also fall under the same identity of being an Arab, or an Arab woman. Thus such a broad label as Arab woman may at times also encompass conflicting and antagonistic identities and experiences.

The bodies of Arab women have, however, long been a subject of fascination and scopic investigation which is evident if one examines Orientalist discourses. One of the problems that Arab women posed for the Orientalists and colonists of the nineteenth century was that in many ways they resisted representation. Malek Alloula speaking of the Algerian woman says, "The opaque veil that covers her intimates clearly and simply to the photographer a refusal ... Draped in the veil that cloaks her to her ankles, the Algerian woman discourages the scopic desire (the voyeurism) of the photographer".[1] In general the colonists experienced a sense of frustration during their encounter with the east, for it did not readily offer itself up to be visually consumed. Travellers, and the colonial administrators, as Timothy Mitchell notes struggled to find a vantage point from which to survey the oriental city. There were no large boulevards which allowed one to observe one's subjects, as in the European cities. The east did not have a system of surveillance which the European could access.

But what are the foundations behind the urges of the Orientalists and colonists? Meyda Yegenoglu gives a lucid reply to such a question. In her book, *Colonial Fantasies; Towards a Feminist Reading of Orientalism,* she explains that one of the key tenets of the Enlightenment project was the coupling of knowledge and vision for the acquisition and execution of power. Thus in order to conquer the east it first had to be rendered transparent. This ideology was mobilised around the notion of unveiling the truth and in so doing the faculty of sight was privileged above all senses.[2] It is not hard then in this context to understand how and why the Arab woman, veiled from head to toe,

1. Malek Alloula, *The Colonial Harem*, Minneapolis, University of Minnesota Press, 1986, p7
2. Meyda Yegenoglu, *Colonial Fantasies: Towards a Feminist Reading of Orientalism,* Cambridge, Cambridge University Press, 1998, pp108-109

becomes an object of fascination, a space to be penetrated.

The system of the harem was an additional barrier between the colo-nists and Arab women for it denied access to men outside the family circle. It must be remembered however that not all women lived in a harem and that it was mainly the practice of wealthy families who could afford for their women not to work. The women in the harem and veiled women became an obsession for Europeans and a cen-tral motif in the Orientalist paintings of Eugène Delacroix, Jean-Auguste-Dominique Ingres and Jean-Léon Gérôme, to name some of the most famous artists who projected their fantasies of these spaces onto their canvases. The fantasy was of a space populated by sexually avail-able and subservient women who while away their time waiting for the return of their master. However the image of the Arab woman in the harem was full of ambivalence. On the one hand she was a pas-sive creature, on the other she was slave to her insatiable sexual de-sires, a potential femme fatale, set on corrupting men.

A contemporary Arab Egyptian woman artist who deals explicitly with the issues of female sexuality is Ghada Amer (born 1963). Using em-broidery thread instead of paint, her canvases at first appear as ab-stract formations, with no discernable outlines. However, slowly, as one's eyes adjust, figures come into view, yet as soon as they do, they dis-solve again, constantly resisting our urge for a fixed image. In this series of *Untitled* works, 1996 (Plate 9) Amer plays with the question of visibility and one could argue that her techniques give visual form to the issues that have been discussed above. It is as though we observe these women through the latticed windows of the Arab house, only ever receiving a partial glimpse of the interior. This serves to tantalize, fuelling the imagination of the voyeur and one's own fantasy of the harem and in some way echoes the experience of nineteenth cen-tury Orientalists and colonists. Amer makes us aware of the position from which we observe her canvases and by extension the Arab woman. However there is a fine line between critiquing and repro-ducing the visual strategies that allow for the visual consumption of women. It could be argued that Amer's sexual imagery reproduces

Plate 9 Ghada Amer, Untitled, 1996
Part of *Untitled* Series from 1993,
Embroidery threads, gel medium on canvas, 178 x 152.5cm
Courtesy of Brownstone, Corréard & Cie

notions of the Arab woman and the activity of the harem; of women consumed by sexual desire inhabiting a private space. However, there is a point of difference. Leila Ahmed in her article entitled *Western Ethnocentricism and Perceptions of the Harem* has drawn our attention to one of the unacknowledged fears surrounding the harem which is of it being exclusively a community of women.[3] Amer's paintings also focus on a community of women who, in this case, are engrossed in sensuous acts of licking, sucking each other. One must acknowledge the work of Ghada Amer for she is one of the few Arab women artists whose art work deals openly with issues of female sexuality and female desire, a subject usually considered taboo for a woman to talk about.

Jumana Aboud (born 1971) an Arab Israeli artist living in Jerusalem takes another perspective on Arab women. Using the fairytale of Rapunzel, the girl locked away in the tower, Aboud explores the pri-

3. Leila Ahmed, 'Western Ethnocentrism and Perceptions of the Harem', *Feminist Studies*, Vol.8, No.3, 1982

vate world of women. In a sense her use of what is considered a European fairytale in an Arab context highlights that it is not only in the Middle East that a woman's domain is considered the home, and that she should passively await the arrival of her prince. Aboud works with miniature pencil sketches, old photos, scraps of lace and seeds. In one work of this series we see a young girl, sleeping as though unconscious in her own dream world; she floats in space, her long plait curled around her. In another a tiny woman with wind-swept hair who is menstruating calls out 'why do I have to always be prim and proper, from behind the glass frame'. At this moment she acknowledges her position within the symbolic order in which prescriptive norms define the appropriate behaviour of a woman.

Before continuing a discussion of the work of contemporary Arab women artists, I would like to return to the question of the representation of the harem and the Arab woman from a male perspective in nineteenth century Orientalism. One of the popular images of Orientalism was the Arab woman as a passive helpless creature. This idea was expressed in painting and literature through the technique of realism. If one examines the paintings of Gérôme, one of the most popular Orientalist painters, one finds that the style of painting was instrumental in conveying the impression that what people saw before them was an accurate and true-to-life representation of the east. This style of painting is described by Linda Nochlin as "pseudoscientific naturalism - small self effacing brush strokes, and 'rational' and convincing spatial effects".[4] The paintings were rendered more accurate than photographs and this style of painting can be seen to go hand in hand with Enlightenment rhetoric in which the emphasis is on total command over the field of vision.

Images, and the ideas that they express do not exist in a vacuum. The social context in which they are made contributes to controlling the way in which a subject is represented. The particular representation of Arab women was part of a wider discourse on the east and was used as one of the tools for justifying the subjugation of Arab people. The Arabs, and in particular their customs relating to women, were

4. Linda Nochlin, 'The Imaginary Orient', in The *Politics of Vision, London*, Thames and Hudson, 1991, p44

seen to be a mark of backwardness and barbarity. The plight of the Arab woman was taken up as a central issue in the quest to civilise and modernise the Orient. One can find supporting evidence of this in the literature of colonial administrators, travellers and so on. However, one must not forget the degree of ambivalence that existed for, at the same time that the colonists championed the cause of women, they also enjoyed consuming images depicting "the delicious humiliation of lovely slave girls" [5] from the position of a moralistic voyeur.

Women's bodies therefore became one of the sites on which the battle for the conquest of the east was fought. As Yegenoglu explains, "It was only by rendering Muslim women's bodies visible that they became capable of being recodified, redefined, and reformulated according to new Western codes. The regime and control involved in colonial power needs the creation of docile, obedient subjects".[6] The photographs of Jananne Al-Ani (Plate 10) explore this stripping away of the layers of Arab woman while the stark poses, similar to nineteenth century criminal portraits recall the scientific discourse in which the races of the world were classified.

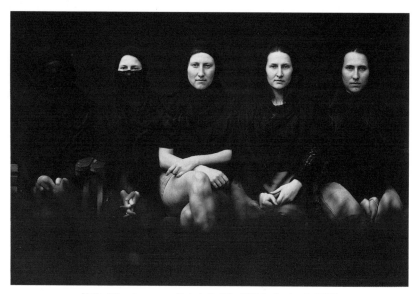

Plate 10 Jananne Al-Ani, *Untitled (Veils Project)*, 1997
Black and white photograph, first of a pair, each 120 x 180cm

5. Nochlin, p44
6. Yegenoglu, p116

It was not only the colonists who used the body of the woman in their emancipation discourse. Anti-colonial struggles in Algeria, Egypt and India, all engaged in debates over the roles, identities and bodies of women. In many instances women of the indigenous community were positioned as the bearers of cultural authenticity, as uncontaminated by the influences of the west. Women were the nurturers of the sons of the revolution. The emancipation of women was confined to improving their education in order for them to be better educators and wives. Deniz Kandiyoti has highlighted that this type of valorization of women serves to, at the same time, mariginalise them, confining them to particular roles in the community.[7] In the rhetoric of modernisation and anti-colonial/nationalist struggles, women's voices are seldom heard and if they do take up a position in the public sphere then often as not it is to step into a pre-defined position, not one which women have carved for themselves.

Born in 1957, Shirin Neshat, an Iranian Muslim artist explores in her photographic works the image of women in revolutionary struggles. Although she is not an Arab, she shares, as a Muslim the commonality of the need to challenge the western stereotype of the eastern Muslim woman as weak and subordinate, and substitutes this Orientalist imagery with scenes of proud militant women. Media images of the Iranian revolution, the Lebanese war, and the Palestinian Intifada have all served to add to our stereotype of the Middle Eastern woman irrespective of their historical and cultural differences. In this context then, the work of Shirin Neshat it could be argued reinforces the stereotype of the eastern Muslim woman that we have become familiar with through our television screens as her works are filled with women veiled from head to toe in black. However her photographic constructions are imbued with artifice. These frozen stills seem to mimic revolutionary poses as for example in *Prayer for Miracle* or *Guardians of the Revolution* thereby questioning the disciplining of the body under such regimes. Nor does Neshat shy away from tackling the issue of sexuality and revolutionary struggle. In *Allegiance with Wakefulness*, 1994 (Plate 11) a gun appears from between a pair of vulnerable feet whose surface is covered in a script that is inaccessible to the majority

7. Deniz Kandiyoti, 'Identity and its Discontents: Women and the Nation' in *Millennium: Journal of International Studies*, Vol.20, No.3, 1991, pp429-43

of us. Naked flesh is juxtaposed with the weapons of death alluding to the notion of the femme fatale. Other works like *I am its Secret* also play on the allure of the veiled woman. The swirling text that is overlaid adds to the feeling of being drawn into a hypnotic and captivating space.

The analogy of woman and land is frequently used in nationalist discourses. Yuval-Davis in her introduction to *Woman-Nation-State* has outlined the way in which the spaces of women's bodies are used to

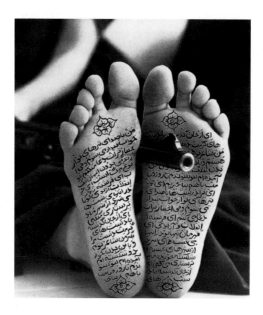

Plate 11 Shirin Neshat, *Allegiance with Wakefulness*, 1994
Black and white photograph with Indian ink, 109.2 x 99cm

mark the boundaries of the nation.[8] Women are seen as responsible for reproducing the boundaries of the nation and maintaining the purity of it, particularly those communities whose national identity is under threat from other forces. This relationship of women's bodies to nation and land is articulated in the most recent work of the Palestinian artist Laila al-Shawa, in which images of the bombardment are superimposed and merged with images and X-rays of breast cancer.

8. Yuval-Davis and Flory Anthias, *Woman-Nation-State*, London, Macmillan, 1989

Here the body and the land become one, the invasion of a foreign body penetrates both the landscape and the bodyscape and suggests that violence inflicted on spaces bears a direct effect on physical bodies. Her use of medical imagery reveals the hypocrisy of an idea of a clean surgical operation for sufferers of war and sufferers of cancer. Both bear scars.

One of the central debates concerning Arab women's bodies over the past hundred years has been the question of the veil. Zineb Sedira, an Algerian French artist, born in 1963, explores the complex issues surrounding this article of clothing. Zineb Sedira speaks of her central interest being that of an idea of a mental veil, and the veiling of the mind. In *Silent Witness* (Plate 12) the body has been condensed to the space of the eyes and it is worth noting that in the Arabic language there are numerous words used for the eye and the area around the eye, indicating the regard with which eyes are held in Arabic culture. In this work the eyes rotate, evoking a sense of confinement further enhanced by the narrow strip from which the woman looks out and the fact that no other part of the face can be seen. Yet the use of herself as the subject of her work serves to give identity to the normally anonymous veiled Arab woman. Zineb takes up the issue of veiling in another of her works, *Don't Do to Her What You Did To Me No. 2* (Plate 13). This photographic series shows the artist veiling and unveiling. We intrude on this private movement in which the artist does not confront our gaze. The veil is a patchwork of photographs of the artist unveiled with her hair down and so renders the veil redundant.

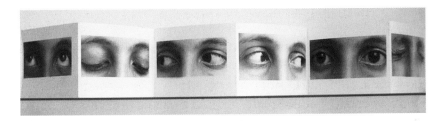

Plate 12 Zineb Sedira
Silent Witness, 1995
Black and white photographs stitched together, 40 x 180cm

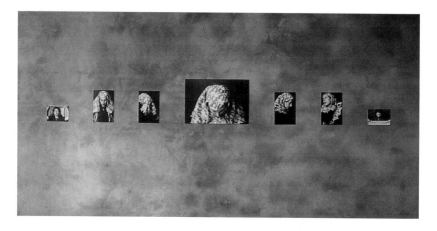

Plate 13 *Zineb Sedira*
Don't Do To Her What You Did To Me, No. 2, 1996,
Installation of colour photographs; scarf made and worn by the artist

However this binary opposition of veiled or unveiled has been problematised by Yegenoglu who argues that the philosophy behind an idea of the veiled or unveiled woman has its roots in Enlightenment ideology which was premised on the importance of transparency and visibility of the colonial subject, and the idea that underneath the veil is concealed the essence of the Arab woman. Yet, as Yegenoglu clearly argues, it is upon the surface of the body that power is inscribed and subjects are disciplined: "The body is the medium through which power operates and functions".[9]

Yegenoglu cites Kaja Silverman who argues that "Clothing exercises a profoundly determining influence upon living breathing bodies ... affecting contours, weight, muscle development, posture movement and libidinal circulation. Dress is one of the most important cultural implements for articulating and territorialising human corporeality".[10] Thus it is not the question of the body being under the veil, but that the identity and the body of the Arab woman is made in the surface of her clothing, an interweaving of her skin and cloth; "if the veil is part of her body, part of her being in the world then it differs from a simple cover that has an inside and outside In the ambiguous position it

9. Yegenoglu, p116
10. Yegenoglu, p118

occupies, the veil is not outside the woman's body. Nor is she the interior that needs to be protected or penetrated. Her body is not simply inside of the veil: it is of it; she is constituted in and by the fabrication of the veil".[11] The logic of the argument reveals to us that the veiled woman and the unveiled woman are both constructed positions, but that the image of the unveiled woman has become over-identified with an idea of a civilised and free-thinking female subject.

What I have attempted to do in this essay is to explore the inheritance of Orientalism and the stereotypes that Arab women artists encounter when they take on the task of representing the Arab woman's body. My aim has been to point to the way in which the bodies of Arab women are spaces deeply inscribed with ideologies and fantasies and that contemporary attempts at representation are necessarily fraught with complexities. Arab women's bodies have been a subject for artists and colonialists for over a hundred years. By stepping into the frame of representation at this point in history, contemporary Arab women artists are reclaiming their bodies and challenging the ideologies which have been dominant for too long.

11. Yegenoglu, pp118-119

Chapter Four

ELEMENTS OF EMPOWERMENT:
Support Systems in Women's Art Practice
Salwa Nashashibi

It is not possible to discuss art in the Arab world without some understanding of the support systems which enable a professional artist to practice. This essay identifies the diverse elements which are part of the current support systems which have contributed to the success of women artists in different areas within the Arab world. It also aims to provide an understanding of the differing cultural and historical contexts in which Arab women in the Middle East and North Africa practise as artists.

The published resources available on the support systems in the Arab world are scant and I have had to gather material and data largely through interviews with Arab women artists and visits to Arab art institutions documented between 1986-1998. My association with the International Council for Women in the Arts, an educational organisation dedicated to the promotion of Arab women artists, has allowed me an exceptional opportunity to maintain a dialogue with several artists over a number of years and this has been invaluable. Unfortunately, the Council has limited research opportunities in the Gulf and Saudi Arabia, a region that has recently witnessed a phenomenal increase in the number of women artists, as well as a healthy public interest in the arts with substantial support from the private and government sectors. Much of the information on this region had therefore to be assembled from catalogues of recent exhibitions and a few selected interviews.

I have chosen to focus on the case of Egypt (1900-1960) as it provides a useful starting point for understanding artistic developments in the

formative years of art education in the Arab world. This helps to shed light on countries such as the United Arab Emirates, Saudi Arabia, Kuwait, Oman, Qatar and Bahrain that adopted the Egyptian curriculum at the primary, secondary and tertiary level. By comparison, Algeria, Lebanon, Morocco and Tunisia adhered to a strictly French curriculum with little or no modification.

Part I Histories and Conditions

The French occupation of Algeria and Egypt in the early part of the nineteenth-century marked a pivotal phase in the European influence on Arab art. It also initiated a tense dialogue between eastern and western ideologies. Today, this tension is reflected in the continuing struggle over the region's heritage, the perceived authenticity of its art and the integrity of its artists. Schools and universities established by the foreign missions, the cinema and the mass media have all affected the cultural models and values of the Arab world. In countries such as Syria, the precepts and examples of western art have been resisted, while in Lebanon these new values and models have been completely and freely absorbed, becoming almost indigenous.

EGYPT , 1900 -1960

1798 French Occupation
1952 Egyptian Revolution

Napoleon's invasion of Egypt in 1798 opened the door to European artists who flocked to Egypt to paint the exotic east; their imagination, fuelled by the writings of European travellers, created a world of romance and adventure. The Egyptian élite purchased their work and many were employed by Muhammad Ali Pasha to decorate palaces and public spaces. During this period the first group of Egyptian artists was given scholarships to study abroad. Several women from upper class families studied art with the help of foreign artists. Among them was the sculptor Princess Samiha Hussein, Huda Sha'rawi (a leading feminist) and Nafisa Ahmad Abdin.

In 1908 the first School of Fine Arts in the Arab world opened in Cairo, staffed by European teachers. The school offered free education to talented Egyptians regardless of their social standing or gender. Several women graduated from this school and were given scholarships to study abroad. In 1924 Afifa Towfik was the first woman to receive a scholarship to study art in England and she was followed by Zainab Abdou, Iskandara Gabriel and Ismat Kamal. At the same time art education was introduced into the secondary schools for both girls and boys. The Higher Institute for Female Teachers (now the College of Art Education) was first established in 1939 under the director Zainab Abdou (b.1906); in 1947 it became co-educational.[1]

The first major Egyptian art exhibition opened in 1919; it coincided with the peasant uprising and the 'March of Veiled Women' against British colonial rule. This growing nationalist consciousness was also represented in the Pharaonic symbols which many artists combined with western stylistic influences. Women artists, among them Effat Nagui, joined this group which is referred to as Neo-Pharaonism. They used a symbol called the 'fellaha' (peasant women) to represent three important elements: woman (beauty and art), the veil (feminist emancipation) and the peasant (land, nationalism).[2]

Art teachers, many of them male, acted as mentors to both men and women art students and it was a common practice for women to take art lessons with leading male artists of this period. As a result several formed life-long friendships. In 1940 a new radical movement named Art and Freedom emerged. It began as a Surrealist-inspired movement but later encompassed several trends and called for resistance against cultural oppression and Fascism. Among the women who belonged to this group were Aida Shahadi and later Khadiga Riad, who was one of the first abstract expressionist artists in Egypt. Art and Freedom welcomed innovations in art stating that: "True Egyptian art will not exist unless our past heritage is allowed to react with the international heritage".[3] The State, supported by many academics and art patrons, opposed this trend and it took several years for them to come to terms with the idea of self-expression as part of a revolution-

1. Aimée Azar, Femmes Peintes d'Egypte, Cairo, Imprimerie Française, 1953
2. Liliane Karnouk, Modern Egyptian Art: The Emergence of a National Style, Cairo, American University of Cairo, 1988, p33
3. Liliane Karnouk, Modern Egyptian Art: The Emergence of a National Style, Cairo, American University of Cairo, 1988

ary and nationalistic art. Among the leaders of this movement was Hussein Youssef Amin (b.1906), a dedicated teacher, who strove to make art accessible to the Egyptian people.

Amin was convinced that the essence of nationality was not embodied within an aesthetic but that the work of art gave nationality its character and allowed it to be discovered and understood by others. His students came from the working class and they were encouraged to maintain their local and often folk art roots. In 1944 they founded the Group of Contemporary Art which believed that art mirrored the consciousness of a society and had to include diverse social groupings including the poor. Amin encouraged his students to express themselves freely without adhering to mainstream ideas of either the west or the east. This was in effect an 'art revolution' and the concept of art having a social responsibility was considered both politically dangerous and anti-establishment. Both Amin and his famous student, Abdul Hadi Al Jazzar (1925-1965) were arrested. These were probably the first artists arrested for the treason of self-expression.

After the Egyptian Revolution of 1952 which ended the monarchy and initiated the rise of Arab nationalism, new movements advanced nationalism through the use of symbolism. Inji Efflatoun, a leader in the national feminist movement, was part of one such grouping. The writings and the journals she kept while incarcerated for her political views are a testament to her unyielding determination to assert her rights as a woman artist and political activist. Working in different styles Gazibia Sirry, Inji Efflatoun, Tahia Halim and Marguerite Nakhla shared common themes of urban and peasant women's daily life, human relations and woman's equality. Efflatoun (1924-1989) described these changing trends: "My early surrealistic phase ended in 1946 with my complete absorption in feminist, political and social work, I began to search for the personality of the Egyptians and the special character of their surrounding environment". [4]

Meanwhile, art education continued to expand with the addition of art departments at several universities, (see Appendix for a list of art

4. Nazi Madkour, *Women and Art in Egypt,* Cairo, State Information Office, 1993

institutions in Egypt). Women graduates found jobs as art teachers in Egypt or in Kuwait and Bahrain. In the sixties and seventies they had ample opportunities at the newly opened girls schools in Saudi Arabia, the United Arab Emirates, Oman, Qatar and the Yemen. Recent statistics show that art education is the first choice of study for the majority of Egyptian female students, followed by the decorative arts, painting, ceramics, textiles, sculpture, computer arts (limited enrolment) and graphic art. However, such information should be carefully interpreted as several factors may influence the student's choice of study. In order to enter the universities' professional faculties or science departments students must achieve an average of at least sixty five percent in the High School State Examination. This leaves students with lower grades the choice of a liberal art education and many choose art education because it guarantees a job in the public sector. In this case, the statistics reflect the market trends rather than the actual individual interests of the student or the evaluation of his or her portfolio.

Presently a number of universities offer degrees in the Fine Arts at various levels including BA, MA or Ph.D. Few scholarships are offered for studying abroad. Those who can afford to, choose postgraduate programmes in Spain, Italy, France, Eastern Europe, the United Kingdom or the United States. An equivalent of an MA received from an accredited university abroad is considered equivalent to a doctorate at art departments in Egypt.

State Support Systems

The Modern Art Museum in Cairo has a large permanent collection of art representing local art movements from the late nineteenth century until today. It is under the directorship of the National Centre of Fine Arts, which is part of the Ministry of Culture.

Two museums house the work of Mohammed Nagui and Mahmoud Mukhtar. Four years ago the Ministry of Culture announced plans to dedicate two museums to the women artists, Effat Nagui and Inji Efflatoun. The National Centre of Fine Arts operates all the state art

centres. Artists submit an application months in advance for the use of state art venues, which are available to artists for a nominal fee. It also organises the annual art festivals, biennales, art conferences and international visiting exhibitions. An international jury is formed for each Biennale where prizes are awarded in graphics, painting and sculpture. The Youth Salon is an annual event. The selection committee for competitions is formed from chairs of the respective art departments, art critics and members of other art professions.

LEBANON

Formerly part of the Ottoman Empire until end of World War I

1919	French Occupation
1924	French & Arabic official languages
1940's	Independence
1975-1991	Lebanese Civil War
1978	Israeli invasion; 1982 Fall of Beirut

In 1931 women artists participated in the first organised group exhibition in the Lebanon held at the Arts and Crafts School. Their work received immediate recognition and was highly praised by a French art critic. This event marked the beginning of an era of exceptional achievements by women artists in the Lebanon. In 1937 Alexis Boutros founded the Académie Libanaise des Beaux Arts (ALBA) where foreign and local teachers gave lessons to students irrespective of their economic backgrounds or gender. In the mid-forties women comprised fifty percent of the student body. By the time the Institute of Fine Arts of the Lebanese University was established in 1963 sixty percent of the students were women, while during the same period the Fine Arts Department at the American University of Beirut boasted a student body of seventy five percent women.[5] The Beirut College for Women (now the Lebanese American University (LAU)) also offered a major in Fine Arts. Currently ALBA, LAU and the Lebanese University grant a degree in the Fine Arts.

In 1976, Helen Khal (b.1923), a prominent Lebanese artist and critic, conducted the first research on women artists in the Lebanon. The

5. Helen Khal, *The Woman Artist in Lebanon*, Beirut, Institute for Women's Studies in the Arab World, Beirut University College, 1987, p33

study revealed that the proportion of women artists to the total number of artists was higher in Lebanon than in most other countries, whether in the Arab world or in the west; and that four out of the twelve leading artists in the Lebanon are women. Khal cites the following contributing factors: "The Lebanese progressive society offered unlimited possibilities for women; there were approximately one hundred and fifty exhibitions each season; about one-third of these exhibitions were for women; critics judged art work on merit, giving equal attention to male and female artists and the exhibitions received good coverage".[6]

Certainly by the 1960s Beirut had become the intellectual centre of the Middle East and a crucial bridge between the art worlds of the east and the west. The Lebanese Civil War which started in the 1970s sadly destroyed this thriving centre.

State Support Systems

In 1952 the Sursok family donated their stately residence to the Municipality of Beirut which now houses a permanent collection of artwork by Lebanese artists. Each year the museum organises the Fall Art Competition and several women have won its prestigious award. The director is a woman with specialised training in art administration. A sizeable Armenian community lives in Beirut and there are several galleries and a museum that house art works by Armenians. Armenian women artists work within a rich symbolic tradition. The Cilicie Ethnographic Museum of the Armenian Church has a section dedicated to contemporary Armenian Art. Another traditional setting for a modern gallery is Beit el Dine. The programme director is a young Lebanese woman with exceptional organisational abilities. A public space at the UNESCO building is also open for art exhibitions.

IRAQ

Formerly part of the Ottoman Empire until end of World War I

1917-32 British Occupation
1921-1958 Constitutional Monarchy
1958 Overthrow of Monarchy

6. Helen Khal, p33

1968	Iraqi Socialist Party came to power
1980's	Iran-Iraq War, Gulf War
1991	Iraq invaded Kuwait, Gulf War
1998	Bombing of Iraq

In the early 1930s Madiha Umar (b. 1908) was the first woman to receive a government scholarship to study at the Maria Grey Training College in London. Unlike other European colonies in the area, when the Institute of Fine Arts opened in 1936 in Baghdad, the government appointed an all Iraqi faculty. The art school accepted boys and girls from the age of sixteen with most coming from poorer districts to study under the guidance of the leading Iraqi artists Jawad Salim (b. 1921-1961), Fayek Hassan and Shaker Hassan (b.1925).

In addition, the House of Heritage and Popular Arts is a specialist institute which provides a five year western style curriculum after which graduates receive diplomas in painting, ceramics and handicrafts. Art lessons are also offered at the Institute of Applied Arts which is under the Ministry of Higher Education.

State Support Systems

In 1962 the National Museum of Arts was established under the guidance of the Ministry of Information. The Ministry invested a considerable budget in the arts expanding the Museum's permanent collection; organising biennales; subsidising artists' trips to international art festivals; opening regional art and craft centres; publishing an excellent literary and art journal and opening Iraqi cultural centres abroad, including one in London. In 1986 the Saddam Arts Centre replaced the National Museum and the International Festival of 1986 attracted artists from around the world. Leila al-Attar, director of the centre in Baghdad, organised the largest exhibition of Arab and international artists here in 1988. Her tragic death in 1993 during a bomb attack on Baghdad was a major loss to the Arab art world.

JORDAN

Formerly part of the Ottoman Empire until end of World War I

1922-1948 British Occupation

1948 Independence, West Bank annexed to Jordan until

1967 Arab-Israeli War

Art education was first introduced into schools and teacher training colleges in the 1950s at the same time that male students were granted scholarships to study abroad. On their return they opened their own studios and trained Jordanian male and female artists. Fahrelnissa Zeid (1901-1991) of Turkish descent, was an accomplished artist and an exceptional art teacher. She came to Amman from Paris in 1975 with her husband Prince Zeid. The informal art school she established was an open studio for many women who discovered their talent under her guidance. (Plate 14) Now her students are leading artists and art patrons in Jordan. The Fine Arts Department (est.1980) at Yarmouk University in the north of Jordan grants a degree in the Fine Arts with an emphasis on painting, photography, ceramics and sculpture. The Institute of Fine Arts (est. 1960s) grants a diploma in the arts.

State Support Systems

Jordan has two important non-profit-making foundations as a result of the efforts of two women who chose to dedicate their lives to championing the arts. HRH Princess Wijdan Ali (b.1939), a painter, writer and art historian first trained in Beirut at the Women's College and became the first woman diplomat to enter the Ministry of Foreign Affairs in 1962. Ali had a vision to assemble in Jordan works of art from all parts of the Muslim world and in 1979 she founded the Royal Society of Fine Arts which is dedicated to the promotion of the visual arts in Jordan and the Islamic world. In 1980 the Society established the Jordan National Gallery which initially opened with only twenty seven works. It now has a permanent collection of over one thousand works and is one of the largest collections of contemporary art from the Islamic world. It has been a major success with the Arab public and organises travelling and in-house exhibitions, including the successful exhibition, *Contemporary Art*

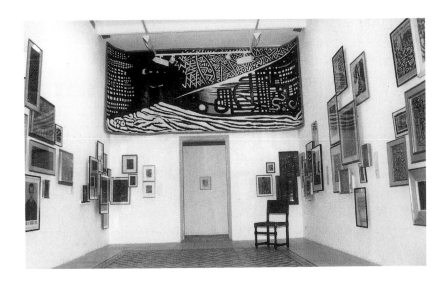

Plate 14 Exhibition of Fahrelnissa Zeid: Prints and Drawings
at Darat al Funun, Amman, Jordan, December 1994

Plate 15 Workshop at
Darat al Funun the Abdul Hameed Shoman Foundation, Amman, Jordan

from the Islamic World presented at the Barbican Centre, London in 1989.

The second foundation, the Darat Al Funun, Abdel Hameed Shoman Foundation, was realised through the initiatives of the artist Suha Shoman. After graduating in Law from the Sorbonne in Paris, Shoman trained with Fahrelnissa in Jordan. As the wife of the chairman of The Arab Bank, the oldest and most powerful banking institution in the Arab world, Shoman suggested they create the Foundation which is dedicated to the promotion of the fine arts and the fostering of a cultural dialogue among the people of the Arab world. The Foundation's art gallery was opened in 1987. It incorporates exhibition spaces, a research and video library, resident artists quarters and open workshops and studios where visiting Arab and foreign artists teach. (Plate 15) Darat al Funun and the Jordan National Gallery collaborate and share their resources. The National Gallery's specialised printing press is housed at Darat.

PALESTINE
Formerly part of the Ottoman Empire until the end of World War I
1917-1948 British Occupation
1948 Israeli Occupation; West Bank under Jordanian rule
 until 1967 Gaza Strip
1967 Palestinian-Israeli War

Prior to 1948 Palestinian men and women artists faced the same dilemma. Art education did not exist and they were forced to train abroad. Fatima Muhib (b. 1920) was the first Palestinian woman to study art abroad at the College of Fine Arts in Cairo. She pursued her Masters of Fine Arts at Helwan University and graduated in 1942. Sofia Halaby, famous for her landscapes, studied art in Paris and now lives in Jerusalem while Lydia Atta, a self-trained artist from Bethlehem, left for Australia in the 1940s.

In 1948 Palestine was occupied by the Israelis and many Palestinians were forced to leave their homes. Some took refuge in the West Bank

which was under Jordanian rule until 1967. However the majority, now made refugees, moved to other areas within the Arab world while others scattered all over the globe. In 1948 many Palestinians were uncertain about their future; according to UN resolutions they were promised repatriation but meanwhile they had to survive. Few students during this period chose to study art in Palestine. A large number entered professional schools in Egypt, Lebanon and Syria and later found jobs in the oil-rich countries.

In the mid-fifties art education was introduced into the UNRWA (United Nations Refugee Welfare Agency) schools and training centres and a small number of art graduates returned to Jordan from abroad. Among them was Afaf Arafat who had graduated from the Bath Academy in England. In 1964 she served on the first committee to design a curriculum for art education in Jordan and interestingly, five of the committee's six members were women art teachers.

In the West Bank many families sent their children to missionary schools where art education was minimal. Beir Zeit University was established four years after the Israeli occupation of the West Bank. Currently art education in the Palestinian West Bank is limited to studio art courses in ceramics, painting and sculpture at Al Najah and Beir Zeit University. Vera Tamari is the head of the art department at Beir Zeit University.

The war in the Lebanon in 1982 meant further displacement and some artists like Laila al-Shawa moved between Gaza and London where Palestinian art has been relatively well represented.

Support Systems

The Sakakini Cultural Centre in Ramallah organises lectures and exhibits for Palestinian artists living in Palestine or abroad. It is an essential link for the artists who seldom leave Ramallah. In Jerusalem, the Al-Wasiti Cultural Centre maintains another vital link for those Palestinian artists living in Jerusalem. It maintains an important database on Palestinian artists and organises art programmes for children.

The first Palestinian Artists Group and Craft Council was established in 1962 in Jerusalem. Until the 1967 Occupation the Council helped many young Palestinians to exhibit their work. The Palestinian Artists' Association was established in 1969 in Amman with chapters in several Arab countries. Those artists who remained in the West Bank formed a chapter in 1972.[7]

SYRIA

Formerly part of the Ottoman Empire until the end of World War I
1918 Monarchy briefly
1920-1946 French Occupation

The first generation of Syrian artists, heavily influenced by the French, adopted either an early Orientalist style or outdoor Impressionist methods. Meanwhile the Byzantine tradition of painting frescoes and icons remains unique to Syria and several folk artists have appropriated elements of Byzantine art in their paintings on glass. Typically these paintings illustrate scenes from folk tales and storytelling traditions. On a recent trip to Syria I met several self-trained women artists who are working in this genre on paper.

The College of Fine Arts at Damascus University was established in 1959. It was based on the Egyptian model and many of the first teachers were Egyptian. There is no evidence that Syrian women artists were active prior to the mid-sixties although several may have been studying privately. By 1968 women artists such as Laila Naseer (b. 1941) were part of the dominant Expressionist trend in Syria.

State Support Systems

The National Museum of Damascus houses archaeological and Islamic works and in 1956 a new wing was added that exhibits modern Syrian art. Similar additions have been created in the museums of Busra, Aleppo, Dayr al-Zur and Raqqa. The Ministry of Culture opened several fine art centres during the 1960s and 1970s where two year art courses are available free of charge. They also initiated a Cooperative Housing Society for artists which helped them to build studios

7. Samia Taktak Zaru, 'Palestine' in Wijdan Ali (ed)., *Contemporary Art from the Islamic World*, London, Scorpion Publishing Ltd, 1989, p239

and living accommodation. Najah al-Attar is the first woman Minister of Culture in Syria.

NORTH AFRICA

ALGERIA

Formerly part of the Ottoman Empire until the end of World War I
1830-1962 French Occupation
 French made official language

The French established the Société des Beaux-Arts in Algiers in 1851, its membership restricted to artists of French origin. From 1894 they had an annual salon in Paris and in 1900 the Musée d'Alger opened as a showcase for their art in Morocco. Algerians were not allowed to join the French Art Associations or work with them in the same studios except as models. In 1920 when the French established the Ecole des Beaux-Arts in Algiers, with partner schools in Oran and Constantine, they were staffed by French teachers who aimed to prepare students for the Paris Ecole.

I have found no record of Algerian women artists in any archive before the late 1960s with the exception of Baya Mehieddine. Although women had the opportunity to study at any one of the departments at the Ecole des Beaux-Arts; it is only since the seventies that their number has significantly increased. Similarly, few Algerian women exhibited in private galleries between 1960-70s. Again the exception was Baya (b.1931 - December 1998), the self-trained artist, orphaned at the age of five and adopted by a French couple. Baya began to paint after her mother died and her naive style of painting, based on dream-like imagery and Arabo-Berber-Andalusian culture, brought her fame at the age of sixteen when she had her first solo exhibition at the Maeght Gallery in Paris in 1947. André Breton admired her work and Picasso invited her to his home and watched her shape clay into animal forms. Current conditions in Algeria are a disaster. Most of the art school's staff are in self-exile; two were killed and the school is now closed.

State Support Systems

The Musée D'Alger was rehoused in the Musée Nationale des Beaux Arts in 1930 to celebrate the Centennial anniversary of French rule in Algiers. It has a collection of Orientalist paintings and a limited selection of works by Algerian artists. The most recent museum director is Malika Bouabdellah.

MOROCCO

1912-1956 French Occupation
 Tangiers under French and Spanish administration

The French cultural policy in Morocco differed from that in other Maghrib countries; they preserved the Moroccan Islamic architecture, turning the buildings into museums and fine arts centres. Traditional crafts were documented and preserved and the Ecole des Arts et Métiers was set up in 1930 to encourage the study of the Moroccan heritage. This policy would later steer art education in Morocco away from a singular Orientalist approach.

In 1945 the Escuela de Belles Arte was established in Tetouan (then under Spanish administration) and in 1950 the Ecole des Beaux-Arts was founded by the French in Casablanca. After independence male students were sent on scholarships to study in Europe. Presently both art schools in Tetouan and Casablanca offer degrees in Fine Art. A number of Moroccan women artists study and live in France and Spain.

The first Moroccan woman artist to study abroad was Meriem Mezian. Born in 1930, she graduated from the San Fernando School of Fine Arts in 1959. Her first exhibition was in 1953 in Tetouan. Her work is a synthesis of Islamic symmetry and Berber symbols painted using western techniques. A number of women artists are self-trained and although their work remains at the periphery of the modern art movement it has gained popularity among art foreign collectors and is exhibited frequently in Morocco and abroad. Fatima Hassan's work, for example, portrays scenes of traditional folk festivals, henna ceremonies and other activities that revolve around the life of women in

Morocco. Similarly, Chaibia Talal's large paintings focus on women and are full of energy, vitality and a sense of regeneration.

State Support Systems

The two main museums are the Musée d'Art Contemporain de Tangier and the National Ceramics Museum in Safi. In 1978 the annual Asilah Cultural Season was inaugurated and every summer visual artists, writers, poets, musicians, actors and dancers come from all over the Arab world to this small coastal town. Organised by the Ministry of Culture, the event lasts for a month and includes the use of studios and workshops.

SUDAN

Formerly part of the Ottoman Empire
1821-1897 Under Turkish-Egyptian rule
1898-1956 British Occupation

In the early thirties art education was introduced at all levels by the British administration who recognised the role of art in education. Both the Institute for Teachers and the College of Fine and Applied Art (now the School of Fine and Applied Arts, est. 1971) were established in the early thirties. The first generation of Sudanese artists studied abroad in the mid-forties and brought western approaches back to Sudan. In the 1950s the next generation associated with the Khartoum School sought to make a 'Sudanese' art which paralleled recent nationalistic developments in literature. Kamala Ibrahim Ishaq, who had studied at the Royal College of Art in England in the 1960s, taught for several years at the School of Fine and Applied Arts and was initially part of the Khartoum School. In the mid-1970s she broke away to found the Crystalist School, a movement that was inspired by the spiritual practices of women in central Sudan.[8]

The Khartoum School remains an important art institution in North Africa and offers courses in painting, sculpture, Arabic calligraphy, graphic design, ceramics, textiles, art history, aesthetics, and the history of design. It also offers an MA in Fine Arts and Art History.

8. Salah Hassan, essay in *Seven Stories about Modern Art in Africa,* Whitechapel Art Gallery, 1995

The major state museum is the National Museum in Khartoum.

TUNISIA

Formerly part of the Ottoman Empire
1881-1955 French Occupation
1956 Independence

The art of portraiture was the first form of European art introduced to Tunisia in the early part of the nineteenth century and was popular among the upper classes who commissioned European artists to do their portraits. In 1894 the French administration founded the Institute de Carthage which served as a showcase for French cultural domination with its annual exhibits at the Tunisian Salon (1894-1984) which displayed Orientalist paintings by French and Tunisian artists. The Ecole des Beaux-Arts (now the Institute for Arts and Architecture) was established in 1923 with French teachers who maintained western traditions. As in the cases of Algeria, Morocco and Syria, Tunisia was presented with an imposed system of art movements which local artists had to negotiate.

The first generation of Tunisian artists studied in Tunisia within the French system or were self-trained. The major change occurred in the 1950s with the founding of the Tunis School. Although started by a French artist, most members were Tunisian and believed in the value of folk culture and a traditional way of life. The group is still active and was instrumental in introducing the traditional arts into the realm of modern art. Safeya Farhat (b.1924) an important member of the group, turned her family home outside the capital into a weaving centre where young men and women from neighbouring villages still work at upright looms 'painting' abstract shapes by weaving. Farhat's work can be seen at the Centre de Ville in Tunis. She donated her time, funds and family home bringing joy to others while teaching them a new craft.

With the exception of Safiyya Farhat, there is no mention in the published literature of women artists before the 1960s, although women

artists may have worked at home. In the 1960s, by contrast, artists such as Fawzia el-Hicheri (b.1946) who studied graphic art abroad, have had more attention and more women are now training as artists. However, those that have recently studied abroad have tended to remain there.

State Support Systems
The Centre d'Art Vivant de la Ville de Tunis which includes the Museum of Modern Art is under the Ministry of Cultural Affairs. It has a permanent collection of art by Tunisian and Orientalist artists who lived or were born in Tunisia. The government has inaugurated several annual exhibitions and biennales that are held at this centre.

ARABIAN PENINSULA
Separated from the rest of the Arab world geographically and politically, the peninsula has a complex history with most states being relatively recent creations.

The Arabian Gulf Co-operation Council was established in 1981 as a political and economic union and include the UAE, Bahrain, Saudi Arabia, Oman, Qatar and Kuwait.

KUWAIT
Formerly a British Protectorate
1961 Independence

In the late 1940s Kuwait introduced art education into the school curriculum and it was also the first state in the peninsula to grant a scholarship to a male student to study art in England. Bahrain followed in 1952, then Saudi Arabia in 1957 and Qatar and the UAE in 1965. Most artists have trained abroad including Thuraya al-Baqsami (b.1952) who studied in Moscow in the early seventies and joined the Kuwaiti Formative Art Society in 1969. Sabiha Bishara (b.1949) and Nesrin Abdullah are also successful women artists.

State Support Systems

The Free Atelier in Kuwait was established in 1960 and offers instruction in painting, sculpture and graphics and provides free class materials to amateurs, students and artists alike. It has a library and well equipped studios for painting, ceramics and graphics. Each year one artist is granted a one-year paid sabbatical.

The National Museum of Kuwait was established in 1983 and included the Dar al-Athar al-Islamiyyah, an ethnographic wing, and a gallery for Modern Art and Sculpture. Dar al-Athar is a semi-private institution that promoted Islamic Art and housed the private collections of Sheikh Nasser Sabah and Sheikha Hussa Sabah. It organised educational programmes which included lectures in art history and art appreciation. It also included the Al-Muhtaraf workshops which provided courses in pottery, metal work, and jewellery. Destroyed during the Iraqi invasion in 1990, Kuwait now lacks a major art centre. Kuwait University plans to open a department for Islamic Art Studies.

BAHRAIN
Formerly a British Protectorate
1971 Independence

Bahrain was the first state in the Gulf to provide educational opportunities for women who were given scholarships to study abroad. Balqees Fakhro (b.1950) studied art in the 1970s in California and has returned to become a member of several local art societies including the Bahrain Art Society which was founded in 1983. Other women artists include Safiya Swar, Haya Al Khalifa and Samiha Rajab.

Bahrain Museums have dedicated spaces for contemporary art exhibitions and they also have state programmes that support young artists. Bahrain University plans to open a Fine Arts Department within the next two years.

OMAN
Formerly a British Protectorate
1968 Independence

Modern art education began in Oman in the 1980s with the establishment of the Free Atelier of Fine Arts in Muscat which provides free lessons in drawing and painting as well as free art materials. The government offers scholarships for artists to study abroad mainly in Egypt, Iraq or Bahrain. Two of the most important artists are the self-taught sisters, Rabha bint Mahmoud (b. 1949) who paints expressionist works, and Nadira bint Mahmoud (b. 1959) who is an abstract painter.

The Muscat Youth Biennale for young artists from Asia, Europe and the Arab world was founded in 1988 by the Ministry of Culture. More recently, in 1992 the Omani Society of Fine Arts was also created in Muscat under the auspices of the Royal Court while most exhibitions take place in the Cultural Club in Muscat.

QATAR
Formerly a British Protectorate
1971 Independence

Qatari artists have tended to train abroad in Egypt, Iraq or Europe. Art structures are only just developing and following the successful experiments in Kuwait, a Free Atelier in Fine Arts now exists in Doha.

SAUDI ARABIA
Formerly part of the Ottoman Empire until the end of World War I
1919 French Occupation
1924 French & Arabic official languages
1926 Kingdom of Saudi Arabia

Art education was introduced into the secondary schools in the late 1950s and courses for art teachers began in 1965 at the Institute for Art Education and subsequently at the Colleges of Education in Mecca and Jeddah. The first women to study abroad in the 1960s were Safeya

Binzagr and Mounirah Mosly (b.1952). Both work as professional artists and organise exhibitions. As Wijdan Ali notes: "In Saudi Arabia, where women are still veiled in public and where strict codes enforce segregation of the sexes, artists hold two exhibition openings: the first, official one for men and the second for women." [9]

State Support Systems
Saudi Arabia has a diploma in art education at the women's colleges and has recently granted several students scholarships for postgraduate studies in art education. The General Presidency on Youth and Welfare, founded in 1973, promotes cultural activities, finances the work of young artists, organises exhibitions and sponsors Biennale participants.

UNITED ARAB EMIRATES
Formerly a British Protectorate
1971 Independence

Created in 1971, the United Arab Emirates is a union of several small sheikh-doms including Sharjah, Fujairah, Ras al-Khaimah, Abu Dhabi, Dubai and Ajman. Most artists train abroad on government scholarships and it is only since the mid-1970s that one could identify specific local art practices.

Sharjah inaugurated a highly successful International Arts Biennale in 1993. The newly opened Sharjah Arts Museum (1997) is an unrivalled exhibition space in the Gulf with excellent lighting as well as a climate-controlled environment. In addition, Sharjah has several dedicated spaces for contemporary art exhibitions and a state programme that supports young artists. The Sharjah Women's Club, as well as providing an informal art education for women, has a flexible space for temporary exhibitions. An objective of the Sharjah Women's Club is to encourage women's participation in the arts.

The Cultural Foundation in Abu Dhabi offers a large flexible space in its main hall for temporary exhibitions. Smaller exhibitions are shown in

9. Wijdan Ali, *Modern Islamic Art: Development and Continuity*, Florida, University Press of Florida, 1977, p131

the smaller halls on the first floor.

Art exhibitions in Dubai are mainly shown in hotels and clubs. The annual art event is the Dubai Shopping Festival. As the name of the Festival suggests, its focus is not on education. A Dubai Museum of Art is being proposed.

Part II Elements of Empowerment

Whether an Arab woman artist is self-trained or has achieved a degree in the arts she depends on several support systems that contribute to her success in the profession. The importance of these systems becomes apparent as one follows the career of women artists whether they are practising in their home country, in exile, or as emigrants. Some support systems have been in place for many years; others are more recent and hopefully more will be forthcoming.

Most crucially artists need public spaces in which to show their work and an audience to acknowledge it. Many artists see their artwork as belonging to the public once it enters the gallery and the audience is therefore the first supporter of the artist and their response is taken very seriously. Galleries are multiplying in the Arab world and large crowds attend exhibition openings and works sell. All of these factors indicate the support of the public. At the same time on any given day including Friday, modern art museum halls are almost empty and at times it seems that most of the potential visitors to a gallery attend the opening night with very few returning later. The Jordan National Gallery, for example, informs schools of forthcoming exhibitions, first by mail and then by a follow-up telephone call but few schools respond to these invitations. The major question of why Arab audiences do not regularly visit exhibitions has yet to be answered effectively. It will require detailed studies of the audience but, until this happens, one has to rely on an analysis of other conditions.

The museum is now considered an essential component of public education in the west and museums devote enormous budgets to art

education programmes which aim to appeal to a diverse age range. This requires an enlightened leadership willing to redesign and invigorate art education, but it also requires co-operation and collaboration. Art educators in the Arab world need to work together with museum staff to develop educational programmes that suit their own local and international needs. Saudi Arabia is an example where this has begun to happen and the government has committed itself to developing all facets of art education including scholarships, visiting artist programmes, conferences, biennales and exhibitions for artists, both locally and internationally.

Travel is equally essential for professional growth and this is problematic for differing reasons for many artists in the Arab world.[10] Egyptian artists face major obstacles with a bureaucracy that permeates all government institutions. As an example, an artist planning to participate in a private exhibition abroad (for profit or no profit) must submit a request to the Head of the Fine Arts Centre which must include a detailed list of the art works and supporting photographs. Prior to shipment, and in order to receive a release form from the centre for custom purposes, the artist must assemble his/her artwork at the Fine Arts Centre for documentation. Three art inspectors verify that the work accords with the photos and each work is then stamped with three different stamps and signed by the three inspectors. The artist must pay customs and taxes on all sales. Thus, in effect, the centre makes the final decision in the selection of artists for group exhibitions in foreign countries.

Conversely, Egypt has shown much foresight in supporting artists within the country. It has recently created several new exhibition spaces and given priority to young artists by providing them with studios and an annual Youth Salon. These measures were well rewarded in 1995 when three young artists (all males) won for Egypt the prized Golden Award at the Venice Biennale. The catalogues of Egypt's Biennales indicate a strong visibility for women artists with an average participation of thirty to forty percent. This is borne out by the women artists I interviewed who all felt that they were well represented. In this year's

10. For example, in Saudi Arabia, women are not allowed to travel overseas without the written permission of the male head of their family.

overpacked Biennale, for example, the largest space was allotted to an installation by a woman artist. In the Gulf States prominent male members of the government or the ruling family have presided over the opening of several exhibitions by women artists where it is also noteworthy that art festivals are now held in conjunction with national celebrations.

In the past five years a number of private galleries have opened in Egypt, Jordan, Lebanon, Palestine, Syria, and the United Arab Emirates. Most strikingly, the majority of these galleries in the Arab world are owned and/or supervised by women; at least half in Egypt, Lebanon, Saudi Arabia, Kuwait, Syria and Tunisia while in Jordan and possibly Iraq they are almost all owned and/or supervised by women. These successful women have several things in common. They have some experience of art, excellent public relations skills, regular customers (both Arab and foreign collectors) and a good understanding of the local and Arab art scene. Few act as exclusive agents for the artists.

Meanwhile, Arab women artists in Jordan are doing exceptionally well compared with their male counterparts and with other Arab women in the region. The art market is particularly strong in the United Arab Emirates, Bahrain, Qatar, Kuwait and Oman. I interviewed fifteen women artists who had recently exhibited in the Arabian Gulf area and they were all encouraged by the public response and the success of the exhibitions. One lone male gallery owner credited this success to the social connections and support systems of the women artists involved! This may be true in a small country or where there are a smaller number of artists but women gallery owners in nine Arab countries emphatically denied that gender had anything to do with their selection of the art work: 'Arab Women can stand on their own and do not need assistance to promote themselves!' An Egyptian and a Tunisian gallery owner both felt that because I came from the United States my perspective was coloured by feminism. Can one be too supportive? Certainly, the large number of exhibitions by women

artists does seem to confirm that they are not marginalized and the reviews are equable.

Women patrons are not a new phenomenon in the Arab world. Zubayda (died 831AD), the wife of Harun al Rachid, built palaces, gardens, and pavilions and commissioned the construction of nine hundred miles of road from Kufa to Mecca (Darb Zubayda) with hostels and other amenities for pilgrims. The two oldest Islamic monuments in North Africa, the Qarawiyyin and the Andalusian Mosque, were commissioned by women in the 850s AD.[11]

Corporations are now the biggest supporters of art in the United States and businesses in the Arab world, especially the Gulf States, are also supporting the arts on their own terms. Art exhibitions are frequently held in hotel lobbies, trade centres, clubs, and more recently in car showrooms. The obvious advantage to the artist is that the work is presented to the public but such sites also raise interesting questions about how the art work is perceived and appreciated outside of the gallery; who determines which artists are shown and what attracts the attention of a dealer. The World Trade Centre in Dubai is a good example of business patronage which has overcome some of these difficulties. They have dedicated halls for art exhibitions as well as artists studios.

The growth of business sponsorship is particularly impressive in Jordan. In less than twenty years this small country, with limited economic resources, has assembled two important art collections (sponsored by the banking world) and opened a commercial gallery, the Alia Gallery (sponsored by The Royal Jordanian Airlines). It has also created in the Abdel Hameed Shoman Foundation the first non-aligned foundation which is a new concept in the Arab world. Instead of serving purely local interests the Foundation is dedicated to the development of the people of the Arab world in the sciences and the humanities. For example they support the Darat el Funun in Jordan and recently the publication of catalogues for exhibitions in the Lebanon.

11. Esin Atil, essay in 'Patronage by Women in Islamic Art', *Arthur M. Sackler Gallery, Smithsonian Institution*, Vol. VI, No: 2, New York, Oxford University Press, 1993

A noticeable rise in the number of private collectors of Arab-Islamic art in the Arab world is also evident. Unfortunately collectors have entered this field relatively recently and much of the Islamic heritage is already in western museums. Conversely, contemporary art collectors have steadily acquired works and hopefully their collections will be left to the national museums in the future. Generally collectors have bought specific artists and, as far as I am aware, there is no collection that has concentrated on Arab women's art.

Meanwhile, foreign cultural centres and institutions still remain faithful supporters of art. They have the space, the budget and the built-in support systems which ensure the success of their programmes. Their libraries have the latest art magazines, journals and videos while visiting art exhibitions and conferences provide excellent opportunities for artists to meet. They also act as information centres and provide details of possible scholarships to study abroad.

Equally important has been the steady growth of art associations and artist groups. Every Arab country has at least one art association and every Arab artist can become a member of the Arab Artists Association which was established in 1971. In addition, Saudi Arabia has a women artists group which is open to all women from Arab countries. The degree of participation is obviously different in different countries. The most active associations are in Egypt and Iraq. Egyptian women artists have had a long history of participating in the heated debates which have taken place at different points in the Egyptian art world and anyone visiting the Alexandra Atelier is impressed by the women's contributions at all levels. Men and women artists work in an atmosphere of mutual respect and refer to each other as comrade *Zamil* or *Zamila* thus defining art as a common 'cause'. In certain Arab countries, the artists address each other as brother or sister '*akh*' or '*al ukht*'.

In Iraq the Friends of the Arts (now the Iraqi Artists' Society) was established in 1941 and held its first exhibition in the same year. Although there is no record of women artists participating in this exhibition the

records do show that they soon became active members by serving on the executive board and organising events. The Iraqi women artists clearly benefited from these informal gatherings which they referred to as 'The Club'. They organised meetings with fellow artists and art critics, created opportunities for discussion and helped form the student-mentor relationships which subsequently played a significant role in art education.

Peer evaluation and networking is a rewarding experience for any artist at both local and international levels and this is beginning to be recognised with the growth of biennales, art festivals, workshops and conferences. When twenty six Arab women artists met in Washington DC at the opening of the *Forces of Change* exhibition in 1994 many had not met before or even known of each other.(Plate16) It was a memorable event which has served as a model for four further projects.

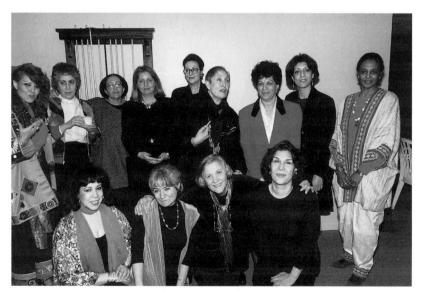

Plate 16 Group photograph at *Forces of Change* exhibition opening, February 1994, Washington, USA; back row, left to right: Mourinah Mosly, Samia Halaby, Mona Saudi, Hind Naser, Laila al-Shawa, Hugette Caland, Thuraya al-Baqsami, Balqees Fakhro, Amna Abdallah; front row, left to right: Houria Niati, Liliane Karnouk, Helen Khal and Princess Wijdan Ali

No less important are the critical discourses which surround the work of art. Reviews, articles, books, catalogues and other forms of documentation have become increasingly essential to the professional artist particularly in the international art world. This ongoing discourse on art, which is an integral part of an artist's education and professional development in the west, has little presence in the Arab world. The artists and gallery owners that I interviewed felt that there is little healthy criticism in the arts. In particular, it was generally felt that in order to be effective art critics needed to be familiar with the international art scene and to regularly visit other Arab countries and meet foreign artists. Equally, artists felt that they often lacked a supporting art review system. Some countries like the Lebanon had several experienced art critics and a well developed review system which includes weekly newspaper reviews such as those written by Helen Khal for the *Daily Star,* but most Arab countries lacked such structures. Instead, the artists relied upon local writers and poets and firmly rejected the idea that journalists should review their exhibitions as most newspapers do not have a resident critic but usually rely upon a freelance journalist who 'works' the gallery scene for a number of newspapers.

Art journals are equally unsatisfactory. Most Arab art journals publish one or two issues then disappear and currently there is not a single journal dedicated to visual arts in the Arab world. *Arts and the Islamic World* and *Eastern Art Report,* both excellent resource material are published in London, UK. Consequently, essays on art frequently appear in literary journals. Judging by the comments of artists, art critics and art educators, support at university level in the fields of aesthetics, art appreciation and art criticism could help overcome these problems but this depends on the necessary funds being available to maintain a competitive academic programme. Several countries such as Bahrain are aware of this need and are planning to open art departments to support these areas.

> *"The characteristic symptoms of the spiritual condition of our age is that the arts aspire, if not to take one another's place, at least reciprocally to lend one another power".*
> Baudelaire about Delacroix (1821-1867)

Unlike recent developments in the west which have seen the rise of the professional art critic, writers and poets are still the most respected art critics in the Arab world. There is a long established and significant relationship between many Arab intellectuals and artists while poets recognise elements in a painting that relate to their poetry and the artist's use of line, form and colour to construct the composition of the poem.[12] Poets and writers are like soul mates to the artists. Etel Adnan, who incorporated poetry by Fawziyya Abu Khalid into her artist's books describes this process as 'poetry that reverberates in art'.[13] The list of writers and poets who have written on Arab women's art or collaborated with Arab women is extensive and includes Adonis, Buland Al Haydari, Mahmoud Darwish, Jabra Ibrahim Jabra, Yusuf al-Khal and Nazik al-Mal'ika.

A further point that arose through the interviews was the view that Islamic art education has been neglected in the Arab world for too long. This issue has been recently examined by conferences on art. Although many women artists are inspired by Islamic art, few have studied it and there are hardly any Islamic scholars from the Arab world. Arab women artists are heirs to a rich tradition in the arts of calligraphy, textiles, pottery, weaving, leatherwork, brass work, mosaics, jewellery design, painting on wall panels and ceilings, frescoes and icon paintings, ceramics, glass, and embroidery. There is a mutual benefit for the artists and the crafts person in working together and local crafts need to be discovered by the artists and rejuvenated. Recent research shows that this is already taking place in certain areas such as weaving, jewellery and pottery where many women have pioneered such collaborations. Artists such as Safeya Farhat move easily between the categories of craft and fine art and, like many women artists in the Arab world, she sees the traditional arts as a support system which is always there to inspire and to be discovered.

Perhaps most basically, finding a workspace may be more of a problem for women artists than for men. Many women artists work full time and have to take care of their children and the daily household chores which does not leave much time for art. The artists with children often

12. Salwa Nashashibi, *Rhythm and Form, Visual Reflections on Arabic Poetry*, Lafayette, California, International Council for Women in the Arts, 1998
13. Salwa Nashashibi, *Interview with artist*, 1998

found it particularly difficult to work at home because of the many distractions and fears about the harmfulness of their paint materials. Many women had made the painful decision to quit and to return to art after their children had grown up. Others who could afford house-keepers and space were able to be more productive.

Evidently, women artists may or may not get the support they need in a patriarchal culture. Could the husband take care of the children after he comes home from work? Maybe, but often state-owned studios are in the worst neighbourhoods and far from residential areas. Limited by economic factors, few women in the Arab world have access to large studio spaces or to the sophisticated technology of computers and videos that have become commonplace in the west.

In order to reach her goals the artist needs space but she also needs to be assured that professionals are responsible for operating the various sub-systems that will help her achieve her potential. These include: framers, conservators, packing companies, curators, education specialists, museum administrators, public relations directors and designers. Such sub-systems are often taken for granted in the west but in some Arab countries they present major difficulties. Countries like Kuwait, Saudi Arabia, Bahrain, Qatar and Oman have consulted with museum professionals before embarking on their museum expansion programme and their museum systems work efficiently attracting visitors and artists.

In conclusion, it is worth noting that all of the support systems discussed here have some presence, however uneven and contradictory, in each country which makes up the Arab world. The efforts of gallery owners, businesses and private collectors, writers and poets, foreign cultural centres and foundations, and the respective governments have succeeded in laying the foundation for an effective art support system. Equally, it is evident that more work needs to be done on the support systems which disseminate art through public education, professional art support, conferences and journals, the writing of art critics and in the field of Islamic art education and the traditional

arts. All of these elements are interdependent and they work best if addressed concurrently so that they can contribute to the strong support systems which artists in the contemporary Arab world, as elsewhere, need.

The impressive number of women in art institutions is promising. It indicates that Arab women are not only making art but that they are also steering art into new and challenging directions.

APPENDIX

Art Sites: Galleries, Museums, Associations and Events

In the following lists state institutions are listed first, followed by non-governmental foundations, foreign cultural centres, private galleries, festivals and biennales and then art associations. When available the date of the first biennale is listed.

NB * Marks galleries owned and managed by women or art institutions with women directors.

- Information for these lists was gathered from the following sources: the respective country's Ministries of Culture, Education or Information; interviews with art professors, artists, art critics, gallery owners; cultural magazines (infrequent, only one or two dedicated to the visual arts); *Arts & the Islamic World* and *Eastern Art Report* magazines, published in the UK are both excellent resource material.

- Information on the Maghrib is based on visits to the region between 1989-1993.

- The list for private galleries in the Middle Eastern countries was gathered during a recent two-year residency in Jordan.

- Islamic or Coptic museums are included as they are an essential resource for art students.

- Courses in ancient art are offered at all listed universities.

 Art students are surrounded with ancient art, in many cases archaeological sites and museums are within walking distance of classrooms. However, a list of archaeological museums is beyond the scope of this essay.

- Information was not available for Arab countries not listed.

- Hotels, clubs and craft shops are popular venues, especially at times of economic and political crisis.

- The first Arab Biennale was held in 1977. Arab countries take turns in hosting this event. The Union of Arab Plastic Artists was formed in 1971.

- In Algeria art has almost ceased to exist. According to one artist 'we are simply out of art supplies, I sketch at home!'

ALGERIA
Musée des Arts Traditionals et
 Populaires d'Alger
Musée Nationale des Beaux-Arts, El
 Hamma* (est. 1930)
El Wassili Gallery du Palais de la
 Culture et des Arts, Oran

Associations
National Union of Plastic Arts

BAHRAIN
Art Centre, National Museum of
 Bahrain, Manama
Bahrain Art Centre
Bahrain Fine Art & Heritage Centre,
 University of Bahrain

Associations
MANAMA
Bahrain Art Society (Gallery),
 (est.1983)
Bahrain Contemporary Arts Society
 (Gallery), est. 1969
Bait Al Qur'an

Festivals
Annual Art Exhibition (est. 1972)

EGYPT
ALEXANDRIA
Alexandria Atelier*
Art Appreciation Palace
Museum of Contemporary Art
Municipality Museum of Alexandria
 (est. 1904)

CAIRO
Mahmoud Mukhtar Museum, Gezira
Mohammad Mahmoud Khalil
Mohammad Nagui Museum, Giza
Museum Dokki (19th Century
 European painting)
Museum of Modern Art, Gezira (est.
 1931)

Others
Coptic Museum, Old Cairo
Islamic Museum, Bab El Khalq

State Galleries & Other Institutions
The Centre of Arts, Akhnaton
 Gallery, Zamalek
The Faculty of Applied Arts, Giza
The Faculty of Fine Arts, Zamalek
The Gallery of Education for Art and
 Music, Dokki
Hannager Gallery, Opera House
 Grounds, Gezira*
Horizon I Gallery, Dokki
Horus Gallery at Faculty of Art
 Education, Zamalek
Ismailia Cultural Palace
National Centre of Fine Arts
 Opera House Gallery, Gezira
El Nile Gallery, Opera House
 Grounds, Gezira
The Round Gallery, Syndicate of
 Plastic Artists, Gezira
• There are also regional centres
for the arts in provinces outside
Cairo

Foreign Cultural Centres
Cairo Berlin Gallery, Bab Al-Louq
Cervantes Institute for Spanish
 Culture, Dokki
French Cultural Centre, Mounira
Goethe Institute, Cairo & Alexandria
Greek Consulate, Alexandria
Italian Cultural Centre, Zamalek

Egyptian Academy of Arts, Rome
 (est. 1927)

Private Galleries
Ahram Building Foyer
Arabesque, Dokki*
Atelier du Caire, Antikhana
Duroub Gallery, Garden City*
Ewart Gallery, American University
 of Cairo

Extra Gallery, Zamalek*
Espace Gallery, Downtown
Khan el Maghrabi Gallery, Zamalek
Monamak Gallery, Mohandessin
Mashrabiya Gallery, Downtown*
Ragab Gallery, Giza
Rare Books and Special Collections
 Library, Downtown*
Riash Gallery, Zamalek
Salama Gallery, Mohandessin
Sheba Gallery, Zamalek*
Sony Gallery, (photography),
 American University of Cairo
Townhouse Gallery, Dokki*
World of Art Gallery, Maadi*

Associations
Cairo Art Guild
Friends of Art Society
Friends of Museums Society
Higher Council for the Patronage of
 the Arts (est. 1927)
Society of Art Critics
Society of Fine Arts (est. 1921)
Society of the Friends of the Art (est.
 1923)

Festivals
Alexandria Biennale (est. 1960)
Alexandra Biennale for Mediterra-
 nean Countries
Cairo Biennale (est. 1982)
Egyptian International Print
 Triennale (est. 1993)
International Cairo Triennale For
 Ceramics (est. 1992)
Society of Fine Arts Alumni, Annual
 International Biennale of
 Cairo (est. 1984)
Youth Salon (est. 1988)

IRAQ
Saddam Arts Centre (formerly
National Museum of
Modern Art), (est.1962)

Al Rawaq Gallery (First director:
 Leila al-Attar)
Al Rouad Museum for Pioneer
 Artists (est. 1979)

Private Galleries
Ain Gallery
Abla al-Azzawi Gallery (Ceramics)*
Alweya Gallery*
Baghdad Gallery*
Dijla Gallery*
Hewar Gallery
Inana Gallery
Mahil el Saraf*
Naqqash*
Riwaq Risen Gallery
Wadad Orfali*

Associations
Baghdad Group
Iraqi Artists Society (former
 Friends of Art Society),
Gallery est. 1941
Iraqi Artist Union (semi-governmen-
 tal: governs other arts:
 theatre, music and
 visual arts; est.1960)

Festivals
Baghdad Biennale, (International;
 est.1986)

JORDAN
Amman Municipality Centre,
 Ras El Ein
Royal Cultural Centre

Foundations
(non-profit making,
non-governmental)
Darat al Funun, Abdel Hameed
Shoman Foundation*
Jordan National Gallery (The Royal
 Society of Fine Arts)*

Foreign Cultural Centres

Cervantes Institute
French Cultural Institute
Italian Cultural Centre

Private Galleries

Alia Fine Art Gallery
Baladna Art Gallery*
The Gallery (est. 1972) by Nuha
 Batshon*
Hamourabi Gallery*
Orient Gallery*
Orfali Gallery*

Associations

The Plastic Arts Association (Gallery)
The Royal Society of Fine Arts

KUWAIT

Dar al-Athar al-Islamiyyah, 1983
The Free Atelier (Al Marsam al Hur)
Kuwait National Museum, 1983
 selection of Modern Art
 (awaiting major rennovation
 after Iraq's invasion)

Private Galleries

A. Al-Adwani Gallery
Boushahri Gallery, Salmiya
Ghadir Gallery*
Sultan Gallery*

Associations

Hiwar (Dialogue)
Kuwait Society for Formative Arts
Kuwait Society of Fine Arts (est.
 1967)
Al-Muntada
The National Council for Culture,
 Arts and Letters (est. 1973)

Festivals

Kuwait Biennale, 1969
The Society of Formative Arts Annual
 Exhibition (est. 1968)

LEBANON

Beit el Dine Gallery*
Lebanese University Art Department
 Gallery
Sursok Museum
 (Beirut Municipality)*
UNESCO Palace

Others

Académie Libanaise des Beaux Arts
 (ALBA)
American University of Beirut,
 School of Architecture
 Gallery
Lebanese American University, Art
 Department*
Celicie: Armenian Orthodox Church
 Museum

Private Galleries

Agial Art Gallery
Alice Mogabgab*
Alwane Kaslik*
Basbous Sculpture Gardens,
 Rochana
Chahine Gallery
L'Entretemp*
Galerie Epreuve d'Artists*
Galerie Janine Rubeiz*
Galerie Hrair
Galerie Rochan*
Maraya Gallery*
Noah's Art Gallery
Varoujian Art Centre
Zaman Gallery

Foreign Cultural Centres

British Cultural Centre
French Cultural Centre
Goethe Institute
Institute Cervantes
Italian Cultural Centre

Associations

Lebanese Sculptures & Painters
 Association

Festivals
Rachana International Sculpture
 Forum
Sursock Museum Fall Festival of the
 Arts

MOROCCO
The Musée d'Art Contemporain de
 Tangier
The National Ceramics Museum,
 Safi

CASABLANCA
Alif Ba Gallery
Charfi Art Gallery
Espace Wafa Bank
Fine Art Gallery
Gallery Nadar
Meltem Gallery
Museum of ONA Foundation

RABAT
Galerie Bab el Rouah
Musée des Oudayas
National Gallery of Bab
Rouah Marsam Gallery

Foreign Cultural Centres
American Cultural Centres &
 Library: Casablanca, Rabat,
 Tetouan, Tangier
British Council, Casablanca
French Cultural Centre, Rabat,
 Casablanca
Goethe Institute, Casablanca
Spanish Library, Tetouan

Association
Moroccan Fine Art Society

Festivals
Asilah Cultural Festival, Morocco
1978

OMAN
The Omani Atelier of Fine Arts,
 Muscat

Private Galleries
Yiti Art Gallery

Foreign Cultural Centre
The British Council

Associations
The Cultural Club, Muscat
Oman Fine Arts society
Youth Free Atelier

Festivals
Annual Exhibitions (est. 1980)
Biennale for Youth, Muscat (est.
 1988)
Muscat Biennale (est. 1988)

PALESTINE
Department of Cultural Affairs,
 Gaza (exhibition hall)
Popular Art Centre, Ramallah

Foundations (non-profit making, non-governmental)
Khalil Sakakini Cultural Centre,
 Ramallah*
Shawa Cultural Centre, Gaza*
Al-Wasiti, East Jerusalem*

Foreign Cultural Centres
British Council
French Cultural Centre, Jerusalem,
 Ramallah, Nablus, Gaza

Private Galleries
Anadiel Gallery, The Old City,
 Jerusalem
Two new restaurants in Ramallah
 exhibit Palestinian art

Associations
General Palestinian Fine Arts Union

QATAR
The Free Atelier, Doha
Al Jassrah Cultural Club
Qatar Museum

Festivals
Annual Art Festival (est. 1972)

Associations
Qatari Society of Fine Arts (Gallery),
(est. 1980)

SAUDI ARABIA
The State supports annual exhibi
tions and art societies'
programmes

Private Galleries
Arabian Collections Gallery
Arab Heritage Gallery, Khobar*
Art Line Gallery, Riyadh
Dhahran Art Group Centre
Gallery Rochan, Jeddah
Ibda Gallery, Madina
Rida Art Gallery, Jeddah

Festivals
Annual Art Exhibition (est. 1978)
Saudi Arabia Festivals: Janadriya

Associations
Eastern Province Women Artists'
Group
House of Saudi Arts (Dar al-Funun
al-Saudiya, est. 1980)
Saudi Arabian Society for Culture
and Arts, branches in
Damam, Jeddah & Al-Ahsa

SUDAN
The National Museum of Sudan,
Khartoum

SYRIA
Aleppo Museum (est. 1974)
The National Museum of Damascus,
(Ministry of Culture*, est.
1965)

Private Galleries
Gallery Atassi *
Gallery Kosah
Gallery Al-Saayed
Ishtar Gallery
Shora Gallery

ALEPPO
Atassi Gallery*
Al-Qawaf Gallery
Al Sayed Gallery

Foreign Cultural Centres
The French Cultural Centre
Goethe Institute

Festivals
Fine Arts Directorate,
Fall and Spring Exhibitions
Latakia Biennale

Associations
Fine Arts Association
Fine Arts Trade Union

TUNISIA
Carthage Centre*
Centre d'Art Vivant de la Ville de
Tunis, Ministry of Cultural
Affairs
Maison des Arts, Tunis
Musée d'Art Moderne, Tunis
Musée Bordo, ceramics
Ruaq al-Sahreef, Sidi Bou Said
Sidi Bou Said Museum
Yehya Centre for the Arts

Private Galleries
Akhbar Gallery
Galerie Kalyste
Irtsam Ruaq

Foreign Cultural Centres
Italian Cultural Centre
French Cultural Centre

Associations
Fine Arts Society

Festivals
International Biennale, Tunis (est. 1985)
Carthage Youth Festival for the Arts, Tunisia
Annual Festival of Arts, Sfax, Tunisia
Annual Art Festival, Qairauan, Tunisia

UNITED ARAB EMIRATES
(ABU DHABI, AJMAN, DUBAI, FUJAIRAH, RAS Al KHAIMAH, SHARJAH, UMM Al-QAIWAIN)

ABU DHABI
Abu Dhabi Cultural Foundation

Private Galleries
Zeidan Gallery

DUBAI
Dubai Arts Centre

Private Galleries
Al Multaqa Exhibition Suites at the Dubai World Trade Centre
Green Art Gallery *
Majlis Art Gallery
Aati Gallery

Festivals
Dubai International Art Centre holds Annual Art Festival (est.1994)

SHARJAH
Sharjah Art Museum
Sharjah Cultural Centre
Sharjah Heritage Museum
Sharjah Islamic Museum

Foreign Cultural Centres
The British Council
Alliance Française

Art Festivals and Biennale
Abu Dhabi Cultural Foundation's Annual Art Exhibition (est. 1985)
GCC Annual Youth Exhibition
Gulf Cooperation Council (GCC) Biennale (est. 1976)
Dubai Annual Shopping Festival incorporating art exhibitions (est.1995)
Sharjah Cultural Centre Annual Art Exhibition (est. 1987)
Sharjah's International Arts Biennale, Sharjah (est.1993)

Art Associations
UAE Society of Fine Arts (est. 1980)
Emirates Fine Arts Society
Dubai Arts Society
Gulf Friends of the Art Society

YEMEN
Department of Plastic Arts, Ministry of Information

Art Associations
General Association of Yemen Fine Artists (est. 1987)

UNIVERSITIES AND ART COLLEGES

ALGERIA
Ecole Supérieure des Beaux-Arts,
 Algiers, (est. 1881)
Higher Institute of Fine Arts Union
 of Plastic Artists
National School of Fine Arts, (est.
 1920)

BAHRAIN
Bahrain University: Art Education
 Diploma (an art department
 is in the planning
 stage)

EGYPT
Alexandria University, Faculty of
 Fine Arts
American University of Cairo, Dept.
 of Visual and Performing
 Arts (minor in art)
Helwan University
 Faculty of Fine Arts, (est.
 1908) affiliated with
 Helwan Faculty of Applied
 Arts, Faculty of Art Education
Higher Institute of Art Criticism
Higher Institute of Child Art
Institute of Art Education, Luxor
Institute of Vocational Art Al Minia
 University Faculty of Fine Arts

IRAQ
The Art Education College, Hila
 (Kufa University)
College of Fine Arts, (formerly the
 Academy of Fine Arts, est.
 1962)
College of Fine Arts, Babil
Faculty of Arts, (est. 1937)
House of Heritage and Popular
 Arts
Institute of Applied Arts
Institute of Fine Arts, (est. 1940)
Institute of Fine Arts, Mosul

Sulaimania University, Art Dept.
University of Basra, Art Dept.
University of Mosul

JORDAN
Institute of Fine Arts, (est. 1970) -
 Diploma
Institute of Islamic Art and Architec-
 ture, Al Bayt University,
 Mafraq, Jordan - courses
Yarmouk University, Fine Arts
 Department, Irbid, (est.
 1980) - Degree

KUWAIT
Teachers Institute, (est. 1960s) -
 Diploma

LEBANON
Académie Libanaise des Beaux
 Arts (ALBA) - Degree
American University of Beirut -
 minor
Institute of Fine Arts, Lebanese
 University - Degree
Lebanese American University -
 Degree

LIBYA
Al Fatih University,
 School of Fine Arts
 School of Applied Arts
 School of Art Education
Garyunis University, Benghazi
Omar Al Mukhtar University,College
 of Art and Architecture,
 Darna
Tripoli Arts and Crafts School

MOROCCO
Ecole des Beaux Arts, Casablanca
Ecole des Beaux Arts, Tetouan
National School of Architecture -
 art courses
School of Applied Arts, Rabat

OMAN

Courses in art education, painting, ceramics, sculpture and graphic art are elective courses at colleges and universities. Most students study overseas.

PALESTINE

Beir Zeit University, Beir Zeit - Minor
Al Najah University, Nablus - Degree

QATAR

College of Art Education, Qatar
 University
Most students study overseas

SAUDI ARABIA

Centre of Fine Arts in Jeddah -
 Courses
Institute of Art Education,
 Riyadh (est. 1965) - Diploma
King Abdul Aziz University, Jeddah
 (Art Education) - Degree
Teacher's College, Diploma
Um-el-Qura, College of Art
 Education, Jeddah - Degree

SUDAN

College of Fine and Applied
 Arts, Sudan University of
 Science & Technology,
 Khartoum, (est.1950) -
 Degree

SYRIA

Damascus University, (est. 1959),
 College of Fine Arts -
 Degree

TUNISIA

Ecoles d'Arts de La Méditerrane
School of Fine Arts, (est. 1963) -
 Diploma
Technology Institute of Art and
 Architecture, Tunis - Degree

UNITED ARAB EMIRATES

(ABU DHABI, AJMAN, DUBAI, FUJAIRAH, RAS AI KHAIMAH, SHARJAH, UMM AL-QAIWAIN)

Courses in art education, painting, ceramics, sculpture and graphic art are elective courses at colleges and universities. Most students study overseas, scholarships are available for UAE nationals.

ARAB WOMEN ARTISTS' EXHIBITIONS

1975	*Egyptian Women in Half a Century* for the International Year of Women, Ministry of Culture Fine Arts Gallery, Cairo
1976	*Iraqi Women Artists' Exhibition, Kuwait, Madrid, Vienna, Italy*
1980	*National Arab Women Artists' Exhibition,* Baghdad, Iraq
1983	Royal Cultural Centre, Amman
1987	*Arab Women Artists in the UK,* Kufa Gallery, London
1990	*Three Women Painters: Baya, Chaibia, and Fahrelnissa Zeid,* Institute du Monde Arabe, Paris
1990	*Iraqi Women Artists' Exhibition,* Brazil
1992	*Tunisian Women Artists,* Hammamet Centre De Recher-che De Documentation et l'information sur la Femme (CREDIF)
1992	*Egyptian Women Artists,* Cairo
1992	*Iraqi Women's Festival of Culture,* Kufa Gallery, London, UK
1994-5	*Forces of Change: Women Artists of the Arab World,* USA tour. International Council for Women in the Arts, California
1995	*Egyptian Women Artists,* Beijing, Alliance for Arab Women
1996	*Sharjah - Arab Women Artists,* Sharjah
1996	*Women Artists of the Islamic World,* Islington Museum Gallery, London, UK
1997	*Lebanese American University Alumni Artists,* previously known as Beirut College for Women
1999-2000	*Dialogue of the Present, the Work of 18 Arab Women Artists,* UK tour

Dialogue of the Present
18 Contemporary Arab Women Artists

**Diverse
Bodies of
Experience**

Artists and Audience

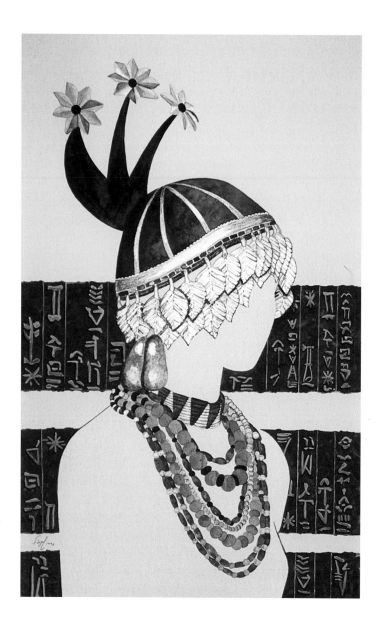

Plate 17
Firyal al-Adhamy
Ur Princess, 1993
Acrylic and gold on paper
72 x 52cm

Plate 18
Firyal al-Adhamy
Looking Forward, 1997
Acrylic and watercolour on paper
75 x 55cm

Plate 19
Malika Agueznay
Sérénité 1993
Copper etching
39 x 60cm

Plate 20
Malika Agueznay
Peace, (Salem), 1997
Zinc etching
29.5 x 22.5cm

Plate 25
Rima Farah
Red and White Letter, 1997
Carborundum etching
55 x 55cm

Plate 26
Rima Farah
Blue and Gold, 1997
Carborundum etching
55 x 55cm

Plate 27
Maysaloun Faraj
Eruptions ... of the Soul, 1994
Glazed stoneware with onglaze and gold metal
Height 18cm, width 26cm

Plate 28
Maysaloun Faraj
Sisters of Black and Gold, 1988
Glazed stoneware with onglaze and gold metal
Height 57cm, width 28cm
Collection Raya Jallad

Plate 29
Batool al-Fekaiki
Ecstasy, 1993
Oil on canvas
120 x 100cm

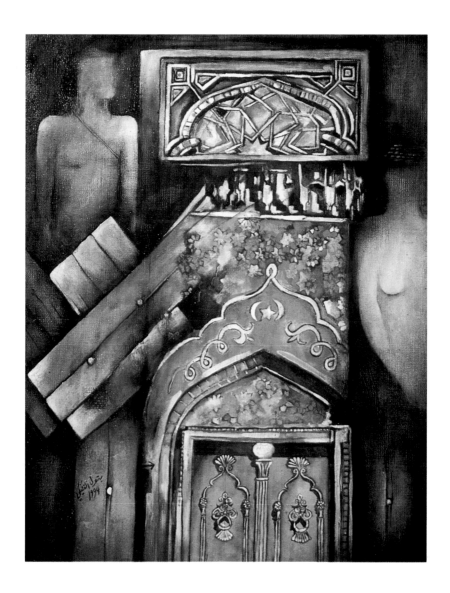

Plate 30
Batool al-Fekaiki
Closed City, 1997
Oil on canvas
80 x 70cm

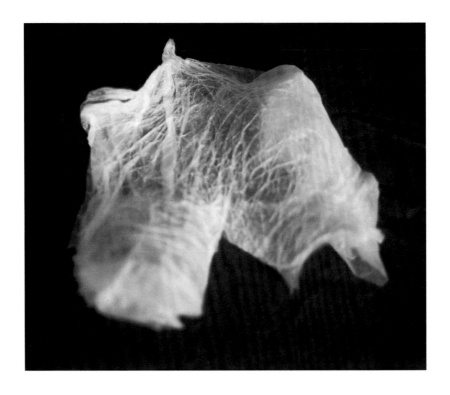

Plate 31
Saadeh George
Today I Shed My Skin: Dismembered and Remembered, 1998
Mixed Media
Detail of installation, life size

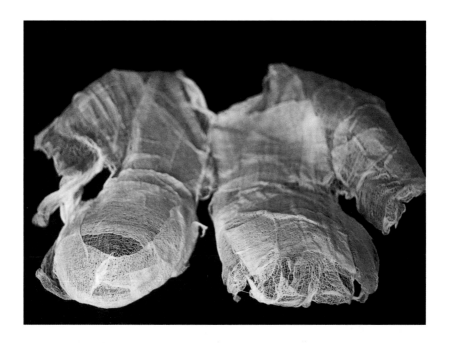

Plate 32
Saadeh George
Today I Shed My Skin: Dismembered and Remembered, 1998
Mixed Media
Detail of installation, life size

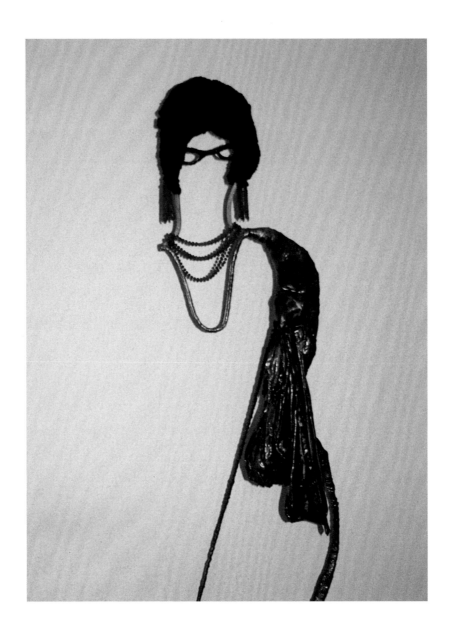

Plate 33
Mai Ghoussoub
Diva, 1998
Iron, aluminium, wool and resin
200 x 50 x 30cm

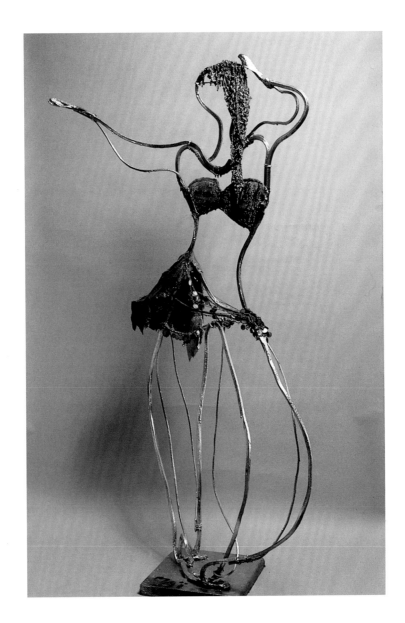

Plate 34
Mai Ghoussoub
Belly Dancer, 1994
Aluminium, resin and cloth
155 x 30 x 15cm

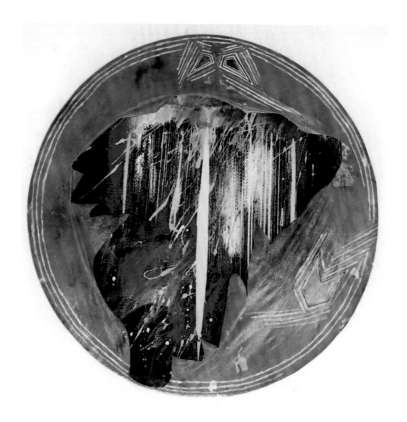

Plate 35
Wafaa El Houdaybi
Meknès I, 1998,
Mixed media; thread and paint on stretched leather
100cm diameter

Plate 36
Wafaa El Houdaybi
Meknès II , 1998
Mixed media; thread and paint on stretched leather
Top: 50cm diameter Bottom: 40cm diameter

Plate 37
Kamala Ibrahim Ishaq
Images, 1985
Oil on canvas
87.5 x 50cm

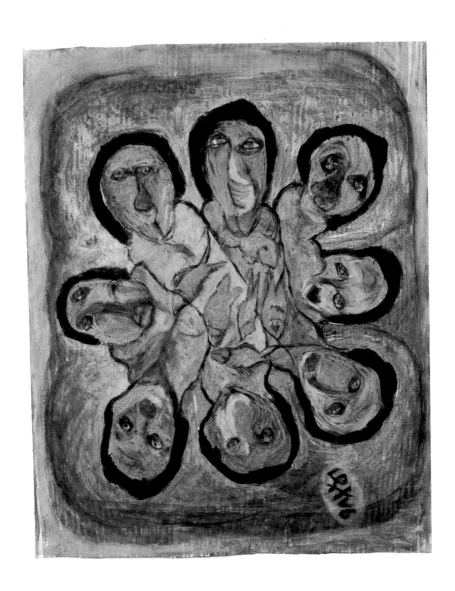

Plate 38
Kamala Ibrahim Ishaq
Reflection at Dinner Table, 1998
Acrylic and coloured ink on paper
50 x 40cm

Plate 41
Sabiha Khemir
Shipwreck 1
Illustration for book cover *The Island of Animals*, 1994
12.5 x 32cm

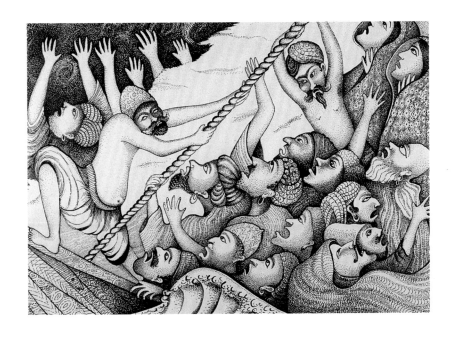

Plate 42
Sabiha Khemir
Illustration for *The Island of Animals*, 1994
Quartet Books, London 1994
20.8 x 28.8cm (Private collection)

Plate 43
Najat Maki
Untitled 1, 1998
Mixed media and oil on canvas
128 x 95cm

Plate 44
Najat Maki
Untitled 2, 1998
Oil on canvas
128 x 95cm

Plate 47
Azza al-Qasimi
No Strings Attached III - Guitar, 1998
Watercolour and collage on paper
54 x 74cm

Plate 48
Azza al-Qasimi
Geometrics I, 1997
Etching and collage
75 x 54cm

Plate 49
Zineb Sedira,
Don't Do To Her What You Did To Me, 1998
Video still

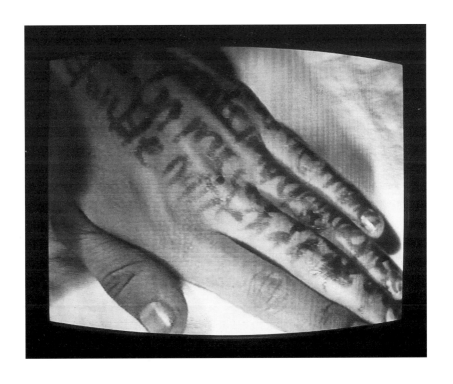

Plate 50
Zineb Sedira,
Untitled, 1996
Video still

Plate 51
Laila al-Shawa
Children of Peace, 1995
Part of the Walls of Gaza installation
Silkscreen on canvas
100 x 230 cm

Plate 52
Laila al-Shawa
Children of War, 1992-1995
Part of *The Walls of Gaza* installation
Silkscreen on canvas
100 x 230cm

FIRYAL AL-ADHAMY

I was born in Baghdad, Iraq where the rich colours of hand woven textiles brought from the villages, the arts of jewellery making and detailed wood carvings are an integral part of daily life. These oriental surroundings triggered my senses and enhanced my desire to contribute to this rich and colourful artistic heritage. Encouraged by my father, who has a keen appreciation of the arts, and other friends, I decided to become an artist. Though my academic studies in art were limited to a few brief courses I attended in London, these helped to develop my technical skills.

The beauty of the Arab and Islamic arts of traditional costumes, textiles, jewellery and other handicrafts are central to my work. While my paintings have an artistic value, which I enjoy, they also set out to document and, in a way, preserve items which are gradually disappearing from our heritage.

I choose objects which are geographically and historically scattered. My sources therefore vary from objects found in small villages, in an oriental section of an international museum, or within the pages of history books in public libraries or in private collections. Detailed observation of these objects is essential and, in certain instances, I may need to use the camera to capture the item before my eyes for in a glance I could lose it, perhaps, forever.

In my works I basically aim to reproduce the item concerned in very minute detail and to achieve the utmost degree of precision. To do so I usually use acrylic or watercolour paints, alongside other mediums such as gold leaf and Chinese black ink for the small details.

I see my work as part of a continuing tradition where detail and decoration is uppermost in the every day experience of Arab culture. In this sense, although unintended, my work can be seen as carrying

feminine traces which may be reflected in the precision acquired whilst minutely detailing the texture of a Bedouin dress or an old ornament.

My works usually attract a wide range of audiences, both in the West and in the Middle East. Most are looking for a perfection in these works and this adds another dimension of challenge to my profession.

Plate 53
Firyal al-Adhamy
Ur Royal Princess' Head Band, 1998
Acrylic and gold on canvas
35 x 25cm

Firyal is a painter who has gained a wide reputation for fine depictions of jewellery in watercolour and acrylic. Sumptuous embroideries, Arab and Bedouin jewellery, sheet metal filigree work, ornate trappings of Arab steeds, necklaces and pendants come alive in a riot of colour and detail in her paintings. Firyal's highly decorative and beautifully composed paintings, with their delicate outlines worked in glowing acrylic, gold leaf and silver paint, reveal her acute sense of detail and love of traditional and antique Islamic works of art.

Firyal graduated from Baghdad University. Here she initially took up painting as a hobby, first working from her own collection of Arab jewellery, and then widening her range of subjects through research in museums and diverse geographical locations. She admires the skills employed by Arab craftsmen. Sumerian carving, Iraqi jewellery, Arabian khanjars (swords), Yemeni janbiyas (daggers), Palestinian jewellery, Tunisian belts and Najdi earrings of gold all provide the basis of her painstaking work.

While delighting in this rich Arab heritage, Firyal is also aware of its fragility and vulnerability. Painting is her way of capturing and preserving the continuities of this heritage in a modern world.

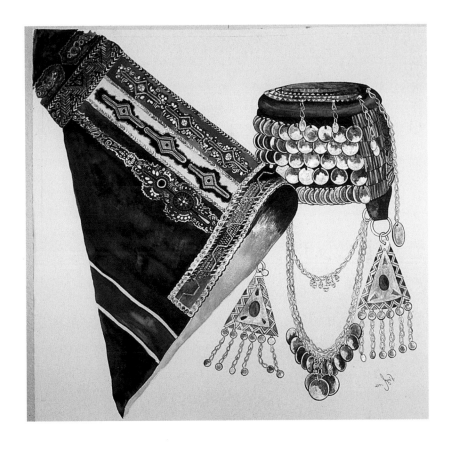

Plate 54
Firyal al-Adhamy
From Jerusalem, 1992
Acrylic and gold on canvas
25 x 35cm

MALIKA AGUEZNAY

My works are both image and writing and contained within them is my artistic statement. They do not need a halo of words surrounding them.

Plate 55
Malika Agueznay
Le Soleil et L'étoile, 1997
Zinc etching
39 x 60cm

*If painting is essentially feminine, is the woman artist the embodiment
of the feminine in its broadest sense?*

The two essential elements of Malika Agueznay's work are her
calligraphic marks and her use of seaweed imagery. Calligra-
phy is both a form of writing and the pleasurable act of writing
the body across the supporting surface of the canvas or paper. Simi-
larly, the seaweed images function as figurative elements while also
referring to the basic forms of calligraphy. More precisely one could
say that the seaweed imagery becomes handwriting or even a text.
Seaweed has multiple associations:

> "It ensures the safety of sailors and eases childbirth. Plunged in
> its marine element, the reservoir of life, seaweed symbolises a
> limitless, indestructible life, an elementary life and a primordial
> nurturer". *(Dictionary of Symbols)*

Agueznay uses the symbolism of seaweed in two ways. Firstly, as a
calligraphic element, possibly of Berber or Arabic origin; secondly, as
a conscious intervention within a calligraphic tradition which has usu-
ally been confined to pure decoration. Through her work Agueznay
presents the spectator with a new Moroccan perspective on this tradi-
tional art form where the body of the woman artist is permanently
inscribed on its surface. The sensuousness of the act of mark-making
is evident while the feminine body is subtly embodied in the visual
forms. All of Agueznay's works are etchings or reliefs and these quali-
ties are present even in her paintings. In Arabic engraving is 'nagsh'
or 'hafr'. 'Nagsh' literally means 'leaving one's mark in the ground'
while 'hafr' comes from 'burrowing' into the earth ... until it reveals its
secrets. It is as though the tradition of engraving does not surrender its
richness unless one is ready to search and find the treasure within it.
The seaweed and the feminine encapsulate this treasuring on a sym-
bolic level. The feminine both safeguards and perpetuates this for
future generations. Thus the feminine body, inscribed and etched into
the work of Agueznay, becomes part of the continuing tradition of
calligraphy in contemporary Morocco.

Moulim El Aroussi (translated from French text by Saadeh George)

JANANNE AL-ANI

My early work explores issues around sexual and gender politics and the representation of women, in particular the fetishised oriental woman in western art and photography. The issues at the heart of the differences between east and west are the ones that interest me and inform my work.

My interest in Orientalism was the beginning of a long process of re-examining my Arab cultural background which I had rejected out of hand on arrival in Britain. In 1991 the war in the Gulf brought me face to face with the issue of my own cultural identity with a great jolt, and it was out of this experience that a body of work emerged in which I attempted to explore the events that occurred during and after the conflict. I placed the images I used in a cultural, historical and personal context in order to offer my views on a highly complex and multilayered situation.

Most recently I have been exploring a number of ideas that have emerged from studying the representations and descriptions of Middle Eastern women by late 19th and early 20th century European photographers, travellers and writers.

I am currently working towards the production of a video installation, *One Thousand and One Nights* which explores the subject of memory through the use of family history and story telling.

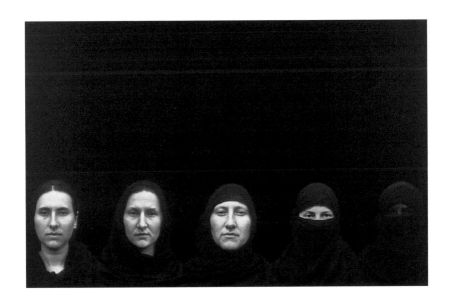

Plate 56
Jananne Al-Ani
Untitled (Veils), 1997
Still from tape/slide projection installation

Jananne Al-Ani was born in Kirkuk in the north of Iraq in 1966 to an Arab father and an Irish mother. She arrived in Britain in 1980 with her mother and three sisters. Writing of her work, Jananne Al-Ani has observed that "it has been informed by my experience of being a mixed race woman, of growing up in the Middle East, of moving to Britain at the age of thirteen, of the breakdown of my parents' marriage and of the intense relationship I have with my mother and three sisters". [1]

Jananne Al-Ani has been exhibiting since 1987. She began working as a painter and gradually moved on to produce photographic installations, audio-visual, film and video works. More recently, she has worked with the computer, using photographs, video and sound as source material. She gained a Fine Art Diploma at the Byam Shaw School of Art in 1989 and recently graduated with an MA in photography from the Royal College of Art.

In her early photographic installation works, Jananne Al-Ani examines the issues of sexual and gender politics and the representation of women, particularly the fetishised oriental woman in western art and photography. By appropriating imagery from Orientalist paintings, she explores "traditional representations of women in western art and in advertising in this era of shopping culture. The piece which superimposes a green grocer's shop window over *The Turkish Bath* by Ingres, the curvaceous fruit wonderfully echoing the voluptuous women, takes a light-hearted look at serious issues of eroticism and objectification of women". [2]

The Gulf War of 1991 led Jananne Al-Ani to examine her cultural identity and it was out of this experience that a body of work emerged in which she constructed images in a cultural, historical and personal context in order to offer her view on a highly complex and multi-faceted event. As Val Williams has observed, Jananne Al-Ani "uses photography to juxtapose views of her Iraqi homeland (employing war reportage, historical documentation and the family album) to create a composite picture which offers no explanations and no easy solu-

1. Artist's statement, 1997
2. *Fine Material for a Dream* - Emma Anderson, Harris Museum and Art Gallery, Preston, 1992

tions to the dysfunction which comes not from within the family, but from the ambitions of politicians and the turmoil of war". [3]

In the course of recent research, Jananne Al-Ani has been examining the representation and description of Middle Eastern and North African women by late nineteenth and twentieth century western artists, photographers and writers. Of particular interest are the studio portraits, which range from the ethnographic to the pornographic and which employ the theatrical use of backdrops, props and costumes in order to construct fantastic tableaux exposing the western fascination with the veil.

Writing of Jananne Al-Ani's recent video and tape slide installations, Val Williams observes that "The way to an understanding of Jananne Al-Ani's work, which is so multi-levelled and multi-layered, lies perhaps in the realisation of the ways in which she, as an artist, has absorbed and reworked this history. During the course of her research, she encountered photographs from the turn of the century in which the conventions of the studio portrait were used to present the fetishised Middle Eastern woman to the western gaze. Her own contemporary work is an exploration of what one could call a collaborative and mutual gaze, a dialogue which not only interrogates the past, but also examines the present. She looks closely not only at the ways in which photography has contributed to western notions of 'the Other' but also at our contemporary fascination with the meanings and nuances of the photographic image".[4]

"In her works of the 1990s, which have included video pieces, photographs and double image duratrans, Jananne Al-Ani has entered into a highly conceptual, yet deeply intimate dialogue to discuss issues about gender, race and relationships. By the use of filmic techniques, she underlines the shifting nature of the discourse and has dwelt on subtleties and ambiguities, while maintaining her politics (both personal and public) intact. By her use of still photography, she has acknowledged a history of representation, both public and private". [5]

3. *Who's Looking at the Family?* Val Williams, Barbican Art Gallery, 1994
4. *Modern Narrative: the Domestic and the Social,* Val Williams, 1997
5. *Modern Narrative: the Domestic and the Social,* Val Williams, 1997

THURAYA AL-BAQSAMI

I am a Kuwaiti woman artist who first trained for two years in Cairo and then in Moscow for a further seven years where I received a Masters Degree in Graphic Art and Book Illustration. I have spent six summers in London attending graphic print workshops and additional craft workshops in pottery and batik as well as attending writing workshops in poetry and short stories. These constantly influence my work.

I usually use a variety of media and enjoy creating different bodies of work. My paintings are generally done in acrylic while my print work uses relief print, lino cut, collograph, monoprint, screen print, etching and lithography. In addition, I also produce drawings, illustrations and ink and print collages.

Sketches are an essential part of my working process. They provide a means to generate ideas and to help me articulate my thinking. I never copy photographs or directly imitate the exterior world. Instead, I reach into my thoughts to find the basis for the works. Often it may take some time before a subject is found and the sketches make the image clearer for me. Although the idea for a project exists from the beginning, it never fully develops until after I start working. In this way the sketches are like the skeleton of my future painting, a sort of scale for my work, while the colours develop as I paint.

I work very quickly and it does not take much time for me to finish a painting. I never copy my work or do a work twice. If I do one piece of art it will be unique. In the process of painting I get excited by the use of various techniques and sometimes I develop special methods such as using acrylic and masking glue which I only discovered by accident when I was doing silk painting.

The techniques I use are always western but they are combined with

my experience of an oriental art tradition. Most of the motifs are derived from Arabic folklore and I have always been drawn to Arabic mythology and popular Arabic design, especially the use of symbols. The hidden symbolism, or 'black magic', found in urban Arab architecture, furniture, walls, clothes, tattoos and henna designs have had an influence on my work. All of these contribute to the atmosphere and style of my painting.

One of the subjects constantly present in my paintings is that of being a woman in my country. I am concerned with the relationship of women within Arab society, the environment, human relations in general and the continuing inspiration offered by Arab mythology and folklore.

My identity as a woman from an Arab country, especially as a woman artist in Kuwait, and my cultural heritage are important to me. Although there are no obvious obstacles to my profession as a woman artist in my society, I cannot express myself as an artist as openly as I would wish, particularly given the recent debates about the freedom of women. Opinions on what women should do or be are rife.

Having said this, my Arabic heritage and my background as a writer and a journalist help me to be brave in my art work. Support from my family, husband and friends encourages me tremendously. As a rather famous artist in my country, in which the number of other women artists is small, the scale of my audience extends from the general public to local artists and international and national art critics.

B orn in Kuwait, trained in Cairo and Russia, Thuraya al-Baqsami then lived in Senegal and Zaire in Africa for several years before returning to her home country in 1985. The experience has had a profound effect on her work and she continually draws on the rich symbolism of both Russian and African folklore and mythology while also acknowledging her Arab cultural inheritance.

True to these cultural traditions, and in contrast to western attitudes, al-Baqsami refuses to distinguish between fine art and craft and uses a variety of media including painting, printmaking, ceramics and batik. Her work also refuses other hierarchical distinctions. Love symbols from traditional Russian folklore co-exist and share the same space as angels drawn from Russian icons and the marks of Arab calligraphy. Neither the secular or the religious dominate and the surface becomes a place of meeting and dialogue.

Al-Baqsami is acutely aware of the need for such dialogues. She witnessed the suffering and horror of the Iraqi invasion of Kuwait and the imprisonment of her husband in a detention centre north of Basra. Equally, as a mother of three daughters, she is alert to the specific problems women currently face in the Islamic world and frequently addresses these issues in her writing both as a journalist and novelist. In particular, "I fear some Arab women are losing their enthusiasm and hope for the future. So many voices are now asking Arab women to go back into the home, to care for their children and to give up their jobs".[1]

Al-Baqsami's recent paintings directly engage with this fear and depict images of Islamic women covered by an *abaya*, a cloak-like wrap, and the *burqa* or head cover. For al-Baqsami these are potent symbols as the "women in my paintings are not only covering up their bodies but they are also covering their souls. They are fearful of losing their freedom to express their humanity".[2]

In the 1998 *Blue Dreams* series, the three canvases act like a triptych and focus on the passing of time, while each individual canvas is

1. ' An artist's view of Kuwait' in *Kuwait:* 28, August 1996, p4
2. Ibid p4

further divided into three zones with woman occupying the middle zone of the present. The body of the woman is invisible, covered by the cloak and, together with the symbol of the plant, they become signifiers of the passage of time from youth to old age, from fertility to barrenness. The centralised image of the rich blue, jewelled covering gives way to that of the decentred and unadorned and finally to the pale and marked outer clothing. For al-Baqsami, the woman is in a 'waiting position', hemmed in by the confused signs which symbolise Arabic culture and "the worries of the coming autumn and the leaving of spring - of getting older".[3]

Such an active presence in both the Arab and the international art world is much needed.

Fran Lloyd

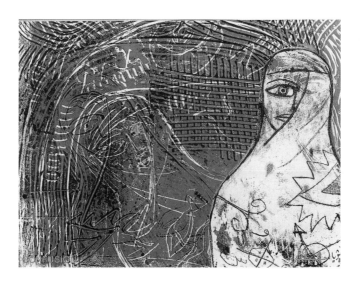

Plate 57
Thuraya al-Baqsami
Confusion, 1997
Coloured monoprint
30 x 40cm

3. Correspondence with author, 1998

RIMA FARAH

I have always worked as a printmaker and long dreamt of using this medium to render the letters of the Arabic script visible. In 1995 I embarked upon this project.

My childhood vision of letters saw them as incomprehensible, cut into stone, punched onto leather, gilded, waxed, or inked onto paper, parchment or silk. I felt the need to recapture these elusive memories of broken letters, whole letters, smooth or textured letters, upside down, all jumbled together and set in squares.

These six images see this process of rediscovery in progress. Out of such beauty of form a statement or visual gesture is created that carries a message of its own beyond sound and literacy. Is there a point where a letter ceases to be a fragmentary symbol of language and becomes instead a visual feast?

The fascination continues as the present reveals so much more to explore. It might be too easy to make it a game, to play with it, but that would be an indulgence. Instead, it has become a constant source of enquiry in my work.

The paper's sensuality is the final ingredient in these prints. The silken quality of red mulberry paper is set in the sweep of a letter defined by black relief rolled ink. The techniques of printmaking are ideal to express the elemental forms that dictate these compositions. The methodology in the working process is equally sympathetic. There are echoes of stonemasonry and leather working in the physical carving and forming of the printing plates. Simultaneously, there is the precision and quality of the quill or brush, and even the shadows cast across coloured inks by embossed forms are like light falling on a mosaic panel.

I do not wish to define myself as working in traditions, though obviously educational and cultural influences are unavoidable. Facts are facts: I am an Arab woman, living in the UK, but I feel no extended responsibility because I am an artist.

My priority as an artist is to the relationship formed between the work and the viewer irrespective of considerations of gender or origin.

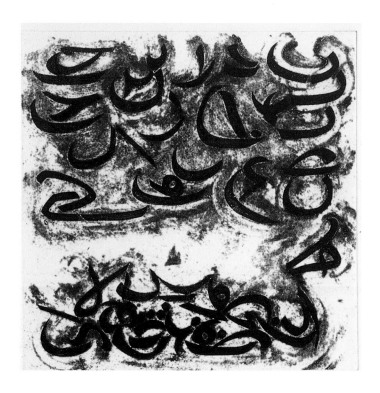

Plate 58
Rima Farah
Alphabet II, 1994
Etching
55 x 55cm

Rima Farah is a Syrian artist living in the UK where she frequently works collaboratively with the British artist, Kevin Jackson.

In wishing to emphasise the relationship between the work and its audience Farah draws on traces of tradition and memory from both Middle Eastern and western cultures. Her play on the forms of Arabic script running to the edges of, or being contained within, the limits of the frame remind us of the merging of the literate and the decorative both in the art, architecture and writings of Islam, and in the dramatic starting point of the decorated letter in the medieval manuscript, invariably the precursor to a valued text.

In exploiting the controlled and controlling surfaces of the print form, Farah creates an expressive tension between partially obscured and often dramatically dominant forms. She commutes between a light stream of consciousness style where rolling romping fragmented letters pour off the edges of the picture plane, and a single forceful incursion into the visual consciousness drawn up from the base surface in jewel-like colour.

Calligraphy is seen by Arab artists as the connecting tissue throughout the history of Islamic art. As Rima Farah deconstructs its possibilities through the cultural and decorative, the abstract and the particular, she mediates gently but intelligently on the potentials for art within her lived experience of two very different cultures.

Melanie Roberts

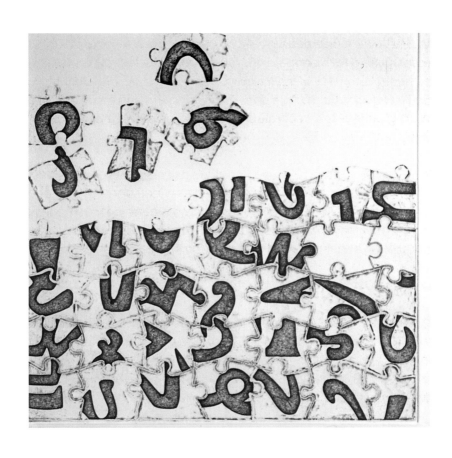

Plate 59
Rima Farah
Jigsaw 11, 1994
Etching
67.5 x 67.5cm

MAYSALOUN FARAJ

I was born in the USA in 1955 to Iraqi parents. I returned to live in Baghdad at the age of 13 and continued my studies gaining a B.Sc. in Architecture from the University of Baghdad in 1978. I have been living in the UK since 1982. The majority of my life has been spent in the 'west'. Nevertheless, my roots run as deep as the rich soils of Mesopotamia, the 'cradle of civilisation'. I am an Iraqi, an Arab and, above all, a Moslem woman living in a western world. I consider myself fortunate to have had the opportunity of this east (Traditional) - west (Modern) upbringing.

> "He who has lost precious gold, in the gold market find it may he. He who has lost a loved one, a year will pass and begin to forget may he. But he who has lost his home-land, a homeland find, where would he?"
> *Translation from an old Iraqi folk song*

Clear blue skies, blazing sun light, star-studded moonlit velvet nights. Elegant date palms, pomegranates, orange and lemon blossom drenched with the sweet waters of Dijla and Furat. 'Ziearat' (visits of respect) to the holy shrines accompanied with moving recitals from the holy Qur'an, the warmth and hospitality of a modest and proud people are all beautiful images . . . that haunt me.

January 17th, 1991, TV screens across the globe aired the brutal bombardment of the city of 'One Thousand and One Nights', my home-land. Gazing in disbelief, horror, shock and despair, our only solace has been through prayer, and perhaps in my case, through my art work.

The sophisticated high-tech Gulf War! 'Precision-Pin-Point' missiles of the 'civilised' nations put to the ultimate test! YES, the children ARE dying, mothers and fathers ARE crying and what was once a rich

resourceful land is now a death trap. Sanctions on the innocent continue. Is this the new world order?

Since then, all these issues have been at the core of my artistic expression, be it through painting or ceramics. I often burden my soul with the immense task of trying to recreate all that is precious, all that is being destroyed: a rich culture, ancient civilisations, the Garden of Eden, a palm tree, a people, a profound faith, and a spirit ... that will never die. In a humble attempt to record or preserve a piece of my history and indeed world history, within my capacity as an individual, as an artist, I do what I cannot do without - I create and recreate with paint, with clay, my innermost feelings, my art.

In *Dialogue of the Present* I will be exhibiting ceramic work only. These are hand built forms constructed mainly through the coiling technique using a highly grogged earth-stone clay. This particular type of clay allows for more flexibility in building larger forms. Once the basic construction is completed, images symbolising my innermost emotions are engraved into the surface, both inside and out. Once a balanced composition between the basic form and the motif is achieved, the clay is left to completely dry before it is bisqued to 1000^0c. Thereafter, glazes/oxides/velvet stains/underglazes are applied and the clay is refired up to 1260^0c for stoneware or 1160^0c for earthenware. Colour is an essential component of the final piece, with turquoise having a special precedence in my heart. This colour, be it as paint on canvas or as a glaze, seems to generate within me a serene and spiritual emotion charged with 'hope' in a longing for a more peaceful and harmonious existence.

I am inspired to a large extent by my Islamic faith which expresses itself naturally in my work. My perception has been influenced by the works of prominent contemporary Iraqi artists of the 1960s, by Islamic art and architecture and modern western art movements.

At the end of the day I am essentially a mother, a wife and a daughter trying to do the best I can for my children, husband and parents. With

an intense need to stand up and express my thoughts and beliefs out loud, I thank God for the gift of my ability to do so through the beautiful, silent yet powerful language of art. It is creating this balance between all that is essential, that is the ultimate challenge and truly an art form in the making.

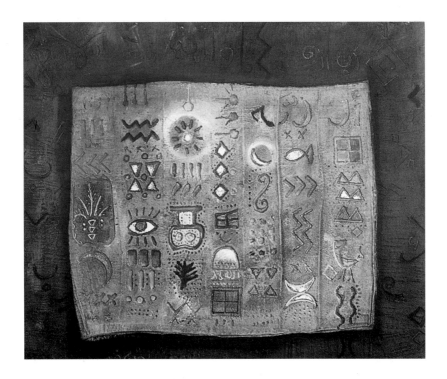

Plate 60
Maysaloun Faraj
Traces of Time ... & Moon, 1993
Mixed media and oils on primed board
51 x 61cm

Born in Hollywood, California where her Iraqi parents were working, Maysaloun Faraj returned to study in Iraq and has lived in Britain since 1982. Over the past twenty five years she has participated in numerous international exhibitions and her work is in various public collections including the British Museum, The National Museum for Women in the Arts in America and other art institutions throughout the Middle East.

Part of this success lies in her ability to create harmonious and sensual forms whether in paintings or ceramics. As her personal statement shows, the key elements that underlie her work are her profound faith in the Qur'an, her love of Arabic and Islamic design and her Iraqi roots. Using the rich resources of her culture Faraj creates objects which embody these beliefs. *Eruptions ... of the Soul* is a good example. The curved shape of the bowl and its uneven edges suggest it has been simultaneously filled and formed from an interior force that has opened it out to the world. The marks of the artist are clearly visible in the inscribed surface, the layers of glaze and the gold metal decoration that encloses verses from the Qur'an.

Trained as an architect in Baghdad, Faraj understands the intimate connection between the mathematical harmony and geometry of structure and organic form as decorative counterpart. The stoneware vase, evocatively entitled *Sisters in Black and Gold* of 1988, is a perfect example of this balance where neither form or decoration is permitted to dominate.

However, such works do not attempt to recreate a forgotten past but are fully informed, as the titles suggest, by contemporary conditions in both her native Iraq and in Britain. Faraj's work is part of this modern world and is a means of articulating her hopes and her spiritual beliefs in such precarious times. Aware of her rich cultural heritage and of the many difficulties Iraqi artists now face, Faraj is currently planning an ambitious exhibition project which will focus on contemporary Iraqi art.

Fran Lloyd

BATOOL AL-FEKAIKI

I am one of the generation of artists who trained in the 1960s in Iraq. For over thirty years I have tried to produce works of art which give material form to my personal and artistic views of the world around me. On one level these may focus on local or national events, drawn from the past or the present, but they also possess a broader relevance within the contemporary, international world.

My paintings are musical, symbolic and realistic. This is not a direct and bare realism but a mixture of the real within the symbolic and poetic world of the canvas. It is, in other words, a kind of personal symbolism, based on experience, and woven in an apocalyptic way.

For me, a painting is a key to unlock the internal world or the private sphere which would be impenetrable otherwise. I do not like to hide the keys to my soul's many gates and I do not veil the thoughts which my inner world is rich with.

My art is concerned with desire and loss, with distance and nearness and with memories and hopes. It is as such because I believe that it is a human right to express yourself without the slightest fear. Accordingly, one can be fully responsible for one's soul and one's very own self.

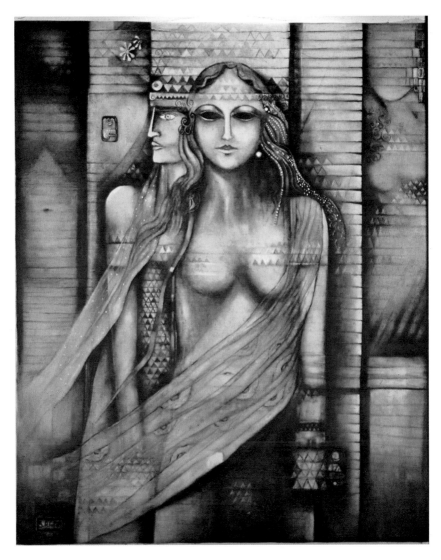

Plate 61
Batool al-Fekaiki
Ishtar, 1998
Oil on canvas
120 x 100cm

We two live only to be life companions Paul Eluard

B atool al-Fekaiki's paintings convey a dream of eternal yearn ing. She prefers not to depict the swallow directly but rather to live through the life of the migrant bird, thus stirring up feelings and memories.

The forced banishment due to the Gulf War on the one hand and international sanctions on the other create a state of prohibition with all the resultant restrictions on life. Consequently, dreams become a natural outlet for hopes and Fekaiki's paintings are a vehicle for her feelings in such difficult political times. Pillage, prohibition, imprison- ment and misery have their counterparts in a paradise on earth; a happiness in love, dreams and the sum total of the past.

Misery itself never ceases nor does imprisonment. They are made all the more poignant by the distance between the banished and his own country and loved ones. This is a distance that can never negate the homeland, nor the love of one's own country. Such details are given a special place in Fekaiki's paintings because they are truly representative of that which is loved. Separated from her home city of Baghdad, she recreates its ancient buildings and its atmosphere through the veils of memory. The migrant bird cannot but beckon to the call for a nest and a home. Even if he is behind lock and chain he looks forward with certainty and hope.

Fekaiki's paintings are like acts of personal defiance against the state of war, sanctions and misery. They remind one of Babylonian and Sumerian mythology where Ishtar rises from the depths of the under- world and returns to the spring of her life. Preoccupied with this yearn- ing for renewal, Fekaiki's recent paintings are images of love and the beloved. Like enduring monuments, her figures speak not of individual identity but as symbols of a collective cultural lineage and a human presence that cannot be erased.

Saadeh George

My work is a homage to all those who experience the painful state of being an 'other': those caught up in a conflict of identity/ies, those who experience loss and alienation for a variety of different reasons. It also honours the victims of war; those who lose home, land, limbs and loved ones; those who experience partial death and dismemberment through the loss of their careers in foreign countries; to women who assume motherhood at the expense of losing independence and freedom ... to all those who become strangers to others and to themselves.

The origins of my work lie within my own personal journey - coming from a mixed marriage, practising medicine in a battlefield, assuming different roles as mother, interpreter, translator, artist ...

I have always made art and wished to pursue this at some point in my life. After leaving the Lebanon in 1984, I trained at Central St. Martin's College of Art & Design on a part-time basis and attained a B.A. in Fine Arts in 1997.

The materials I use are translucent media: tissue paper, muslin and gauze. They reflect the fragility of life but also the superficiality of the arbitrary landmarks attached to identity.

Today I Shed My Skin, Dismembered and Remembered consists of two parts. Part one, *I.D. Therefore I Am Not* of 1998, is a rejection of all classification beyond that of being human. It is an installation made up of life-size moulds of different parts of my body as a symbol of all those who lose limbs or life because of religion, race or colour, the arbitrary division lines inflicted on peoples and bodies ... the secret wounds and scars ... or, as Julia Kristeva puts it, "The foreigner lives within us" ... in "the hidden face of our identity, the space that wrecks our abode".[1] It also references women torn between their many

1. Kristeva, Julia, *Strangers to Ourselves*, translated by Leon S. Roudiez, New York, Columbia University Press, 1991, p1

different roles, "assuming a kaleidoscope of identities ... constantly being consumed and annihilated ... "[2]

Part two, *Surface Tension,* is an assemblage of different body parts moulded in gauze and sutured together. It represents the desire to heal but also the desire to be liberated from limitations determined by superficial criteria.

In *Metamorfosi Dolorosa,* the wings of a butterfly symbolise rebirth after the endless dark cocoon existence of multiple alienations . "The ability to accept new modalities of otherness for ... according to the utmost logic of exile, all aims should waste away and self-destruct in the wanderer's insane stride toward an elsewhere ... Between the fugue and the origin: a fragile limit, a temporary homeostasis ... like fire that shines only because it consumes ... fleeing eternity or that perpetual transience always further along ... a beyond ... an insipid intoxication that takes the place of passion".[3]

Finally *Pockets of Resurrection* has evolved from a previous site specific work constructed in Gunnersbury Park in 1995, in collaboration with Cheryl Ann McKenna and Jana Hassan, which consisted of planting herbs in the cadaver of a tree destroyed by a hurricane. This work is a photographic installation showing new growths emerging from seeds in unlikely places. It is a celebration of life and of hope in the face of adversity, for, as soon as one takes action or has passion, one takes root. It celebrates a "Time of a resurrection that remembers death", changing previous "discomforts into a base of resistance, a citadel of life" ... assuming "the vulnerability of a medusa".[4] It is also a reference to the many stories of resurrection originating in Mediterranean mythologies and cultures.

2. Kristeva, Julia, *Strangers to Ourselves,* translated by Leon S. Roudiez, New York, Columbia University Press, 1991, p14
3. Ibid. pp2-6
4. Ibid. pp7-8

S addeh George was born in the Lebanon where she trained as a doctor. In 1984 she moved to London and later studied Fine Art at Central St. Martin's College of Art. She now works as an artist, a translator and an interpreter being fluent in Arabic, English and French.

Informed by her experience as a doctor in war-torn Lebanon, George's work is permeated with both an awareness of human fragility and suffering and the possibilities of physical and mental healing. The process of healing is multi-layered involving the body and the mind and George's work acknowledges this complexity through her choice of materials and imagery. *Windows* (1997) is a hanging installation made up of a series of translucent resin plates. Each contains a photograph and a photo etching on thin paper: tangible records of her life in the Lebanon. Like fragments encased in resin and frozen in time, these fragile memories become a means of reflecting on the past while acknowledging its presence in the lived experience of the present. Acting simultaneously as frames of the mind and X-ray plates, they poignantly recall the windows and balconies of a once vibrant Lebanon and the experiences of being an art student in London, watching the windows of the tube carriage flash by.

Integration is essential to the process of healing on both a mental and physical level and memories are a crucial part of this process. Although usually associated with the past, memories are always active in the present, drawing together the fragments which are part of our lived experience and in works like *Windows* and the appropriately named, *Echoes* (1997), George gives visual forms to these elusive but critical processes.

In recent work George literally takes her own body as the site of her art. Using the fragile materials of tissue paper and gauze she makes casts from her body and then sutures or sews them together. The processes and materials, associated with the wrapping of wounds, the setting of limbs and the stitching of surgery, are central to the works. The different parts of the body, carrying the imprints of time and expe-

rience, are joined together to create another body which suggests a process of healing and transformation. And yet, encountering these hanging bodies in the gallery space one is aware of the complexities and contradictions involved in this process; they are both resilient and vulnerable, symbols of hope and suffering, life affirming and like shrouds of mourning, the containers of identity but also empty shells. The marks of change are imprinted on their surfaces and like ghostly materialisations they remind one of impermanence. Change encompasses life and death, joy and suffering and all attempts to classify and control the body pale into insignificance when confronted with the universal processes which we are all subject to.

Fran Lloyd

Plate 62
Saadeh George
Echoes (detail),1997
Detail of mixed media installation: photography, photo etching and resin
9 plates each 25.4 x 20.3cm

MAI GHOUSSOUB Diva

She stood straight and tilted her head slightly towards her public. I have to bend the aluminium rod harder towards her neck. I stop. I look at her. I have the feeling that she is staring at me. I pull harder and bang heavily on the material but I still can't reduce her to her own figurative self.

Here she is again, triumphant in her myth. A winner. A goddess that we can hear, imagine, long for, scream with, cry for. A goddess that can be worshipped but never touched.

"I will make you touchable again" I say to her while I am unrolling the black woollen threads that will stand severely combed around her face; an austere perfect chignon.

I stretch the wool but I can't get to her. She is absolutely unreachable. She is definitely looking at me now. She can see me, I would swear to it. And I, with the millions who worshipped her, cannot see but her aura.

"AH! AH!" she sings, "YOU KEEP ME WAITING - MY OPPRESSOR - YOUR DEVASTATING EYES - IF ONLY" - and millions of Arab women and men sigh listening, late at night, to her complaints and becoming increasingly and desperately addicted to her voice.

No I cannot carve her mouth. It would not be right, it would be blasphemous. The melodies and the tunes of Um Kulthum, her longing, belong to an ancestral memory, they do not seem to emanate from her lips, her throat or her tongue.

The songs that have marked her fans in their millions will erupt from an

abstracted, elliptic and suggested space. Only narrow realism cares about 'truth' in art. The more I work on her shoulders, the closer I am getting to her secrets. Her shoulders are as stiff as authority! It is not easy to be a Goddess and an entertainer. Once, on a rare occasion, she gave us a little clue. Early this century, she had left her little village for Cairo - the mother of the universe - to witness 'the great disdain in which Egyptian society held all entertainers and particularly female entertainers'. Not anymore she told herself stubbornly. I want respect and I will obtain it. I can only impose myself if I give them the best of me. And the best of me will always be the best.

I will elongate the iron rod that holds her body. She will appear as her full imposing self.

Her glamour will be intimidating. Is it because her father dressed her as a boy in front of village audiences that she never flirted with her fans the way other Egyptian stars did so lovingly? Had she been terrified by the snobbery of cosmopolitan Cairo and defied it by making herself above anybody's reach, above gender limitations?

I will widen her waist and tighten her hips. I will pull the iron in opposite directions.

That's it, I am happy now, I can go away, come back to her later, look at her with 'new eyes' as they say in her country and perfect her image.

I think I understand her better now. She is hiding an oppressive vulnerability behind her carefully composed persona! A cold image of unreachable power! Oh how I wish I could make her reveal her vulnerability. I know it is there, hidden by the stiffness of her posture. I want to see through her. I will make her big, imposing: I will hide her behind her dark glasses as she wished - yes! but I will make her transparent. I will enable us to see through her persona, I will make us love her more than worship her. I look at her and all I see is her severe chignon, her dark glasses and her scarf. My efforts are hopeless.

The scarf never left her during her performances. Billy Holliday would never appear on stage without her gardenia. Carving the scarf is relaxing, its drapes have a therapeutic effect on me, it softens her expression.

But Billy, the other great Diva, allowed us to witness her distress. She went to jail, loved with passion and paid dearly for her emotions. Her pain was exposed for all of us to see. Um Kulthum's pain was told in her songs, it was never shown on her face. She never allowed us into her joyous moments. She never had 'fun' with us. Or maybe once, just once, when she asked her lover with a charming flirtatious voice to sing for her; 'Sing for me, sing and I would give my eyes for you'. But can you remember her eyes? They were so often hidden behind her glasses.

I cannot block her glasses. I will keep the wire, the plaster and the resin away from their centre. It is because of her begging him for singing that her glasses will not be terribly blocked and impermeable. I will do it for her. I will do it out of solidarity.

I am almost there.

All I succeeded in doing is to turn her into her own symbols. She is still resisting, long after many women singers imposed themselves and were called 'ladies' in Egypt, long after the lady whom she became acquired unequal power, long after she was mourned by millions who cried as if the gods had heartlessly abandoned them when they took her.

She is resisting, she can watch me better than I can make her visible.

B orn in Beirut and brought up in the French educational system, Mai Ghoussoub first studied French literature before working as a freelance journalist after the Lebanese civil war. In 1979 she moved to London where she co-founded Saqi Books, a bookshop and publishers, and in 1981 began to study sculpture. Since then Ghoussoub has continued to work as a writer and artist. She is co-editor of *Abwarb*, a quarterly magazine published in Arabic in Beirut and London, and has written various books including *Leaving Beirut, Women and the Wars Within*, 1998.

Mai Ghoussoub is well aware of the privileging of what she calls 'words and letters over the brush and the figure in Arab culture".[1] And, as she states, she has "always dreamt of challenging the power of the word".[2] Her work in sculpture and installation do just this.

Taking the female figure as her starting point, Ghoussoub concentrates on the world of rhythm and movement as experienced through the body in dance and music. Like Barthes' 'grain of the voice,' these fluid, metal sculptures emphasise bodily experiences known through the materiality of the body rather than through the logic of the word. Thus, the body (equally denigrated in both western and eastern societies) becomes a powerful source of knowledge and experience.

However, it would be a mistake to essentialise Ghoussoub's work. As titles such as *Homage to Josephine (Baker)* and *Diva* show, she is wary of dominant histories that have marginalised women, made them 'other' or fixed their achievements within overly determined cultural frameworks. Ghoussoub, reluctant to allow any fixing of meaning in her writing and/or her art, is conscious that different cultures privilege differently but the categories are familiar: art/craft, word/image, mind/body and so on.

Displaces, for example, a collaborative installation work with fellow Lebanese artist Souheil Sleiman, is described as "an evocation of the experience of 'unbelonging'."[3] The three different rooms, chiefly filled with plaster objects, both contain and challenge assumptions about

1. Text of artist talk at *Story Time* symposium, Candid Arts Centre, London Dec. 1998
2. Ibid.
3. Shaheen Merali, 'The Topology of Unbelonging' in *Displaces*, 10-20 July, 1997, exhibition leaflet, unpaginated.

what signifies home or belonging and resist any fixing of identity by gender, race or sexuality.

Fran Lloyd

Plate 63
Mai Ghoussoub and Souheil Sleiman
Displaces (detail),1998
Plaster installation in three rooms

Plate 64
Mai Ghoussoub and Souheil Sleiman
Displaces (detail), 1998
Plaster installation in three rooms

WAFAA EL HOUDAYBI

Ever since I was a young girl I have always felt a desire for beauty and art but the decision to become an artist was not without much anguish. It is an unusual choice for a female in my country and I had to first convince my family that this was what I really wanted and that I needed their confidence and support.

At first, I had no particular artistic direction and following the major western forms of modern art, I experimented with abstraction, then Cubism and finally Surrealism. Encouraged by other Moroccan artists, I decided to concentrate on a surrealist style thinking that I could find myself in this way. I travelled to Lisbon, in Portugal, and continued to paint in oils on canvas in this manner. I became increasingly aware of a feeling of something boiling up inside of me and, although I never understood what this feeling was, I knew I had to find a way of exteriorising it.

In 1987, I returned to my home town of Asilah and I started working with simple, ordinary things which are part of the daily life of Morocco including wrapping paper, clothes pegs, threads of wool and wax. Although these materials might be seen to have no importance, they are essential elements in our lives. We are always wrapping things up, hanging things out or being warmed by the individual threads of our bed covers which are usually hidden from view.

My recent work uses stretched leather, paint and threads which are still traditional, everyday materials in Morocco. The threads are like the threads of society which unfold in time but they also veil and unveil this history. These simple things are so ordinary but in every simple thing we can see something beautiful and holy.

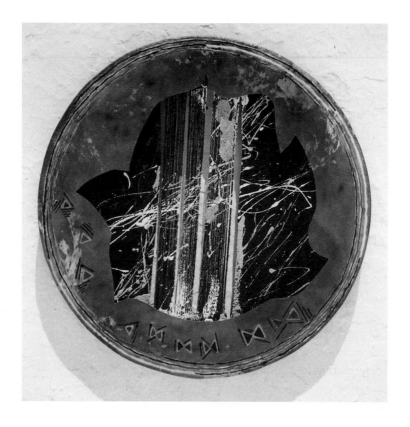

Plate 65
Wafaa El Houdaybi
Meknès, 1998
Mixed media; thread and paint on stretched leather
65cm diameter

Born in Asilah, Morocco in 1966, Wafaa El Houdaybi is well known for her innovative and experimental use of materials. Such an exploration of materials is, contrary to commonly held western views of art, not exclusive to western modernism. Experimentation has always been an essential part of what is often termed, incorrectly, the 'common' or 'everyday' arts in Africa and it is this tradition which inspires Houdaybi. All materials are embedded in our memories. There is the memory of leather, that of wood, tissue or copper. Hence, an artist's obsession with particular materials is not just a passing whim or fancy, it arises from a deep sense of being connected to the specific qualities associated with the materials. Materials carry signs, forms and colours and, through an alchemical transformation of the material, they become a visible extension of one's body, feelings and desires.

Indigenous Arab art traditions have generally used materials for decorative purposes; Houdaybi disrupts these decorative ideals. In her use of leather, she allows the physical material to become a carrier of other more complex meanings which express the dynamics and the tensions of the world around her. These tensions are an integral part of Houdaybi's work and she continually attempts to reconcile the various conflicts whether of support and surface, open and closed materials or inert and active elements.

Houdaybi wants to capture and direct the spectator's attention through these materials and she speaks of 'a spectator's gaze that is awakened to the forces of life, to the life of art and to the art of life'.

Abdelkebir Khatibi, Rabat, Morocco (translated by Saadeh George)

Plate 66
Wafaa El Houdaybi
Meknès, 1998
Work in progress, paint and henna on stretched leather
250cm diameter

KAMALA IBRAHIM ISHAQ

My paintings are mostly large oils although I also use acrylic and coloured inks and sometimes paint miniatures as small as 1 x 1 inch. The large oil paintings are usually figurative abstractions which are inspired from old African stories that I used to hear when I was young. Often the figures in the paintings are distorted and appear as if locked in glass spheres or crystal cubes.

After training in the Sudan, I studied at the Royal College of Art (London) in the mid 1960s, where I became fascinated by the paintings of William Blake and his theme of 'spirit possession'. For my thesis I researched the cult of the Zar which was widely practised in North, West and East Africa for healing.

The Zar are a very colourful cult who use costume, music and dancing as part of their rituals. While dancing, they go into a trance and become possessed by spirits. In Arabic Zar means 'visitation', meaning that as a result of spiritual possession the spirit will enter the sick person's body. I recorded the music and the many stories about the spirits and these have been the inspiration for some of my paintings.

The African story-telling tradition and African mythology are an important source for my work. Equally important has been the history of Sudanese culture from the prehistoric, old Egyptian, Napatan and Merawetic periods to the Christian period which I had to acquire in order to produce the mural for the entrance to the Sudan National Museum. Such historical knowledge has since become another layer within my work.

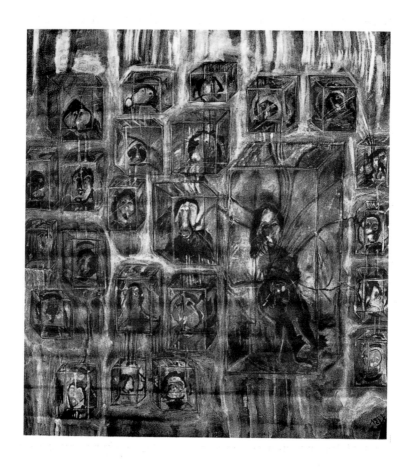

Plate 67
Kamala Ibrahim Ishaq
Images in Crystal Cubes, 1984
Oil on canvas
175 x 175cm

Trained at the Faculty of Fine Arts, Khartoum, and The Royal College of Art, London, Kamala Ishaq combines and recombines art and ideas from the multi-faceted culture of Africa, Middle East and Europe.

In the work for this exhibition Ishaq's visual references can comfortably be read through the western spectacles of Symbolism and Expressionism, Munch and Bacon, yet she cites William Blake, the British elder of the mystical, and the largely woman-centred, broad-based African cult of the Zar as her joint inspirations. These are the influences that she took forward into the work produced for a group she formed with several other artists in the Sudan in the Seventies called The Crystalists, and to which she still makes reference.

The *Crystalist Manifesto* of 1978 chose to define its cultural position as one against a masculine prioritised empirical world view and towards a redesignation of knowledge as insight. Transparency of communication was at its centre with the crystal acting both as metaphoric container/prison, and point of possibility. The Manifesto stated that the Cosmos is "small and large, realised and non-realised, and what separates the two a dialectic of absurd mirrors composed of light and water".[1]

In her work *Images in Glass Cubes, 1998,* Ishaq uses a series of metaphysical cubes to hold the floating heads of women within their transparent boundaries. The sense of the Zar's search for the spirit crosses with the all too human possibilities of psychological warfare and physical entrapment. When she identifies with the Zar in terms of seeing her work as acting in parallel territory, with herself as the Sheikha who is in charge of 'taming' demons, she seems to be using her art to regain power for women against a number of cultural and spiritual impositions.[2] Using morbid, often sanguine colouring in her work, Ishaq takes us into highly ambivalent territories located somewhere between the redemptive and the transgressive, the insightful and the tragically inevitable possibilities of the human condition.

Melanie Roberts

1. *Seven Stories About Modern Art in Africa,* Whitechapel Art Gallery, London,1995, p242
2. Jean Kennedy, *New Currents, Ancient Rivers, Contemporary African Artists in a Generation of Change,* Smithsonian Institution Press, Washington & London, 1992, p116. See also Kamala Ishaq's artist's statement on her relationship to the Zar cult.

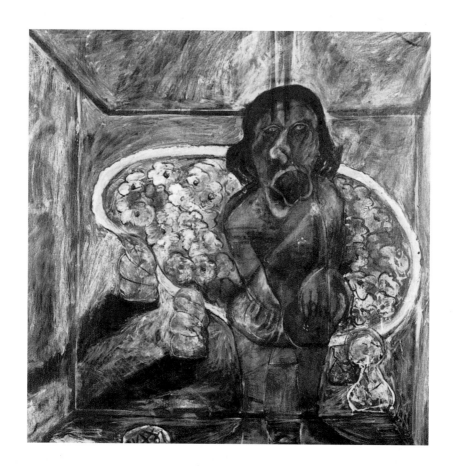

Plate 68
Kamala Ibrahim Ishaq
Loneliness, 1987
Oil on canvas
102.5 x 102.5cm
Courtesy of Jordan National Gallery of Fine Arts

LEILA KUBBA KAWASH Transcending Time

While shifting through sand an archaeologist discovers part of an ancient ruin which conjures up far greater images than the shards of glass or pieces of pottery that are in his hands. Ghosts of the past dance before him.

The ghosts I have drawn from are those inspired by clay tablets of the Sumerian goddess Inanna, the Queen of Heaven and Earth. This goddess is now largely forgotten but once there were many statues, temples, and altars of worship created in ritualistic awe and adoration of her. Such images portrayed her journey from innocent girlhood to womanhood, and finally to goddess.

As a young girl Inanna planted a tree by the Euphrates river. Later Gilgamish helped her to fight off the evil forces and then carved a crown and a throne for her from the wood of that sacred plant. At the height of her powers (for reasons not fully known) Inanna was persuaded to descend into the underworld, the dark subterranean kingdom in which she suffered. Through her suffering she emerged newly humbled and later, her lover and beloved husband, Dumazi, was sent to the underworld for six months of every year in her place.

The complexities of this forgotten goddess have both fascinated me and stirred within me a sense of longing, of loss. She has moved me, even through this gulf of time, and I have painted the obscured outline of her ghosts, her spirits in many different angles and shadows. Inanna embodies woman throughout time in her strength and power, and her vulnerability.

The experience of living in Greece for many years has added a sense of historical drama to my work - the tempestuous sails of Greek mythology, the impressive ancient temples. In direct contrast to Islamic artistic disciplines, Greece has a passion that often verges on the

melodramatic and the magical. Emotion is the opposite of geometry. Yet in my work I have striven to harmonise the two, to find an in-between, a meeting point, an artistic treaty.

Using three dimensional cubes, I have drawn from the Islamic influences of calligraphy and geometry while challenging them with loose, flowing washes of colour. The cubes stand alone or are enclosed in another plexiglass cube. In these works I am trying to tug at boundaries and broaden the vision, deepen the dimension and create something that one can actually walk around. They have an inside and an outside and can be seen from a variety of viewpoints.

Using many layers of paint, fragments of collage, heavy textures and light washes, I have tried to piece together different time periods; to find a place where the past and present overlap, where countries shed their boundaries and distances. The canvas is simply the merging point of these things and of the experiences of my own multicultural perspective, beyond the linear lines of time and beyond the straight gashes of any boundaries. My paintings make sense out of the fragments - the many dimensions of womanhood, of ethnicity, of travel - they fit together and broaden the vision. Like the archaeologist who is essentially the assembler of what is ruined or missing, the unifier of the broken or lost pieces of self.

Leila Kawash was born in Iraq but has lived in Greece, America and Britain. Trained in Manchester and Washington, her work touches on the architectural and the literary, as well as fine art and design.

In the work for this exhibition Kawash explores a range of these references calling on her multi-cultural experience, but anchoring these works predominantly in the Islamic model. In *Seven Pillars* for example she takes a solid rectangular form on which she inscribes Arabic text as well as the lacy pattern of a traditional architectural mosaic. These joint emblems of Islam, more normally seen on the heroically scaled buildings of the Middle East, are here trapped on the façade of a rather prosaic pillar, acting as a movable expression/talisman of her roots.

In *Hexahedron II* Leila Kawash exploits the magical transparency of a plexiglass cube, trapping a rotated solid cube within it. The double cubes have the quality of advanced computer graphics. We expect that they might spin jointly and effortlessly out of sight into the ambiguous depths of the screen, instead of which we are given the opportunity of moving slowly and thoughtfully around them - engaging with their layers of colour, form and text.

In other two dimensional works, Kawash travels between images that touch sensuously and dangerously on the ambivalent language of orientalism, as well as making sensitive modern and often personalised reference to the western tradition of classical myth.

Melanie Roberts

Plate 69
Leila Kawash
Hexadron II, 1997
Acrylic, collage and enamel on constructed wood and plexiglass
15 x 15 x 15cm

SABIHA KHEMIR

My drawings are executed in pen and ink. Perhaps my attraction to this medium stems from the very simplicity of the medium itself: ink, reed and paper are all one needs. Contrary to the way it is often perceived, black and white is not an absence of colour; for me it is a visual expression in its own right, with its positive particularities and with a unique sober quality to it. Black and white carries within itself that dramatic quality which reflects the duality that marks every aspect of our existence.

Not unlike photography, the style of drawing itself, based mainly on the dot, is interesting for me in its relation to the particle, the basic component of the universe and to dust which is the ultimate destiny of everything. The 'accumulation' of dots and lines to 'build up' the various textures of the picture is a relatively slow process, regulated by patience - it somehow escapes the time of the clock.

Very often, I am asked: 'How long did it take you to do this picture?' Though similar effects could probably be achieved by a more speedy technique, the actual drawing of the picture is a wonderful experience and it is the process of making that is more personally satisfying rather than the resulting picture.

The drawings are often illustrations so they are intimately related to a text. I see my illustration work as directly linked to a deeply rooted Islamic tradition of book illustration. Although there is a difference in medium and style from these ancient miniatures, there is somehow a continuity to that tradition. I try to seek a purity of line, a sense of balance in the division of space, a dynamic, a precision and a harmony that is characteristic of traditional art from the Muslim world. In that sense, my work takes inspiration from the civilisation of the culture in which I was born. Inevitably, personal experience also brings its intensity into my work. Being a woman, and a woman from an Arab

culture, is certainly a significant aspect of that personal experience.

The texts, which my drawings have illustrated, have so far come from the Islamic world. Since the work is mainly published in the west, it tends to introduce that world to a western audience, though not to the exclusion of an eastern audience. The work is not addressed to westerners or to people from the east, to men or women in particular. Even feminist expression cannot be isolated or dissociated from the human experience and therefore my work is for everyone to relate to. When I draw, I do not think of or define my audience. Though not a selfish act, the act of drawing remains personal for me, yet its meaningfulness resides in the fact that the personal is the universal.

Plate 70
Sabiha Khemir
Phoenix I (detail), 1998
Illustration
86 x 41.9cm, Private collection

S abiha Khemir is a multi-faceted, multi-talented individual who delicately excavates her Islamic heritage for us in her work for this exhibition. Born in Tunisia and living in London, she is a linguist, writer, academic, archaeologist, artist and illustrator.

Khemir works in black and white, which is normally only seen in print form in the Islamic art tradition that she explains her debt to in her artist's statement. She rightly omits to talk of the outsider's response except as a hoped for potential. This is one where the real difference between her vision and that of the past lies in the fascination created for the viewer by her alternating between an unusually fluid sense of the two-dimensionality of the Islamic tradition, and a rolling, sumptuous, perplexing three-dimensionality of forms which seethe across the paper's surface, drawing us into their literary and pictorial depths.

The fabulous forms that Khemir created, for example, when dealing with the complex moral text in Deny Johnson-Davies's *The Island of Animals*, triggers the sense of the imaginative abstract in all fantasy. As one explores the compelling surfaces of the writhing seas, part octopus, part shell, part nature-generated pattern - both fluid and solid, holding its fish prisoner beneath the obsessively articulated surfaces - it would be possible to see the comedy and the drama of literary and human experience. Glimpsed in the upper half small figures are clinging to a vessel, smiling or screaming - one can't be sure; maybe they are 'not waving but drowning'.

We can see why Sabiha Khemir is renowned for producing masterpieces of storytelling and interpretation calling on the very best of Islamic visual sources.

Melanie Roberts

Plate 71
Sabiha Khemir
The Island, 1994
Illustration from *The Island of Animals* Quartet Books, London 1994
20.8 x 28.8cm, Private collection

NAJAT MAKI

My career as an artist was not one my family would have chosen for me but I was determined to be an artist from an early age. I always enjoyed creating things and at high school my work was selected for a national art exhibition which was then a relatively new phenomenon in the United Arab Emirates. In 1977, I was awarded a government scholarship to study art abroad and was the first woman, among the first handful of artists, to have won this privilege. I studied relief sculpture in Cairo at the College of Fine Arts and in 1982 I was awarded a Bachelor of Arts degree and a medal for artistic achievement. In 1997 I became the first artist from the UAE to gain a Master of Fine Arts in Sculpture.

Most of the inspiration for my paintings and sculpture comes from my own childhood and the Pharaonic sculpture and relief which I have studied since my student days in Cairo. I frequently use mixed media in my paintings including natural dyes and herbs such as saffron and henna. These materials, together with their fragrances, are intimately linked with memories of my childhood where I spent a considerable amount of time in my father's shop which specialised in aromatic oils and traditional herbs.

As well as practising as an artist, I also teach art at the Dubai Women's Association and at the National Youth Theatre and Arts workshops, organise art exhibitions and work as an art supervisor for the Ministry of Education. I firmly believe in the beneficial role of art in society and its particular importance for children. It enriches their minds and makes them aware of their skills. It also allows them to translate their imagination, feelings, and perceptions into colour and line. Through art children can create objects of beauty and these frequently produce joy in the hearts of the beholders.

Plate 72
Najat Maki
Untitled III, 1998
Oil on canvas
128 x 95cm

Born in 1956 in Dubai, in the United Arab Emirates, Najat Maki studied sculpture in Cairo and now divides her time between the UAE and Cairo where she is studying for a Ph.D.

Maki is one of the UAE's leading artists and she has done much to actively initiate and support art education in a country where contemporary art has, until recently, had little prominence. Her national and international presence has been particularly important in a culture where the female is often associated with a decorative tradition and with the domestic rather than the public sphere of art.

Maki's training in Egypt has left a strong mark on her work. Her large paintings are inhabited by figures which recall the monumental sculptures and relief carvings of Ancient Egypt and the concerns of resurrection and immortality of the soul. Avoiding precise historical detail, Maki's figures are integrated into the natural world and are presented as part of the birth, death and resurrection cycles of nature. The frequently shrouded or cloaked figures are enfolded in the rhythmic movements of nature and Maki reinforces this integration through her bands of colour and flowing line. While her choice of colours changes according to the cycle she wishes to evoke, all her works are painted in small, careful strokes with serve to further integrate the subject and the surrounding environment. Up close the surface recalls the precision of the calligraphic mark, from a distance it appears as part of a larger, unfinished mosaic.

For Maki such paintings are symbolic. They are based on an underlying architectural or harmonic structure within which the circular marks symbolise 'life that is endless and eternal: a symbol of perfection ... They refer to the purity of the soul with which we human beings are gifted'. Aware of the symbolic representations of earlier twentieth-century western painters such as Picasso and De Chirico, Maki's work encompasses the traditional and the modern. Her choice of materials and techniques reflect this. In her sculpture she uses plastic, stone, iron, glass, fibreglass, and other found materials. In her paintings she

uses either oil-based or acrylic colour mixed with other dyes on a range of different woven materials. Simultaneously, the resulting images appear to both celebrate nature and change and to mourn the losses which are necessarily a part of the process.

Fran Lloyd

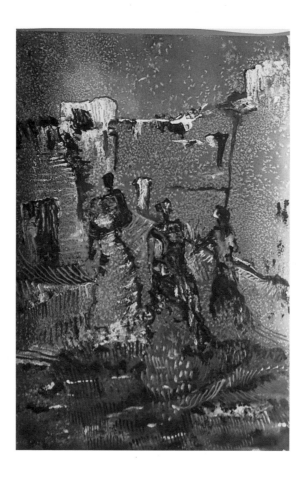

Plate 73
Najat Maki
Untitled IV 1998
Oil on canvas
128 x 95cm

HOURIA NIATI

Ziriab ... Another

Story

Limpid and vibrant was the destiny
Of lyrics and music
Inevitable was the journey
Of the invincible convoys
Of the strings of transmission
Invisible
Strings swollen up
By the centrifugal emotions
That generation after generation had swept away
The most hostile barriers
Beauty and wonder
Colours scents
Gardens satin and rosewood
Crystals of light
Tapestries and candelabras
Candles that had burned during
Millenniums
Intensive tears cascades of laughter
Between the waterfalls
Murmurs of words with orange fragrance
Voluptuous words like infinite rivers
Dark was the destiny
Like the transparency of the gaze over time
Buried by the delirium
Of the untold stories
Words of love and voluptuousness
Of appreciation of compliment
Words of grief of compassion
Of rhythm of breathing
Heart beating with the movement
Cause and effect
Horrid wars and sufferings

Exile river of words
Exile whispers in the silence
Exile rediscovered scents
In the gardens of Cordoba the madness
Parties and revels in the twinkling night
Powerful and eternal perfumes
Of jasmine and immortal amber
Immortality
Voracity and intensive joy
Under the stars protecting sky
Universal memory
Do you remember
Awake get up
Come to admire the spellbinding sun
Rainbow between the arcades
Look around you admire feel
Take a deep breath and feel the breeze
Thousands of dancing flowers
Wild poppies
Delicious roses
Burning was the destiny
Of the nightingale with the darkest plumage
Like velvet embroidered with gold thread
Lute object of love and comfort
Lute made with pearly wood and crying strings
Strings that had touched the hardest hearts
Dreamers
Listeners
The words are woven voluptuous
Recomforting
Happy words and powerful
Fragile words
Reflecting in the mystical mornings
Fully renewed
Look admire observe

Breathe the music
Take your time to contemplate
The speedy moment like a comet
That loses itself in the galaxy
Listen to the sounds in the night
Shelter of emotions
Of dreams of hope
Of destroyed frontiers
By the universal melodies
Of Ziriab's heart
Who gathers us all
Together
In the past the present the future
For ever

Houria Niati
London 1998

Plate 74
Houria Niati
Ziriab...Another Story (detail), 1998
Installation detail: ink on paper

Plate 75
Houria Niati
Bringing Water from the Fountain has Nothing Romantic About it, 1991
Installation comprising of paint on paper, enlargements of colonial postcards and
water pitchers: dimensions variable

Algerian-born artist Houria Niati sees her work as 'a visual explosion of the mind - an interaction of ideas with space and time'.

It is often accompanied not only by her own prose but also live performances of Arab-Andalusian songs in an attempt to bring the past, present and future into a coherent whole. It is work that is increasingly being recognised on a global stage.

Houria Niati specialised in Community Arts in Algeria before arriving in London in 1977 where she studied drawing and printmaking at Camden Art Centre and a three year Fine Art course at Croydon College of Art and Design. In 1983 Niati took part in the *Black Women, Time Now* exhibition in London and in the following year was the first Algerian artist to have a solo exhibition at the African Centre in London.

Her work, mainly in oil and pastel, reflects her rich inherited background and her struggle to come to terms with the dichotomies such diverse cultural sources present. These include the strong Arab-Berber influences from her family, her experiences of growing up in Algeria during the war of liberation against French occupation, her predominantly western education and her deep connection with Africa.

Her paintings and multimedia installations have a truly international presence incorporating Afro-Algerian myths and legends, Arab-Berber metaphorical traditions, French Romantic and Surrealist literature, and recent developments in European art.

Ziriab ... Another Story is an installation of paintings, drawings, photographs, montage and text. It is a tribute to Ziriab Ibn Nafi, the 9th century middle eastern composer who, forced to live in exile in Cordoba in Spain at a time when the Arab-Islamic civilisation was at its peak, inspired countless poets and musicians. Ziriab's music was subsequently brought to Morocco and Algeria by the Arabs, Jews and Maurs who fled from the Spanish Inquisition. This music has survived

colonisation, war and invasion. It has permeated Arab-Islamic civili-
sations and become the classical Arab-Andalusian heritage. Trained
in this tradition in Algiers, Houria Niati performs these Ziriab songs in
the gallery as an integral part of her installations. She embodies the
multi-sensorial experience of the Ziriab through sound, text and im-
age. All are integrated in the space of the present where Niati "con-
tinues to challenge patriarchy and the Islamic fundamentalists' rigid
interpretation of the text in today Algeria".[1]

Fran Lloyd

Plate 76
Houria Niati
Ziriab...Another Story (detail), 1998
Installation detail: ink on paper

1. Salah M. Hassan 'The Installations of Houria Niati', *NKA: Journal of Contemporary African Art*, Fall/Winter, 1995: p55

AZZA AL-QASIMI

In my opinion, art does not just require a medium, it requires expression, creativity, discipline and dedication to what you believe in. My art is a channel for self expression. When I first began painting it was initially a recreational pursuit, a hobby which then changed to become a serious commitment.

Although coming from a western art background, my art is a marriage of two traditions - that of the east, where I was born and brought up, and the west, which I frequently visit. Consequently my work is equally accessible to both eastern and western audiences.

I enjoy working with watercolour and etching. In some of the works, I have developed a technique that takes advantage of the translucency of watercolour as a glaze. In others, I use a collage of material including silver, gold leaf and coloured paper to add texture and an extra tactile dimension to my work.

The inspiration of my work derives mostly from events that I have witnessed and experienced, while the forms are influenced by my Arab culture. My work is mostly autobiographical and, like Pablo Picasso, 'painting is just another way of keeping a diary'. Moments of emotions are clearly visible in my work as in *Into the Heart* which represents sorrow and *Geometrics I* which represents happiness.

My society is patriarchal and women are treated as second class citizens. Female circumcision is common, denying women's sexuality. Arranged marriages are the norm where women are forced into marriage with total strangers. Meanwhile, love is a taboo subject in my culture. My work raises these issues but it is also intended to offer encouragement to women to be non-complacent and to articulate their desires.

Plate 77
Azza al-Qasimi
Into the Heart, 1998
Watercolour, collage on paper
54 x 74cm

Born in Sharjah in the United Arab Emirates in 1974, al-Qasimi is the youngest artist represented here. Although educated and living in the UAE, she continues to visit Britain regularly. Al-Qasimi was trained by various art tutors in Sharjah and has regularly exhibited since 1996 in different locations in the Middle East and the People's Republic of China. This is the first time her work has been seen in Britain.

As al-Qasimi's statement suggests, she has recently become interested in the work of Picasso, particularly his Cubist still life works, where everyday objects become the subject for both formal experiment and the carriers of autobiographical detail. The choice of seemingly ordinary, everyday items is equally important to al-Qasimi. Her richly coloured canvases, held together by the Cubist framework, are filled to overflowing with containers, fruit, musical instruments, jewellery and chess pieces. But, while Picasso frequently used a brief descriptive title, al-Qasimi prefers to play with words as in *No Strings Attached*, *Into the Heart* and *Checkmate*.

It soon becomes clear through the titles and the degree of detail that these are not just ordinary objects. They are objects long associated with the female, with sensuous desire and the intense and often complex, emotional terrain of love. Carefully placed details of jewel-like blue collage, Arab head-dresses and decorative patterning simultaneously signal that the rules of this game are not the same as those commonly defined in the west; they are being played out in a different arena. This becomes more apparent in some of the cubist-inspired collages, such as *Geometrics I*, where the richly patterned surface carries the imprints of traditional Arabic design which overlay and provide partial glimpses of other layers hidden from view. In such surfaces western modernist structures lie side by side with a much older Arabic culture.

Fran Lloyd

Plate 78
Azza al-Qasimi
Into the Blue, 1998
Etching and collage
75 x 55cm

ZINEB SEDIRA

As a daughter of Algerian immigrants born in France, my daily migration between secular France and the traditions of North African Islamic parents placed my everyday life 'in between' two often conflicting cultures and politics. These differing maps have led me to explore and question some of the traditional Islamic images/icons and rituals that I grew up with by reinterpreting them through my art practice.

One of the recurrent themes of my work is the Muslim veil, often used as a metaphor for the 'veiling of the mind'. This concept becomes an analogy for censorship and self-censorship. The absence of the physical veil in some of the works is a comment on the dilemmas and negotiations that take place when we try to expose our multi-layered consciousness. In this way the visible and invisible topology of the veil is explored through its paradoxes, ambiguities and symbolic significance.

It is through perception then, where memory surfaces, that my individuality is continuously affirmed and I renegotiate my presence in French contemporary society and yet again in my migration to Britain. By making this process visible new strategies towards selfhood are recorded through images, reflections, illusions and words.

Plate 79
Zineb Sedira
Self Portrait, 1998
Two computer generated images, slide projected

ZINEB SEDIRA

The Oblique Gaze

Notes of an artist

Notes of a spectator

Identity is brought to the forefront when something assumed to be coherent and predictable is disrupted by experiences of anxiety and uncertainty.

I was born in 1963 from Algerian immigrant parents and brought up in the suburbs of Paris during the aftermath of Algeria's liberation from French colonial rule. Exasperated at losing the war, France during this period generated intense political and racial animosity towards the Algerian community. Through experiencing two conflicting cultures - French and Algerian - and even though I have been living in Britain for eleven years, it is difficult to identify where one begins and the other ends.

To be a 'beurette' is a political statement in France of a cultural mélange. The word beur or beurette is a double inversion, a deliberate mixing up, of the word

To come from elsewhere, from 'there', not 'here', and hence simultaneously both 'inside' and 'outside' the situation at hand, is to live at an intersection of history and memory. Migration and exile involve a 'discontinuous state of being' that assumes the form of a restless interrogation. If voluntary or imposed exile presumes an initial home and the promise of eventual return, questions met en route consistently breach the boundaries of such a clear itinerary. The memory of loss reveals a mode of thinking neither fixed nor stable but open to the prospect of continual return.

To talk of this inheritance, to speak of 'history' is to refer to a translation of memory that is always of the incomplete; the never fully decipherable. For to translate is always to transform. Thought wanders. It migrates and needs translation. The language

arabe. Beurs and beurettes are French born of North African immigrant parents. To be 'beurette' signifies difference, a particular history and context, and is a sign of cultural ambiguity. A language of mixing, remixing, translating and transforming helps to articulate the dissonance of a particular time and place: to be Arab and French and Parisian.

There is the Arabic culture which I see as being below the surface, overlooked, treated with contempt. It needed to be expressed and re-read. Because of my everyday experiences, I became interested in the veil or hijab, the scarf worn by Muslim girls and women. I then took it further and looked at the concept of 'veiling the mind'. The concept of veiling the mind permeates my work and is a complex metaphor for censorship and self-censorship. The physical veil is relevant to understanding the mental veil because it functions like a code for Muslim women - personal, cultural, religious and political - a puzzling emblem of progress, then of backwardness; a badge now of status, then of domination; a symbol of purity and a sign of feminine silence and constraint.

employed is always shadowed by an 'elsewhere', an unconscious, an 'other' text, an 'other' voice, an 'other' place: a language that is affected by the foreign tongue.

Simply looking as a state of neutrality no longer applies as images enter the realm of lost objects whose vanishing points are linked not to surface but to a place determined by experience; a place not easily located, that holds traces of memory and thought.

A video work unfolds: black ink, water, a glass and passport photographs duplicated with the same woman's face. The ink stains the water, drowning the image. The photographs disperse and a frantic hopelessness forces the face to appear and reappear repeatedly in the darkness. A talisman? A religious ritual? There is no relief. Trapped in the studio smile, locked between spoon and glass, the imprisoned images, bound to dark solution, are left to nothingness as the inky water is drunk.

My earlier absence of using the physical veil was a comment on the dilemmas and negotiations that take place for me as an artist trying to expose a multi-layered consciousness. Shrouded with exoticism and stereotype, the physical veil reveals the instinctive voyeuristic aspect of what is strange or other. It is this ambiguity of meaning that parallels the concept of veiling and exposes an exaggerated drama, a script of how the west reads Arabic culture.

Repetition is a component of all my work (partly influenced by Iranian writer Farzaneh Milani's work on the disrupted matriarchal chain) and serves to emphasise the many possible readings of the themes. When I presented the tiled or wallpapered images of women held within a design and repeated again and again it was intended to redraw cultural perceptions; both to dismiss the western belief of Islamic art as being merely decorative, as well as to challenge those Islamic laws of representation whose purpose is to divert from the representational and to firmly exclude images of human beings. That decision marked a breaking of silence and

It is the visual image which appears to order and contain ambiguous experience: words may provide a link to any visual material offered but the difficulties in translating across cultural divides expose a communication gap that is not easily translated. And images themselves appear never entirely still; mingling and disturbing each other as their surfaces break and recombine and one's point of view shifts and adjusts, slipping and sliding, dissecting and adjusting.

This gap cannot be transmitted in words.

Our own faces and our eyes are invisible to us and load with meaning and mysterious significance our continuously projected gaze on the external. It is as if our faces always belong to another. The gaze can powerfully distort the surface to reveal both the sociality of an image or a subject's construction and the manner of its smooth reproduction.

a reclaiming of the feminine text within this masculine form ... it seeks to expose the underlying cultural assumptions and to speak metaphorically for the censorship of the Muslim female experience that influences my work ... in a sense it speaks too of the misreading of images, for there are always further layers of wall and veil. Repetition pushes forward a sense of ambiguity, a continual personal repositioning that plays with clarity and the unclear; between existence and disappearing, taking everything further.

In a veiled society seeing, far from being considered a merely physiological process, takes on a socially determined and highly charged meaning. Considered much more than windows to the soul, eyes become subject to regulation for men and women. The gaze is the marker of the ambiguous and conflicting passage I have chosen, related through my face, the face of other women, and through an ongoing exploration of the visible and invisible topology of the veil.

The images appear and disappear like shifting memories of a performance.

A system holds or contains its subject within certain contours and excludes what is other but the silent spectator can have subtle power of domination and control over the exchange. Such power to dominate does not always reside in the one who speaks (for it can be they who are constrained) but may dwell in the one who listens and says nothing; the one who questions and is not supposed to know.

The migrant's innate romanticism promotes an emotional subtext, in which simply choosing another language, completely abandoning their previous history or freely adopting an alternative is denied.

Edith Marie Pasquier, 1998

LAILA AL-SHAWA

I have not consciously thought of myself as a woman artist, or as an Arab woman artist. I have always thought of myself as a person rather than some one defined by race and gender. In my work I try to reflect on the realities around me, be they social or political, and I see myself as more of a critic or observer. Although not necessarily consciously, I have dealt with socio-political issues that expose the realities of women's lives both at a local and international level. Thus, because I am a woman, I observe certain particularities relating to women's experience.

In my most recent works I reflect a political reality which exists in my country, and in that sense I become a chronicler of events. As a Palestinian I feel involved with the plight of my country and my people.

I have an overpowering dread of the trauma of war and how it marks future generations. I start with the children of my country, but they must also reflect the trauma of all children in war zones.

Other issues I am dealing with relate to breast cancer and although this is a personal experience, I take it outside of myself. I link it with other eruptions taking place in the contemporary world as, for example, the Gulf War, atomic explosions and explosions in outer space. The land and the body are linked and both bear the scars of different forms of invasion.

Plate 80 Laila al-Shawa
100 x 230 cm
Part of *The Walls of Gaza* installation of 10 silkscreens, 1992-1995

Born in Palestine, and living between her homes in Gaza and the UK, Laila al-Shawa was trained at the Leonardo da Vinci School of Art in Cairo, and the Academia de Belle Arte and the Academia St. Giaccomo in Rome, Italy. Whether as a consequence of this multi-national training or through political-artistic choice, al-Shawa is a highly effective exponent of both the Arab and the western traditions' visual vocabulary.

The influence of her early masters/mentors in the form of Oskar Kokoschka and Renato Guttoso is evident only at the most subtle psychological level. She has subsumed the tension that is created by the driving polemic of Guttoso's work and the expressionistic drama of Kokoschka, manifesting a different but parallel energy in a controlled but dynamic form to make powerful visual statements that touch on the political universal and the political particular.

Occupying a highly individual, sensitive, yet cerebral space for the work for this exhibition, she takes the repetitive media-generated postmodern language, of for example Andy Warhol, to touch not on the trivia of the soup can, but to create a visual reminder of the way the male child throughout history is repeatedly caught in the circular or linear 'web' of a historically necessitated defensive destiny - victim and oppressor by turn.

In a universal context, the smooth surface of the silk screen method, and the use of dazzling colour, juxtaposed with newsprint's monochrome, acts as a reminder of the ease, in an image saturated era, with which we are able to casually absorb representations of tragedy and conflict not truly registering their human reality until it is our turn to be in the metaphorical firing line.

In relation to the particular, *Children of War* and *Children of Peace* are part of a series of works: *The Walls of Gaza* which were made between 1992 and 1995. Whilst making a photographic record of the walls in the camps in Gaza, Laila al-Shawa was compelled to photograph the ever-present children even though she did not wish to. As a

result they became an important expression of the lived consequences of political events. She wrote in an unpublished commentary, "I was trying to photograph the walls of Gaza after the Oslo Accord. During the Intifada most walls had monochromatic colours. After the accord the colours changed into brilliant tones, but nothing else changed".[1]

In the commentary al-Shawa describes the appalling circular consequences for the older children who, deprived of education during the Israeli occupation, are encouraged to offer themselves as cheap labour in Israel. Al-Shawa talks of the irrelevance to children of all ages who are still living in refugee camps, still traumatised, still lacking proper education, still the victim of birth deformities bred out of air and water-borne chemical pollutants, and living below the poverty line, of their one compensation - "a piece of paper signed on the lawns of the Whitehouse saying 'we shall have just peace in Palestine'." Laila al-Shawa ended her commentary - "If this sounds too political, it is because one reflects one's reality. I wish it were different".[2]

Melanie Roberts

1. Unpublished commentary by artist, 1996, p1
2. Ibid p2

Chapter Six

FIRYAL AL-ADHAMY

MEDIUM Acrylic, gold and watercolour on canvas and paper

BORN Baghdad, Iraq; lives in Bahrain and the UK

EDUCATION
 Baghdad University

SOLO EXHIBITIONS
1990 Kufa Gallery, London
1988 Intercontinental Hotel, Bahrain

SELECTED GROUP EXHIBITIONS
1999-2000 *Dialogue of the Present, the Work of 18 Arab Women Artists*
 Touring the UK: Hot Bath Gallery, Plymouth Arts Centre,
 Brunei Gallery, Pitshanger Manor & Gallery, University of
 Brighton Gallery
1996 *Women Artists of the Islamic World*, Islington Museum
 Gallery, London
1995 *Arab Women Artists in London,* Saidy Gallery, London
 The World's Women on-line Electronic Ballet, Internet
 Exhibition, UN Conference, Beijing, China
 Arab Fine Art Exhibition, Arab-British Chamber of
 Commerce, London
1994 Al Abbar Gallery, Dubai, UAE
 Aramco, Inmaa Gallery, Saudi Arabia
1993 *Exhibition of International Artists,* Imperial College,
 London organised by 'Eastern Art Report'
 Iraqi Artists' Society, Gallery 4, London
1992 *Iraqi Women's Festival of Culture*, Kufa Gallery, London
 Iraqi Artists' Society, Camden Town Lock, London
 Arab Women Artists by the General Union of Palestinian
 Women, Kufa Gallery, London
1991 *Iraqi Artists,* Kufa Gallery, London
 Iraqi Artists' Society, Gallery 4, London
1988 *Bahrain Art Society Annual Exhibition*, Bahrain
 Alfan Gallery, Bahrain
1987 *Bahrain Art Society Annual Exhibition*, Bahrain

MALIKA AGUEZNAY

MEDIUM Oil on canvas; etchings

BORN Marrakesh, Morocco; lives in Casablanca, Morocco

EDUCATION
1966-1970 Ecole des Beaux-Arts, Casablanca

SELECTED SOLO EXHIBITIONS
1997 The Spanish Cultural Centre, Cervantes Institute, Casablanca
1996 The National Gallery of Bab Rouah, Rabat, Morocco
1993 Alif Ba Gallery, Casablanca
1987 The French Cultural Centre, Casablanca
1983 Nadar Gallery, Casablanca

SELECTED GROUP EXHIBITIONS
1999-2000 *Dialogue of the Present, the Work of 18 Arab Women Artists*
 Touring the UK: Hot Bath Gallery, Plymouth Arts Centre,
 Brunei Gallery, Pitshanger Manor & Gallery, University of
 Brighton Gallery
1998 *Le Face à Face des '8' de Casablanca,* the Spanish
 Cultural Centre, Cervantes Institute, Casablanca
1997 *Art and Dialogue,* National Gallery of Bab Rouah, Rabat
1996 *Three Moroccan Painters,* National Museum of Women
 in the Arts, Washington DC, USA
 18th Exhibition of Drawings, Kanagawa Kenmin
 Gallery, Kanagawa, Japan
 Plasticiens de Maroc, Museum of Marrakesh, Morocco
1995 Al Manar Gallery, Morocco, Syria, Tunisia
 Contemporary Art Gallery, Marsam
1994 Anfa Cultural Centre (Alif Ba Gallery), the occasion of
 the Economic Summit of North Africa & the Middle East
 Women and Peace, Marrakesh, Morocco
1993 Galerie Espace Ligne, Rabat
 Unesco exhibition, Paris, France.
 1st International Biennale of Engravings, Maastricht, Holland
1992 National Gallery of Bab Rouah, Rabat
1991 Grand Palais, Paris, France
1990 *Triennial of Cracow,* Poland
1989 *Contemporary Moroccan Painting,* Del Conde Duque
 Cultural Centre, Madrid, Spain
 Anfa Cultural Centre and French Cultural Centre,
 Casablanca
1988 *2nd Biennale of International Art,* Baghdad, Iraq
 Anfa Cultural Centre, Maarif Cultural Centre, Casablanca
1986 *Exposition des Anciens de l'Ecole des Beaux-Arts de
 Casablanca,* Ecole des Beaux-Arts Gallery, Casablanca

JANANNE AL-ANI

MEDIUM Video installation and photographs

BORN 1966, Kirkuk, Iraq; lives in London, UK

EDUCATION
1986-89 Byam Shaw School of Art
1991-95 University of Westminster, BA in Arabic
1995-97 Royal College of Art, MA in Photography

SOLO EXHIBITION
1997 Harriet Green Gallery, London

SELECTED GROUP EXHIBITIONS
1999-2000 *Dialogue of the Present, the Work of 18 Arab Women Artists*
 Touring the UK: Hot Bath Gallery, Plymouth Arts Centre,
 Brunei Gallery, Pitshanger Manor & Gallery, University of
 Brighton Gallery
1997 *20/20*, Kingsgate Gallery, London
 Ruch, GI Gallery, Poland
1996-7 *John Kobal Photographic Portrait Award* (1st prize
 winner), National Portrait Gallery, London
1996 *Contemporary Art from the Museum's Collection*,
 Imperial War Museum, London
 After Eden, Garden Galleries, Staffs.
1995 *Natural Settings*, The Chelsea Physic Garden, London
 Art History Representation, The Concourse Gallery, London
1994 *Who's Looking at the Family?* Barbican Art Gallery, London
1993 *No more heroes any more*, The Royal Scottish Academy,
 Edinburgh
 *Declarations of War, Contemporary Art from the
 Collection of the Imperial War Museum*, Kettle's Yard,
 Cambridge
1992 *Fine Material for a Dream. A Reappraisal of
 Orientalism*, Harris Museum & Art Gallery, Preston,
 touring to Ferens Museum & Art Gallery, Hull, and
 Oldham Art Gallery, Oldham
 The Whitechapel Open, The Whitechapel Gallery,
 London
1991 *Contact*, Royal Festival Hall, London
 Sign of the Times, Camerawork, London
 Guernica Revisited: Artists' Response to the Gulf War,
 Kufa Gallery, London
1989-90 *The Whitechapel Open*, The Whitechapel Gallery,
 London

THURAYA AL-BAQSAMI

MEDIUM Acrylic, oil on canvas and monoprints

BORN 1952, Kuwait; lives in Hawalli, Kuwait

EDUCATION
1972-73 College of Fine Arts, Cairo
1974-81 Arts Institute, Surikov, Moscow, MA in Graphic Book
 Illustration and Design

SELECTED SOLO EXHIBITIONS
1996 Museum of Applied Arts, Budapest, Hungary
1995 Ahmed Al-Adwani Gallery, Kuwait
1994 Art Centre, National Museum of Bahrain
 National Museum of Scopje, Macedonia
 Opera House, Cairo, Egypt
 Ghadir Gallery, Kuwait
1992 Ghadir Gallery, Kuwait
 Athens College Theatre, Athens, Greece
1991 Ghadir Gallery, Kuwait
 Alpine Gallery, London
 Kiklos Gallery, Paphos, Cyprus
1990 Ghadir Gallery, Kuwait
1988 Ghadir Gallery, Kuwait
1986 Kuwaiti Journalists' Association, Kuwait
1979 Free Art Gallery, Kuwait
1971 National Museum of Kuwait

SELECTED GROUP EXHIBITIONS
1999-2000 *Dialogue of the Present, the Work of 18 Arab Women Artists*
 Touring the UK to: Hot Bath Gallery, Plymouth Arts Centre,
 Brunei Gallery, Pitshanger Manor & Gallery, University of
 Brighton Gallery
1996 *Al Qorin Cultural Festival*, Kuwait
 Arabic Artists' Exhibition, Egyptian Cultural Centre, London
 Kuwait Cultural Week, Beirut, Lebanon
 Arabic Women Artists' Exhibition, Baladna Gallery,
 Amman, Jordan
1995 *Kuwait Cultural Week*, Casablanca, Morocco
 Al Qorin Cultural Festival (2), Ahmed Al-Adwani Gallery,
 Kuwait
 Biennal of Latakia, Syria
 Sharjah Arts Biennal, Sharjah, UAE
 National Museum of Bahrain, State of Bahrain, Manama
1994 *Al Qorin Cultural Festival*, Ahmed Al-Adwani Gallery,
 Kuwait, *Kuwait Association of Human Rights Exhibition*,
 Graduates Society, Kuwait

THURAYA AL-BAQSAMI - continued

1994-95	*Forces of Change,* travelling exhibition, The National Museum of Women in the Arts, Washington DC; Chicago; Miami; S. Atlanta, USA
1993	*International Triennial of Graphic Arts,* Cairo, Egypt *Kuwaiti Ass. for Human Rights,* Ghadir Gallery, Kuwait Albert Gallery, London
1989	*International Exhibition of Children's Illustrations,* Bratislava, Slovakia
1988	*International Festival for Formative Arts,* Baghdad
1985	*Exhibition of the Contest Square,* Kuwait Municipality

RIMA FARAH

MEDIUM Etching and monoprint

BORN 1955, Amman, Jordan; lives in London, UK

EDUCATION
1977 Cambridge School of Art, UK

SELECTED SOLO EXHIBITIONS
1995 Atassi Gallery, Damascus, Syria
 Gallery 50 x 70, Beirut, Lebanon
1993 Aphrodie, Izmir, Turkey
1992 Alef Gallery, Zamalek, Cairo, Egypt
1991 Tanjer Flandria Art Gallery, Tangiers, Morocco
 Plum Gallery, Tokyo, Japan
1989 Sultan Gallery, Kuwait
1987 Sultan Gallery, Kuwait
1986 Van Wagner, Ankara, Turkey
1986 The Gallery, Amman, Jordan
1984 The Graffiti Gallery, London

SELECTED GROUP EXHIBITIONS
1999-2000 *Dialogue of the Present, the Work of 18 Arab Women Artists*
 Touring the UK: Hot Bath Gallery, Plymouth Arts Centre,
 Brunei Gallery, Pitshanger Manor & Gallery, University of
 Brighton Gallery
1995 Aphrodie, Izmir, Turkey
 ODA Gallery, Istanbul, Turkey
1994-95 *Forces of Change,* travelling exhibition, The National
 Museum of Women in the Arts, Washington DC;
 Chicago; Miami; S. Atlanta, USA
1994 The American College, London
1992 Alif Gallery, Washington DC, USA
 Van Cranch, Köln
1991 Studio 5, Seibu, Ikeburkuro, Japan
1990 Majlis Gallery, Dubai, UAE
1989 Egee Art, London
1988-91 *It's Possible*, travelling exhibition, USA & Europe
1987 ICCP, Geneva, Switzerland
1986 *The Bordeaux Collection,* Royal Academy, London
 The Mall Gallery, London
 Falcon Gallery, Riyadh, Saudi Arabia
1985 Arab Heritage Gallery, Al Khobar, Saudi Arabia
 The Islamic Cultural Centre, London
1984 *Arab Artists*, Graffiti Gallery, London

MAYSALOUN FARAJ

MEDIUM Ceramics; mixed media on board and canvas

BORN 1955, California, USA; lives in London, UK

EDUCATION
1973-78 Baghdad University, Architecture B.Sc.

SELECTED SOLO EXHIBITIONS
1995 *Once upon a Culture*, SOAS, University of London, London
1993 *Vibrations from my Past*, Oakshire Gallery, Texas, USA
1990 Rochan Gallery, London
 Argile Gallery, London
1989 *Home Sweet Home*, Baghdad, Iraq
1985 *Longing, Espace 2000*, Paris, France

SELECTED GROUP EXHIBITIONS
1999-2000 *Dialogue of the Present, the Work of 18 Arab Women Artists*
 Touring the UK: Hot Bath Gallery, Plymouth Arts Centre,
 Brunei Gallery, Pitshanger Manor & Gallery, University of
 Brighton Gallery
1996 *Eastern & Icelandic Art,* The Inspiration for William Morris,
 Merton Arts Festival, Merton, London
1995 *Arabian Eyes,* Ministry of Culture & Information, Sharjah, UAE
 Visions of East & West, Sayde Interiors, London
 Arab Artist Fine Arts, Arab-British Chamber of Commerce,
 London
1994-95 *Forces of Change,* travelling exhibition, The National
 Museum of Women in the Arts, Washington DC;
 Chicago; Miami; S. Atlanta, USA
 Culture & Continuity, Midlands Art Centre, Birmingham
1993 Gallery 4, London
 Our Home Land & Us, Imperial College, London
1992 *Iraqi Cultural Festival,* Camden Lock, London
 Arab Women Artists Festival, (General Union of
 Palestinian Women) Kufa Gallery, London
 Iraqi Women's Art Celebration, Kufa Gallery, London
1991 Kufa Gallery, London
 Contemporary Collectors, Artizana Gallery, Manchester
1989 *Baghdad Biennial International Art Festival,* Baghdad
 Orfali Gallery, Baghdad
 International Women's Week, Brazil Gallery, Brazil
1988 *ILEA Grand Exhibition,* Chelsea School of Art, London
 Contemporary Artists & Calligraphy, Egee Art
 Consultancy, London
 Arab Women Artists in the UK, Kufa Gallery, London

BATOOL AL-FEKAIKI

MEDIUM Oil on canvas and drawing

BORN 1942, Baghdad, Iraq; lives in London, UK

EDUCATION
1963 Institute of Baghdad, BA

SOLO EXHIBITIONS
1988 Dr Christian Hyden Hall, Traunstein, Munich, Germany
1997 Beledna Gallery, Amman, Jordan
1994 Sayda Interiors, London

SELECTED GROUP EXHIBITIONS
1999-2000 *Dialogue of the Present, the Work of 18 Arab Women Artists*
 Touring the UK: Hot Bath Gallery, Plymouth Arts Centre,
 Brunei Gallery, Pitshanger Manor & Gallery, University of
 Brighton Gallery
1998 *11th International Exhibition of Fine Art* - Al Mahras, Tunisia
1997 *International Exhibition of Fine Art,* Al-Mahras, Tunisia
1996 *The Palestinian Child Exhibition,* Dubai
1995 *Arab Artists Exhibition,* Arab-British Chamber of Commerce,
 London
1993 Orfali Gallery, Baghdad
1992 *Iraqi Modern Art Exhibition,* The Royal Cultural Centre,
 Jordan
1991 *Joint Exhibition with Ibrahim Al Abdali,* The Royal
 Cultural Centre, Jordan
 Iraqi Modern Art Exhibition, Iraqi Artists' Union, Italy
1990 *Iraqi Women Artists Exhibition,* Brazil
1989 *The Second International Festival,* Al-Benali, Baghdad
1988 *Victory & Peace Exhibition,* Baghdad
1987 *Martyrs Exhibition,* Baghdad
1986 *The First International Baghdad Exhibition,* Al-Benali,
 Baghdad
1985 *Annual Exhibition,* Orfali Gallery, Baghdad
1984 *Graphics Exhibition,* Rewaaq Gallery, Baghdad
1981 *Iraqi Modern Art Exhibition,* Amman, Jordan
1980 *National Arab Women Artists Exhibition,* Baghdad
1979 *Art & Revolution Exhibition,* Thawra Newspaper, Baghdad
1976 *Iraqi Modern Art Exhibition,* Paris, Bonn, London
1975 *Iraqi Women Artists Exhibition,* Kuwait, Madrid, Vienna, Italy
1974 *Mobile Iraqi Art Exhibition,* Paris, Damascus, Kuwait
1973 *Al Wasti Festival,* The National Museum of Modern Art,
 Baghdad

SAADEH GEORGE

MEDIUM Mixed, installation, sculpture, prints and photographs

BORN 1950, Lebanon; lives in London, UK

EDUCATION
1971-76 Trained as a Doctor
1997 Central St. Martin's College of Art & Design, BA
1995 Artist in Residence, Small Mansions Art Centre, London

SOLO EXHIBITIONS
1998 Grapevine Gallery, Ealing, London
1995 Questors, Theatre Foyer Gallery, London

SELECTED GROUP EXHIBITIONS
1999-2000 *Dialogue of the Present, the Work of 18 Arab Women Artists*
 Touring the UK: Hot Bath Gallery, Plymouth Arts Centre,
 Brunei Gallery, Pitshanger Manor & Gallery, University of
 Brighton Gallery
1996 *International Art Exhibition*, Paris
 Cultural Aid for a United Bosnia, Covent Garden, London
 Oleum, Academia Italiana; Italian Trade Centre, London
1995 *Arab Artists in Britain,* Arab-British Chamber of Commerce,
 London
 Seeing ... Believing, Waterman's Art Centre, London
 Faulkner's Fine Papers, Lethaby Gallery, London
1994 *Hard Space,* Waterman's Art Centre, London
1993 *Mono 93*, Small Mansions Art Centre, London
1992 Emerald Centre, London
 Art Themes, Obelisque Gallery, Richmond, Surrey
1989 *Roots*, Bristol
1978 *Rue Makhoul Festival of Arts,* Beirut, Lebanon
1976 *Rue Bliss Festival of Arts*, Beirut, Lebanon

MAI GHOUSSOUB

MEDIUM Sculpture, installation, performance

BORN 1952, Lebanon; lives in London, UK

EDUCATION
1971-74 The American University of Beirut, BA
1971-75 Lebanese University, French Literature
1988-92 Morley College, London, Sculpture

SELECTED SOLO EXHIBITIONS
1995 *Metal Blues,* Argile Gallery, London
1993 Theatrical Performance with Sculptures, Kufa Gallery,
 London

SELECTED GROUP EXHIBITIONS
1999-2000 *Dialogue of the Present, the Work of 18 Arab Women Artists*
 Touring the UK: Hot Bath Gallery, Plymouth Arts Centre,
 Brunei Gallery, Pitshanger Manor & Gallery, University of
 Brighton Gallery
1998 *Displaces,* installation on theme of refugees,
 Shoreditch Town Hall, London
 Installation, Stoke Newington Library Gallery, London
1996 *Under Different Skies,* Copenhagen
1994 Gallery 23, London
1993 Kufa Gallery, London
1993 *The Witching Hour and a Half,* ICA, London
1985 Holland Park Orangerie, London

WAFAA EL HOUDAYBI

MEDIUM Mixed, painting, thread on leather

BORN 1966, Asilah, Morocco; lives in Asilah

SELECTED SOLO EXHIBITIONS
1997 The Cultural Foundation, Abu Dhabi, UAE
1993-94 Henry Kessingser Office, Rabat, Morocco
1993 Arts Centre, Manama, Bahrain
 Al Manzah Hotel, Tangiers, Morocco
1992 Conference Palace, Marrakesh, Morocco
 Museum Al Batha'a, Fes, Morocco
 Al Wadaia Museum, Rabat, Morocco
1985 The Spanish Cultural Centre, Tangiers, Morocco
1984 Qudama' Al Iman Al Aseely Association, Asilah, Morocco

SELECTED GROUP EXHIBITIONS
1999-2000 *Dialogue of the Present, the Work of 18 Arab Women Artists*
 Touring the UK: Hot Bath Gallery, Plymouth Arts Centre,
 Brunei Gallery, Pitshanger Manor & Gallery, University of
 Brighton Gallery
1998 Museum Dakar, Senegal
1997 *Hallamash,* Gallerie Sur, Wien, Austria
 3rd International Arts Biennial, Sharjah, UAE
1996 Al Hassan II Centre, Asilah, Morocco
 Conference Palace, Marrakesh, Morocco
1995 *2nd International Arts Biennial,* Sharjah, UAE
1995 *Pottery Festival,* Bahrain
1994 Arts Centre, Manama, Bahrain
 Homage to Tshikaya Otomsee, International Cultural
 Festival, Asilah, Morocco
1992 Jerusalem Hall - Fes, Morocco
1989 French Cultural Centre, Casablanca, Morocco
1986-88 Al Hassan II Centre (Asilah Seasons), Asilah
1988 *The African Conference* (about the family),
 Hayat Regency Hotel, Casablanca. Morocco
1986 The Association of Qudama'a Al Iman Al Asilee, Asilah
1984 The Culture Palace, Asilah, Morocco
1983 Da'ar El Shabab, Tangier, Morocco
1982 Da'ar El Shabab, Asilah, Morocco
1981 Al Borj Hall, Asilah, Morocco

KAMALA IBRAHIM ISHAQ

MEDIUM Oil on canvas, acrylic on paper

BORN 1939, Omdurman, Sudan; lives in Muscat, Oman

EDUCATION
1959-63 College of Fine & Applied Art, Khartoum
1964-66 Royal College of Art, London (mural painting)
1968-69 Royal College of Art, London (lithography, typography,
 illustration)

SELECTED SOLO EXHIBITIONS
1970 Ikhnaton Art Gallery, Cairo, Egypt

SELECTED GROUP EXHIBITIONS
1999-2000 *Dialogue of the Present, the Work of 18 Arab Women Artists*
 Touring the UK: Hot Bath Gallery, Plymouth Arts Centre,
 Brunei Gallery, Pitshanger Manor & Gallery, University of
 Brighton Gallery
1997 *Transafrican Art*, Orlando Museum of Art, USA
1996 *Arab Artists*, Jordan, Amman
1995 *Arab Women in the Arts/Arab Eyes*, Sharjah, UAE
 Seven Stories from Africa, Whitechapel Art Gallery, London
1994-95 *Forces of Change*, travelling exhibition, The National
 Museum of Women in the Arts, Washington DC;
 Chicago; Miami; S. Atlanta, USA
1986 *Ten Women Artists from the World*, Carolyn Hill Gallery,
 New York, USA
1982 *Biennial*, Sudan Pavilion, Alexandria, Egypt
1977 *Contemporary African Art*, Howard University,
 Washington DC
1973 *African Festival*, Tunis
1970 *Biennal*, Sudan Pavilion, Festac, Nigeria
1969 *Contemporary African Art*, Camden Art Centre, London
1963-68 *Winter Exhibitions*, Association of Fine Artists in Khartoum,
 Sudan
1963-64 Harmon Foundation, New York, USA
1963 *Biennal*, Sao Paolo, Sudan Pavilion, Brazil
1962 *World Fair*, Sudan Pavilion, New York, USA

LEILA KUBBA KAWASH

MEDIUM Mixed media, oil on canvas

BORN 1945, Baghdad, Iraq; lives in London and Washington

EDUCATION
1966 Manchester School of Art & Architecture
1992 Corcoran School of Art, Washington DC

SELECTED SOLO EXHIBITIONS
1997 *Dawns and Invocations,* Magna Art Gallery, Athens
1996 Academias Cultural Centre, Athens, Greece
 Abu Dhabi Cultural Centre
1994 *Crossings,* Royal Cultural Centre, Amman, Jordan
1993 ADC Convention, Washington DC, USA
1991 *Words, Echoes & Images,* Alif Gallery, Georgetown,
 Washington DC, USA
1987 *Movements and Traditions,* Hilton Hotel, Athens, Greece
1986 International Monetary Fund, Washington DC, USA

SELECTED GROUP EXHIBITIONS
1999-2000 *Dialogue of the Present, the Work of 18 Arab Women Artists*
 Touring the UK: Hot Bath Gallery, Plymouth Arts Centre,
 Brunei Gallery, Pitshanger Manor & Gallery, University of
 Brighton Gallery
1995 *Jerusalem Cultural Show,* Cultural Foundation, Abu Dhabi
1994-95 *Forces of Change,* travelling exhibition, The National
 Museum of Women in the Arts, Washington DC;
 Chicago; Miami; S. Atlanta, USA
1993 *Interpretations in Texture,* Michael Stone Gallery, Washington
 DC, USA
1992 Corcoran White Walls Gallery, Washington DC, USA
1990 Alif Gallery, Washington DC, USA
 Braathen Nusseibeh Gallery, New York City, USA
1984-86 *Through Arab Eyes,* touring Middle States of America

SABIHA KHEMIR

MEDIUM Drawing, book illustration

BORN 1959, Tunisia; lives in London, UK

EDUCATION
1986 London University, School of Oriental and African
 Studies, MA (with distinction) in Islamic Art and Archaeology
1990 London University, PhD
 University of Pennsylvania, Philadelphia, USA, Post
 Doctoral Fellow in the History of Art Department

ILLUSTRATIVE WORK
1994 *The Island of Animals,* Quartet, London
1978 *Le Nuage Amoureux,* Maspero, Paris
1975 *L'Ogresse,* Maspero, Paris

BOOK COVERS INCLUDE
 Respected Sir, Naguib, Mahfouz
 Tiger on the Tenth Day, Zakaria Tamer
 Distant View of a Minaret, Alifa Rifaat

SELECTED EXHIBITIONS
1999-2000 *Dialogue of the Present, the Work of 18 Arab Women Artists*
 Touring the UK: Hot Bath Gallery, Plymouth Arts Centre,
 Brunei Gallery, Pitshanger Manor & Gallery, University of
 Brighton Gallery
1998 The School of Oriental and African Studies, London
 University, London
 The Ismaili Centre, London
1994-95 *Forces of Change,* travelling exhibition, The National
 Museum of Women in the Arts, Washington DC;
 Chicago; Miami; S. Atlanta, USA
1993 Kufa Gallery, London
1988 Kufa Gallery, London
1987 Kufa Gallery, London
1986 The Islamic Centre, London
1979 The Beaubourg Pompidou Centre, Paris, France

Her first novel, *Waiting in the Future for the Past to Come* was
published by Quartet (London) in 1993

NAJAT MAKI

MEDIUM Mixed media on canvas

BORN 1956, Dubai, UAE; lives in Dubai, UAE and Cairo, Egypt

EDUCATION
1981 College of Fine Art, Cairo, Egypt
 (Sculpture & relief sculpture)
1997 MA, College of Fine Art, Cairo, Egypt

SOLO EXHIBITIONS
1997 Sharjah Art Museum, Sharjah, UAE
 Writers & Artists Atelier, Cairo, Egypt
1986 Al Wastl Club, Dubai

GROUP EXHIBITIONS
1999-2000 *Dialogue of the Present, the Work of 18 Arab Women Artists*
 Touring the UK: Hot Bath Gallery, Plymouth Arts Centre,
 Brunei Gallery, Pitshanger Manor & Gallery, University of
 Brighton Gallery
1997 *3rd Sharjah International Biennial*, Sharjah, UAE
1996 *International Arts Festival Biennial*, Cairo, Egypt
1995 *2nd Sharjah International Biennial*, Sharjah, UAE
1993-96 Najat Maki has shown in the UAE, Egypt, Sudan,
 Musqat, Qatar, Jordan, Syria, Cairo, Turkey, Germany,
 USA, Spain, Italy, Moscow, Japan and France

HOURIA NIATI

MEDIUM Mixed, installation, performance, painting and drawing

BORN 1948, Khemis-Miliana, Algeria; lives in London, UK

EDUCATION
1969 National School of Tixeraine, Algiers. Dip. Community Arts
1979-82 Croydon College of Art & Design, Surrey, Dip. Fine Art
1984 First Artist in Residence, Riverside Studios, London

SELECTED SOLO EXHIBITIONS
1984-95 Africa Centre, London
 Smith's Gallery, London
 Rochan Gallery, London
 Small Mansion Arts Centre, London
 Ikon Gallery, Birmingham
 Maison de la Culture, Courbevoie, Paris, France
 Galerie du CCWA, Algiers
 Maison de la Culture Tizi-Ouzou, Algiers

SELECTED GROUP EXHIBITIONS
1999-2000 *Dialogue of the Present, the Work of 18 Arab Women Artists*
 Touring the UK: Hot Bath Gallery, Plymouth Arts Centre,
 Brunei Gallery, Pitshanger Manor & Gallery, University of
 Brighton Gallery
1997 *Contemporary Africana Women Artists*, Cornell University, NY
 3rd Sharjah International Biennal, Sharjah, UAE
 Museum of Contemporary Art, Tampa, Florida, touring USA
1994-95 *Forces of Change*, travelling exhibition, The National
 Museum of Women in the Arts, Washington DC;
 Chicago; Miami; S. Atlanta, USA
 New Visions, Zora Neale Hurston National Museum of Fine
 Arts, Florida, USA
1984-94 Battersea Arts Centre, London
 Riverside Studios, London
 Whitechapel Gallery, London
 Barbican Centre, London
 Commonwealth Institute Centre, London
 Mappin Art Gallery, Sheffield
 Castle Museum, Nottingham
 Fruitmarket Gallery, Edinburgh,
 Cartwright Hall Museum, Bradford
 Harris Museum, Preston, Lancs.
 Chicago Cultural Centre, USA
 Wolfson Galleries, Miami, Florida, USA
 Nexus Contemporary Art Centre, Atlanta, Georgia, USA
 Gwinnet Art Centre, Duluth, Georgia, USA
 Bedford Gallery, Walnut Creek Civic Art Centre, Calif. USA

AZZA AL-QASIMI

MEDIUM Mixed, collage, prints and oil on canvas

BORN 1974, Sharjah, UAE; lives in Sharjah, UAE

EDUCATION Higher Diploma in Banking & Finance, UAE

SELECTED GROUP EXHIBITIONS
1999-2000 *Dialogue of the Present, the Work of 18 Arab Women Artists*
 Touring the UK: Hot Bath Gallery, Plymouth Arts Centre,
 Brunei Gallery, Pitshanger Manor & Gallery, University of
 Brighton Gallery
1998 *17th Annual Fine Arts Exhibition*, Sharjah, UAE
1997 *3rd Sharjah International Arts Biennal*, UAE
 GCC Exhibition, China
 Members Exhibition, Dubai International Art Centre, UAE
 The Emirates Artists' Exhibition, Paris, France
 The Emirates Artists' Exhibition, Sharjah, UAE
 16th Annual Fine Arts Exhibition, Sharjah, UAE
1996-97 *Sharjah Women's Club Art Exhibition*, Sharjah, UAE
1996 *Members Exhibition*, Dubai International Art Centre, UAE
 The Feminine Touch, Dubai
 Emirates Fine Arts Society, Al Hanajer Centre, Egypt
 15th Annual Fine Arts Exhibition, Sharjah, UAE
 Jarash International Art Festival, Jordan
 Cairo International Arts Biennial, UAE

ZINEB SEDIRA

MEDIUM Video installation, photographs

BORN 1963, Gennevilliers, France; lives in London, UK

EDUCATION
1992-95 Central St. Martin's School of Art, London. B.A. Hons.
1995-97 Slade School of Art, London. M.A. in Media and Fine Art
1998 Royal College of Art, M.Phil. Photography

SELECTED EXHIBITS/EXHIBITIONS
1999-2000 *Dialogue of the Present, the Work of 18 Arab Women Artists*
 Touring the UK: Hot Bath Gallery, Plymouth Arts Centre,
 Brunei Gallery, Pitshanger Manor & Gallery, University of
 Brighton Gallery
1998 *Showgirls Billboard Project*, Women's Art Factory,
 Sheffield (January)
 Return of the Showgirls, Women's Art Factory, Sheffield,
 (March)
 Interim, Henry Moore Gallery, Royal College of Art, London
 Stream TV, ICA, London
 Is Art Beneath You, site specific project, Serpentine Gallery,
 London
1997 *Point of Entry,* Cable Street Gallery, London
 Out of the Blue, Gallery of Modern Art, Glasgow, Scotland
 Une Génération de Femmes, Silent Sight, MA Degree Show,
 Slade School of Art, London
1996 *Bound*, Commercial Too Gallery, London
1995 *Untitled* (3 screens/video installation), BA Degree Show,
 Central St. Martin's, School of Art, London
1994 *Cité Dortoir,* 198 Gallery, London
1993 *Espoir,* (outdoor sculptures), Skoki Centre, Poland
 Topology of the Veil, Lethaby Gallery, London

LAILA AL-SHAWA

MEDIUM Silk screen, oil on canvas, sculpture

BORN 1940, Gaza, Palestine

EDUCATION
1957-58 Leonardo da Vinci School of Art, Cairo, Egypt
1958-64 Academia de Belle Arte Rome, Italy, BA Hons. in Fine Art
1960-64 Academia St. Giaccomo, Rome, Italy, Diploma in Plastic
 Decorative Arts

SELECTED SOLO EXHIBITIONS
1996 Mermaid Theatre Gallery, London, UK
1992 The Gallery, London
1990 The National Art Gallery, Amman, Jordan
1976 Sultan Gallery, Kuwait

SELECTED GROUP EXHIBITIONS
1999-2000 *Dialogue of the Present, the Work of 18 Arab Women Artists*
 Touring the UK: Hot Bath Gallery, Plymouth Arts Centre,
 Brunei Gallery, Pitshanger Manor & Gallery, University of
 Brighton Gallery
1996 *Transvanguards*, October Gallery, London
 The Right to Write, from the Collection of the National Art
 Gallery, Jordan, Agnes Scott College, Atlanta, Georgia
 The World Bank Gallery, World Bank, Washington DC
 The Winter Exhibition, October Gallery, London
1995-97 *The Right to Hope, One World Art*, World touring exhibition
1995 *Contemporary Arab Artists*, Darat Al-Funun, Amman, Jordan
 Contemporary Arab Artists, Riwaq Al Balq'a Gallery, Jordan
 Artist's View, The Arab World, Willamette Arts Gallery,
 Willamette University, Salem, Oregon, USA
 Contemporary Middle Eastern Art, John Addis Gallery,
 British Museum, London. (Recent acquisitions)
1994-95 *Forces of Change*, travelling exhibition, The National
 Museum of Women in the Arts, Washington DC;
 Chicago; Miami; S. Atlanta, USA
1994 *From Exile to Jerusalem*, Al-Wasiti Art Centre, Jerusalem
 Shawa & Wijdan, October Gallery, London
1993 *Saga*, Salon de L'èstampe et de L'èdition d'art a Tirage
 Limite, Grand Palais, Paris, France
1992 *Three Artists from Gaza*, The Shoman Foundation, Jordan
1990 *Malaysian Experience*, National Art Gallery, Kuala Lumpur,
 Malaysia
1989 *Contemporary Art from the Islamic World,* Barbican Centre,
 London
1988 *The Baghdad Biennale*, the Saddam Centre, Baghdad
1987 *Arab Women Artists in the UK,* Kufa Gallery, London

ARTISTS' BIBLIOGRAPHIES

FIRYAL AL-ADHAMY
Bahrain This Month, March 1998
Greenan, Althea, 'Dialogue of the Present', *Visiting Arts,* No.37,
 Summer 1998: p22-23
Issa, Rosa, *New Horizon,* September 1990
Jalal, A. *This is London,* October 1990, London
Khoury, Anton, *Al Hayat,* 3rd July 1992

MALIKA AGUEZNAY
Galerie Bab Rouah, *Malika Agueznay, Les Mots Magiques*, Rabat,
 Morocco, essays by Toni Mariani and Mostafa Nissabouri, 1996
Greenan, Althea, 'Dialogue of the Present', *Visiting Arts,* No.37,
 Summer 1998: pp22-23

JANANNE AL-ANI
Barbican Art Gallery, *Who's Looking at the Family?* London, essay by
 Val Williams: Barbican, 1994
Greenan, Althea, 'Dialogue of the Present', *Visiting Arts,* No.37,
 Summer 1998: pp22-23
Harris Museum and Art Gallery, *Fine Material for a Dream ... ?*
 Preston, UK, essay by Emma Anderson, 1992
Williams, Val, *Modern Narrative, the Domestic and the Social*, UK, '97

THURAYA AL-BAQSAMI
Al-Baqsami, 'An Artist's View of Kuwait', *Kuwait Bulletin,* London, Issue
 No. 28, August 1996: pp4-5
Ali, Wijdan, *Contemporary Art from the Islamic World,* London:
 Scorpion Books, 1989
Ali, Wijdan, *Modern Islamic Art, Development and Continuity*, Florida:
 University Press of Florida, 1997
Greenan, Althea, 'Dialogue of the Present', *Visiting Arts,* No.37,
 Summer 1998: pp22-23
Nashashibi, Salwa Mikdadi, *Forces of Change, Artists of the Arab
 World*, Lafayette, California: International Council for Women
 in the Arts, 1994
2nd Sharjah International Arts Biennial, Sharjah, UAE: Department of
 Culture, 1995

RIMA FARAH
Arts and the Islamic World, July 1983
Arts Review, July 1983; December 1984; September 1986; Jan.'90
Arts Review Year Book, 1987

Bahechar, S., *Le Journal de Tanger*, July 1991
Egee, Dale, *Eastern Arts Report,* August 1991
Greenan, Althea, 'Dialogue of the Present', *Visiting Arts,* No.37,
 Summer 1998: pp22-23
Nashashibi, Salwa Mikdadi, *Forces of Change, Artists of the Arab
 World*, Lafayette, California: International Council for Women
 in the Arts, 1994
Washington Post, April 1986

MAYSALOUN FARAJ
Faraj, Maysaloun, 'Strokes of Genius ... Contemporary Iraqi Art',
 Visiting Arts, No.37, Summer 1998: pp18-19
Greenan, Althea, 'Dialogue of the Present', *Visiting Arts,* No.37,
 Summer 1998: pp22-23
Nashashibi, Salwa Mikdadi, *Forces of Change, Artists of the Arab
 World*, Lafayette, California: International Council for Women
 in the Arts, 1994
Parmelee, Terry, 'Forces of Change', *Washington Review,* Vol. XIX, No.6,
 April/ May, 1994
Rinaldi, Therese, 'Maysaloun Faraj', *Arts and the Islamic World*, No.29,
 Autumn 1996: pp49-51

BATOOL AL-FEKAIKI
Alray Newspapers, (Arabic), Amman, Jordan, 17 October 1996
Amir, Ali Abdul, *Al Quds Al Arabi*, (Arabic), London, 17 October 1996
 Berlin Cultural Centre, *Contemporary Iraqi Arts*, Berlin, 1979
Greenan, Althea, 'Dialogue of the Present', *Visiting Arts,* No.37,
 Summer 1998: pp22-23
Al-Habib, Kifah, *Al Ayyam Newspaper,* (Arabic), 29th September 1996
Hamdan, Munther, 'Myths of Heart and Home', *The Star*, Jordan, 1997
Al-Matbiey, Hameed, *Encyclopaedia of Well Known People in Iraq*,
 Baghdad: Ministry of Culture, 1995
Morgenroth, Gabriele, 'Batool al-Fekaiki', *Traunsteiner Wochenblatt*,
 (German), 20 December 1997

MAI GHOUSSOUB
Ghoussoub, Mai, *Comprendre le Liban*, Paris,1976
Women and the Male Nature of Authenticity, (Arabic), London, 1991
Postmodernism, Arabs in a Video Clip, (Arabic), Beirut, 1994
Leaving Beirut, Women and the Wars Within, London, 1998
Merali, Shaheen, 'Displaces: Topography of Unbelonging', *Third
 Text,* Vol.39, Summer 1997: pp103-5

WAFAA EL HOUDAYBI

Faiza, M., 'La Rupture avec la norme artistique', *Le Matin du Sahara*, 14 February 1998

Greenan, Althea, 'Dialogue of the Present', *Visiting Arts*, No.37, Summer 1998: pp22-23

Haouzir, Malika, 'Réussir sa vie professionelle', *Nouvelles du Nord*, 6 March 1998

2nd Sharjah International Arts Biennial, 11-22 April 1995, Sharjah, UAE: Department of Culture, 1995

3rd Sharjah International Arts Biennial, April 1997, Sharjah, UAE: Department of Culture, 1997

'Wafaa El Houdaybi expose aux Oudayas', *Le Matin du Sahara et du Maghreb*, 10 January 1992

KAMALA IBRAHIM ISHAQ

Ali, Wijdan, *Contemporary Art from the Islamic World*, London: Scorpion Books, 1989

Ali, Wijdan, *Modern Islamic Art, Development and Continuity*, Florida: University Press of Florida, 1997

Greenan, Althea, 'Dialogue of the Present', *Visiting Arts*, No.37, Summer 1998: pp22-23

Hevesi, J., 'The paintings of Kamala Ishaq', *Studio International*, 1969: p.276

Kennedy, J. *New Currents Ancient Rivers, Contemporary African Artists in a Generation of Change*, Washington: Smithsonian Institution Press, 1992

Nashashibi, Salwa Mikdadi, *Forces of Change, Artists of the Arab World*, Lafayette, California: International Council for Women in the Arts, 1994

Whitechapel Art Gallery, *Seven Stories about Modern Art in Africa*, London: Flammarion, 1995

LEILA KAWASH

Greenan, Althea, 'Dialogue of the Present', *Visiting Arts*, No.37, Summer 1998: pp22-23

Magna Gallery, *Dawns and Invocations*, Athens, essay by Angela Tamvaki, 1997

Nashashibi, Salwa Mikdadi, *Forces of Change, Artists of the Arab World*, Lafayette, California: International Council for Women in the Arts, 1994

SABIHA KHEMIR
Greenan, Althea, 'Dialogue of the Present', *Visiting Arts,* No.37,
 Summer 1998: pp22-23
Nashashibi, Salwa Mikdadi, *Forces of Change, Artists of the Arab
 World,* Lafayette, California: International Council for Women
 in the Arts, 1994
Johnson-Davies, Denys, *The Island of Animals,* Illustrations by Khemir,
 London: Quartet Books, 1994

NAJAT MAKI
Ahmed, Tina, 'Artistic Evolution & Development in Dubai & the
 Northern Emirates', *Eastern Art Report,* Vol. IV, No.3, 1992. p28
Greenan, Althea, 'Dialogue of the Present', *Visiting Arts,* No.37,
 Summer 1998: pp22-23
Howling, Frieda, 'From the Traditional to the Modern & Contemporary
 - Art in the UAE', *Eastern Art Report,* Volume IV, No.3, 1992: p.24
2nd Sharjah International Arts Biennial, 11-22 April 1995, Sharjah,
 UAE: Department of Culture, 1995
3rd Sharjah International Arts Biennial, April 1997, Sharjah, UAE:
 Department of Culture, 1997

HOURIA NIATI
Ali, Wijdan, *Contemporary Art from the Islamic World,* London:
 Scorpion Books, 1989
Chambers, Eddie, *The Art Pack, A History of Black Artists in Britain,*
 London, 1988
Greenan, Althea, 'Dialogue of the Present', *Visiting Arts,* No.37,
 Summer 1998: pp22-23
Hassan, Salah M., 'The Installations of Houria Niati', *NKA, Journal of
 Contemporary African Art,* Fall/Winter, 1995: pp50-55
Nashashibi, Salwa Mikdadi, *Forces of Change, Artists of the Arab
 World,* Lafayette, California: International Council for Women
 in the Arts, 1994
Morris, Susan, 'Forms of Intuition', *Arts Review,* Vol.41, May 1989: p356
Oguibe, Olu, *Cross/ing, Time.Space.Movement,* Contemporary Art
 Museum, Florida: University of South Florida, 1997
Parker, Rozsika & Pollock, Griselda (eds)., *Framing Feminism, Art and
 the Women's Movement,* London: Pandora Press, 1987
The Herbert F. Johnson Museum of Art, *Gendered Visions, The Art of
 Contemporary Africana Women Artists,* New York: Cornell, 1997
3rd Sharjah International Arts Biennial, April 1997, Sharjah, UAE:
 Department of Culture, 1997

AZZA AL-QASIMI
Greenan, Althea, 'Dialogue of the Present', *Visiting Arts,* No.37,
 Summer 1998: pp22-23
3rd Sharjah International Arts Biennial, April 1997, Sharjah, UAE:
 Department of Culture, 1997

ZINEB SEDIRA
Greenan, Althea, 'Dialogue of the Present', *Visiting Arts,* No.37,
 Summer 1998: pp22-23
Gallery of Modern Art, *Out of the Blue,* Glasgow, 4th July - 21st
 September, 1997, essay by Edith Marie Pasquier: pp20-23
London Institute, *Fine Art 1995*, London, June 1995
Serpentine Gallery, *Is Art Beneath You?* London, August, 1998
Slade School of Fine Art, *The Slade Journal*, Volume 1, London, June
 1997

LAILA AL-SHAWA
Ali, Wijdan, *Contemporary Art from the Islamic World*, London:
 Scorpion Books, 1989
Ali, Wijdan, *Modern Islamic Art, Development and Continuity*, Florida:
 University Press of Florida, 1997
Bahnasi, Afif, Dr., Al-Raed al-Arabi, Dar, *Pioneers of Modern Art in the*
 Arab Countries, (Arabic), Beirut, 1985
Greenan, Althea, 'Dialogue of the Present', *Visiting Arts,* No.37,
 Summer 1998: pp22-23
Impressions, Norway, H. Aschehoug & Co.,1996
Khal, Helen, *The Woman Artist in Lebanon*, Beirut:
 Institute for Women's Studies in the Arab World: Beirut University
 College Press, 1987
Laila Shawa Works 1964-1996, Cyprus: MCS Publications, 1997
Nashashibi, Salwa Mikdadi, *Forces of Change, Artists of the Arab*
 World, Lafayette, California: International Council for Women
 in the Arts, 1994
October Gallery, *Shawa and Wijdan*, London, 1994
On The Wings of Peace, New York: Clarion Books, 1995
Shammout, Ismail, *Art in Palestine*, (Arabic): Al-Qabas Press, 1989
The Right to Hope, UK, Earthscan Publications Limited, 1995
The Right to Write, Atlanta, USA, Agnes Scott College, 1996

GENERAL BIBLIOGRAPHY

Accad, Evelyne, *Veil of Shame, The Role of Women in the Contemporary Fiction of North Africa and the Arab World*, 1978

Ahmed, Leila, 'Western Ethnocentrism and Perceptions of the Harem', *Feminist Studies*, Vol.8, No.3, 1982

Ahmed, Leila, *Women and Gender in Islam*, New Haven: Yale University Press, 1992

Ali, Wijdan, 'Artist & Missionary of the Mixed Media', *Eastern Art Report*, Vol.1, Part 4, (16-30th April 1989): pp12-14

Ali, Wijdan, *Contemporary Art from the Islamic World*, London: Scorpion Publication Ltd, on behalf of The Royal Society of Fine Arts, Amman, 1989

Ali, Wijdan, *Modern Islamic Art, Development and Continuity*, Florida: University Press of Florida, 1997

Alloula, Malek, *The Colonial Harem*, Minneapolis: University of Minnesota Press,1986

Archer, Michael et al., *Mona Hatoum*, London: Phaidon Press, 1997

Atassi, Mouna, (ed)., *Contemporary Art in Syria, 1898-1998*, Damascus, Syria: Gallery Atassi, 1998

Atil, Esin, *Patronage by Women in Islamic Art*, Arthur M. Sackler Gallery, Smithsonian Institution, Vol. VI, No.2, N.Y: Oxford University Press, 1993

Augustin, Ebba, *Palestinian Women's Identity and Experience*, London & New Jersey: Zed Books, 1993

Azar, Aimée *Femmes Peintres d'Egypte,* Cairo; Imprimene Française, 1953

Badran, Margot & Cooke, Miriam (eds)., *Opening the Gates: A Century of Arab Feminist Writing*, Indiana: Indianan University Press, 1990

Badran, Margot, 'Feminism as a Force in the Arab World', *Contemporary Thought and Women*, Cairo: Arab Women's Solidarity Press, 1989

Barbican Centre, *Lebanon - The Artists View, 200 Years of Lebanese Art*, London, 1989

Barbican Centre, Concourse, *Signs, Traces, Calligraphy, Five Contemporary Artists from North Africa*, Rosa Issa (curator), London, 1995

Betterton, Rosemary, *An Intimate Distance, Women, Artists, and the Body*, London and New York: Routledge, 1996

Bhabha, Homi, *The Location of Culture*, London & N.York: Routledge, 1994

Bohm-Duchen, M. and Grodzinski, V. (eds)., *Rubies & Rebels, Jewish Female Identity in Contemporary British Art*, Barbican Concourse Gallery, London: Lund Humphries, 1998

Brown, S. Graham, *Images of Women; The Portrayal of Women in Photography of the Middle East*, London, Quartet Books, 1988.

Candid Arts Trust, *Story Time, An Exhibition by Artists Living in Israel/ Palestine*, London, 1998

Fanon, Frantz, *Black Skins, White Masks*, London: Pluto Press, 1986, Ist published,1952

Fisher, Jean (ed)., *Global Visions, Towards a New Internationalism in the Visual Arts,* London: Kala Press in association with The Institute of International Visual Arts, 1994

Fullerton, Arlene, Fehervari, Geza, *Kuwait Arts and Architecture*, Kuwait, UAE: Oriental Press, 1995

Hall, Stuart, 'Cultural Identity and Diaspora' in P. Williams & L. Chrisman, (eds).,*Colonial Discourse and Post-Colonial Theory, A Reader,* Cambridge; Harvester/Wheatsheaf, 1993

Hassan, Ihab, 'Queries for Postcolonial Studies' *Third Text,* Vol. 43, Summer 1998: pp59-68

Hélie-Lucas, Marie-Aimée, 'Women, Nationalism and Religion in the Algerian Liberation Struggle' in Margot Badan and Miriam Cooke (eds)., *Opening the Gates, A Century of Arab Feminist Writing,* Indiana: Indianan University Press, 1990

Ikon Gallery, *In a Unsafe Light*, Charnley, Geogopoulos, Hatoum, Birmingham, UK,1988

Institute of Contemporary Arts/Institute of International Visual Arts, *Mirage, Enigmas of Race, Difference and Desire,* ICA/inIVA season,12 May-16 July 1995, London, 1995

Kandiyoti, Deniz, 'Identity and its Discontents: Women and the Nation', *Millenium: Journal of International Studies*, Vol.20, No.3, 1991: pp429-43

Kandiyoti, Deniz, (ed)., *Women, Islam and the State*, London and University of California: Macmillan, 1990

Karnouk, Liliane, *Modern Egyptian Art, The Emergence of a National Style,* Cairo, Egypt: American University in Cairo, 1988

Karnouk, Liliane, *Contemporary Egyptian Art*, Cairo, Egypt: American University, Cairo, 1995

Kaper, Greta, 'Globalisation and Culture', *Third Text* Vol. 37, Summer 1997; pp21-38

Khal, Helen, *The Woman Artist in Lebanon*, Beirut: Institute for Women's Studies in the Arab World: Beirut University College Press, 1987

Khamis, Zabyah, *Contemporary Gulf Poetesses, a Feminist Perspective,* UK, 1996

Kristeva, Julia, *Strangers to Ourselves*, translated by Leon S. Roudiez, New York: Columbia University Press, 1991

Lewis, Reina, *Gendering Orientalism, Race, Femininity and Representation*, London and New York: Routledge, 1996

Leyton, Harrie, Damen, Bibi (eds)., *Art, Anthropology, and the Modes of Re-presentation, Museums and Contemporary Non-Western Art,* 1993

MacKenzie, John M., *Orientalism: History, Theory and the Arts,* Manchester & New York: Manchester University Press, 1995

Madkour, Nazli, *Women and Art in Egypt,* Cairo: State Information Office, 1993

Meskimmon, Marsha, *The Art of Reflection: Women Artists Self Portraiture in the Twentieth Century*, London: Scarlet Press, 1996

Mernissi, Fatima, *Beyond the Veil,* Cambridge, 1975

Mernissi, Fatima, *The Veil and the Male Elite: A Feminist Interpretation of Women's Rights in Islam*, trans. Mary Jo Lakeland, New York: Addisan-

Wesley, 1991

Mitchell, Timothy, *Colonising Egypt*, Berkeley: University of California Press, 1991

Mohanty, Chandra Talpade, 'Under Western Eyes: Feminist Scholarship and Colonial Discourses', in P. Williams & L. Chrisman, (eds) *Colonial Discourse and Post-Colonial Theory, A Reader,* Cambridge; Harvester/Wheatsheaf, 1993

Museum Fridericianum, *Echolot: Oder 9 Fragen an die Periperie (9 Questions from the Margins)*, Ghada Amer essay by Candice Brietz: Shirin Neshat essay by Octavio Zaya

Nashashibi, Salwa Mikdadi, *Forces of Change, Artists of the Arab World*, Lafayette, California: International Council for Women in the Arts, 1994

Nashashibi, Salwa Mikdadi, *Rhythm and Form, Visual Reflections on Arabic Poetry*, Lafayette, California: International Council for Women in the Arts, 1998

Nochlin, Linda, 'The Imaginary Orient', in *The Politics of Vision*, London: Thames and Hudson, 1991

Norris, Christopher, *Deconstruction: Theory and Practice,* London: Methuen, 1982

Parker, Rozsika & Pollock, Griselda (eds)., *Framing Feminism Art and the Women's Movement, 1979-1985*, London & New York: Pandora, 1987

Pollock, Griselda (ed)., *Generations and Geographies in the Visual Arts*, Routledge: London, 1996

Saadawi, Nawal El, *The Nawal El Saadawi Reader,* London and New York: Zed Books, 1997

Said, Edward W., *Orientalism, Western Concepts of the Orient*, London: Routledge & Kegan Paul Ltd., 1978

Said, Edward W., 'The Voice of a Palestinian Exile', *Third Text*, Vol. 3, No.4, 1988: pp39-50

Said, Edward W., *Culture and Imperialism,* London: Vintage Books, 1993

Salman, A., *Modern Art in the Countries of the Gulf Cooperation Council*, (Arabic), Kuwait: Gulf Cooperation Council 1984

Sha'rawi, Huda, *Harem Years: The Memoirs of an Egyptian Feminist*, London: Virago, 1986

Shammout, Ismail, *Art in Palestine*, (Arabic): Al-Qabbas Press, 1989

Sijelmassi, M., *L' Art Contemporain au Maroc:* ACR, Edition, Paris, 1989

Wolff, Janet, *Resident Alien, Feminist Cultural Criticism*, Cambridge, UK: Polity Press, 1995

Wolff, Janet, *Feminine Sentences; Essays on Women and Culture*, Cambridge, Polity Press, 1990

Yegenoglu, Meyda, *Colonial Fantasies: Towards a Feminist Reading of Orientalism*, Cambridge: Cambridge University Press, 1998

Yuval-Davies Nira & Anthias, Floya, (eds), *Woman-Nation-State, London:* Macmillan, 1989

Zegher, M. Catherine de (ed)., *Inside The Visible, an Elliptical Traverse of 20th Century Art*, MIT Press, 1996

PLATES

INDEX